Finding
Nemon

Nemon in the 1930s

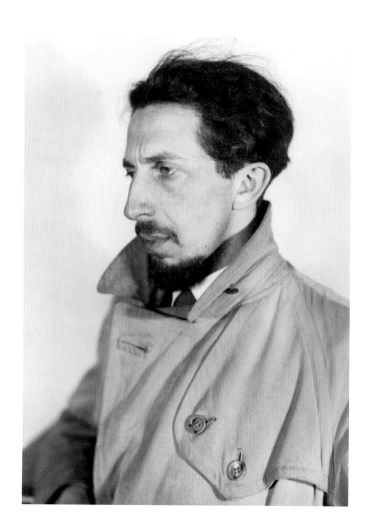

Finding Nemon

Aurelia Young
with Julian Hale

The Extraordinary Life of the
Outsider Who Sculpted the Famous

PETER OWEN
LONDON AND CHICAGO

PETER OWEN PUBLISHERS
Conway Hall, 25 Red Lion Square,
London WC1R 4RL

Peter Owen books are distributed in the USA
and Canada by Independent Publishers Group/
Trafalgar Square
814 North Franklin Street, Chicago, IL 60610, USA

First published in Great Britain 2018
by Peter Owen Publishers
This paperback edition 2019

Paperback ISBN 978-07206-2066-5
Hardback ISBN 978-0-7206-2037-5
Epub ISBN 978-0-7206-2038-2
Mobipocket ISBN 978-0-7206-2039-9
PDF ISBN 978-0-7206-2040-5

A catalogue record for this book is available from
the British Library.

Cover and book design by Graphicacy.co.uk

Printed and bound by Printworks Global Ltd,
London/Hong Kong

Acknowledgements by Aurelia Young

AM MOST GRATEFUL to Julian Hale for the research he carried out into my father's life and for his help in writing this book; without him there would be no book.

My thanks go to George, my kind and patient husband, who has helped and supported me during the evolution of this book.

I would like to thank my sister-in-law Alice for allowing me to use her research into Nemon's creative processes when working with a sitter, and I am grateful to her for giving me access to the letters and photographs and busts owned by the Nemon Estate.

My sister Electra has also been invaluable with her recollections of our father, while Paul Fraser has been wonderful in cataloguing and analysing my mother's letters, which I have quoted throughout the book.

Nemon wrote fluently in Croatian, German, French and English, and I would like to thank Charles and Ingrid Medlam who spent many hours translating his letters from French and German.

I am grateful to the many people who have told me of their experiences and memories of my father and helped with translating documents from Croatian into English. I would like to thank Lana Adam, Ivo and Nevenka Adler, Lady Ashburton, Nigel Boonham, Paul Booth, Mirijana Bračanov, Sophia Butler, Kevin Clancy, Susan Curtis-Kojaković, John Dear, Francis de Marneffe, Dan Dimancescu, Estel Eforgan, Ian Grable, Susan Donnell Griffiths, Eleo Gordon, Leo Goldschmidt, Darko Fischer, Alan Henrikson, Angela Huxter, Edie Jarolim, Jim Kempton, Jane Kennedy, Hilaire Metsers, Sondra Milne Henderson, Ivan Mirnik, Sam Oates, James Oglethorpe, Allen Packwood, Robert Preston, Benedict Richards, Sir Adam Ridley, Jacqueline Rosenthal, Edwina Sandys, Hans Vandevoorde, Johan van Heesch, Lady Williams of Elvel and Daniel Zec.

Thank you to Randolph and Catherine Churchill for their courtesy in allowing for Sir Winston Churchill's paintings to feature in the images of this book and for agreeing to the reproduction of Sir Winston Churchill's bust of my father in

the images and on the cover of this book, and to Curtis Brown for copyright clarification with regards to Churchill material.

Where possible, I have sought permission to use material where copyright exists, and I apologize in advance for any oversight.

Aurelia Young

DEDICATION

As Nemon was a passionate believer in the importance of the family, I dedicate this book to his grandchildren Sophia, Gerry, Hugo, Camilla, Sorrel, Paris, Ze and Pendragon, to my sister Electra, to my sister-in-law Alice and to the memory of my brother Falcon who took many of the photographs in this book.

My brother, the photographer Falcon Stuart
PHOTOGRAPH BY FALCON STUART

Contents

Nemon with Aurelia
in 1945

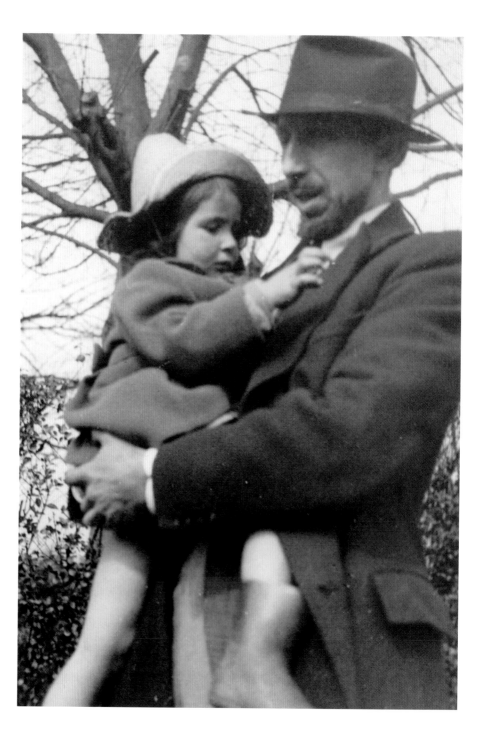

Preface

H<small>E USED TO</small> stand barefoot on the end of my bed, bouncing gently up and down and singing to me in a voice that was soft and tuneful 'Night is falling and my golden one is sleeping . . .' Although he towered over me, he was not a big man. His hair was dark and curly, flying off his head. He had a little black goatee beard on his narrow chin and sparkling grey eyes. I knew him – but not very well. Yet I loved him. He entranced me. He was my father.

Just recently I heard that familiar tune again but with different words. '*Tiho noći, moje zlato spava . . .*', and now I know it is a song from Croatia and a famous lullaby. As I listened to it I smiled and remembered my gentle father. I imagined my grandmother singing the same song to her eldest son and wondered what my father was feeling as he sang it to me, his daughter, his second child, who reminded him, as he wrote to his sister Bella, of 'our beautiful, kind mother'.

My father would arrive at our home – two prefabricated ex-army huts on Boars Hill, just outside Oxford – like a genie. He brought presents, dolls in national dress, Moroccan carpets, embroidered blouses. He had a smell about him of smoky London and earthy clay. His fingers and hands were speckled with flakes of white plaster of Paris. He suffered badly from migraines. As a child I remember him lying, stretched out face down on the floor, and I used to walk barefoot up and down his spine to relieve his pain.

Everyone called my father 'Nemon' – even my mother Patricia – this man who was also 'Papa' to me, my older brother Falcon and my sister Electra who was seven years younger. None of us had ever known him by his birth name, Oscar Neumann. That is why in this book I mostly refer to him as 'Nemon', even though it may seem an anachronism because he adopted this name only when he was in his twenties and living in Brussels.

It took me years to take in the fact that he was Jewish. I remember when I was about seven asking my father why I had only one grandmother, and he told me how his mother had been taken from her home and shot in the woods and her body left there where she fell. This is what he told me, although it has now been proved that she was shot in the Banjica Concentration Camp in Yugoslavia.

I asked him what she had done wrong, and he said nothing; she was simply a Jew. This frightened me, as I was afraid that if he was a Jew and I was a Jew wouldn't we all be killed? He answered, 'I am a Jew, but the war's over, and we are safe in England.'

I didn't know until much later that my parents had not married until near the end of the Second World War so that my non-Jewish English mother's two children would be safe if the Nazis invaded England and wanted to kill anyone with a Jewish name or Jewish blood.

Before we moved to our own home in the country our landlady did not quite know what to make of him. She wrote to her son, 'He is a Yugoslav, a friendly sort, a sculptor by profession with a studio in London. His wife prefers to be writing poetry instead of looking after her children.' I do indeed remember a kind of benign neglect prevailing wherever we lived. My mother had her own passions – not just rather doom-laden poetry but the meaning of numbers, exotic religions and occult practices – and had little time for the domestic round or indeed for her husband's sculpting. She was impatient with him when he was at Boars Hill, possibly wishing he was still away on one of his many trips either to London or abroad, perhaps in Morocco, the USA or somewhere in Europe. He, in turn, would be irritated by the sound of her constant tapping on her typewriter.

It must have been an odd relationship. Monogamy was not Nemon's strong suit; indeed, shortly after I was born he planned to leave his family and go to the USA to join one of his lovers. Yet Patricia tolerated these other relationships and was genuinely fond of him.

Nor was he a reliable breadwinner; the family went from feast to famine as the money from his commissions was spent – often helping people who were themselves going through a hard time.

The house we lived in was far from soundproof. The two joined-together huts had only recently been vacated by Italian prisoners-of-war on Boars Hill. The outside walls and roof were asbestos sheets nailed on to a wooden frame. The inner walls were made of something called Beaverboard, rather like modern pinboard. The panels were six feet high; they bent and flopped and were in constant danger of cracking. Although my father nailed them to the insides of the wooden frame, they would still bulge out. The huts were very cold as there was no central heating. I remember getting dressed in bed and watching the frost forming on the inside of the metal-framed windows. Among so much else, my mother had to become an expert on Crittall windows, Whittlesea bricks and Snowcem, brands still well known today.

Nemon and Patricia called this ramshackle home of ours 'Pleasant Land'. My mother admired the poet William Blake and, for Nemon the wandering Jew, the reference to building Jerusalem 'in England's green and pleasant land' had an

extra resonance. Her first letter to him from Pleasant Land, on 7 November 1948, was headed 'Jerusalem'. Both my parents – but particularly my poet mother – would tell us children how the land had originally belonged to John Masefield and that both Robert Graves and Matthew Arnold had lived near by. 'The land has been consecrated by poets,' Nemon would say.

When he gave up his studio in London just after the war and started working more permanently on Boars Hill, he cut through the roof of one of the huts to make a skylight to let in the precious northern light. I remember all of us playing among the busts standing on their plinths as our father worked, always rolling little bits of clay in his hand.

My father loved to listen to classical music as he worked but had no money to buy more than a few records; so we children would dance to the rather slow strains of Schubert's 'Rosamunde' and, a little later, to Beethoven's 'Kreutzer Sonata' and Mendelssohn's 'Elijah'. All our records were covered in clay.

When I was eleven Nemon took me to my first opera, Verdi's *Rigoletto*, at the New Theatre in Oxford. I have always associated this opera with my father – the outsider at the court of royalty protecting his beloved daughter from a philandering aristocrat. In fact, he was so protective that when I was a teenager he would insist on my being back at home soon after the Oxford colleges expelled all female visitors. If I was late he would be almost unnaturally furious.

Nemon was not just an aesthete. His enthusiasms extended to football (Tottenham Hotspur and the Yugoslav national team), and, although he never passed his driving test, he had a passion for Hillman Minxes (ours was two-tone white and orange). He also had some odd habits. For instance, he would take out the doughy centres of bread rolls and flick them across the table. If any of us had a sore throat he would whip up a concoction he called Sugar Egg – sugar and raw egg yolk beaten into a white froth. It was delicious. He also made pasta with cocoa powder and cream.

One of his strengths was his ability to empathize with others and to understand what made them tick. If they were sitting for him, he would try to capture their personality in his work. This was his talent as a sculptor – extracting and portraying their persona in clay, and he worked quickly to distil this.

He had a natural courtesy. He spoke with a soft voice that made people listen to him carefully (although they sometimes could not get a word in themselves) and was a wonderful and witty teller of stories and risqué jokes. People enjoyed his company and he theirs. I enjoyed his company while he was alive and have since revelled in my discovery of the man who was not just my father but a true, even a great, artist.

I remember him as a figure both shadowy and vivid, loving yet distant; a family man but also a loner, an outsider; an artist and also a kind of psychoanalyst

manqué. It was not until twenty years after his death in 1985 that I began to make a conscious effort to find out more about him. Since then my search for Nemon has become all-consuming. There have been so many exciting things to find out, so many mysteries, parallel lives and loves, evidence of genius and evidence of struggle and rejection.

And there were so many sitters, so many portraits, busts and reliefs. I had no idea quite how prolific he was. This memoir will be focusing on his more famous subjects – Churchill, Freud, kings and queens and presidents – but I have found among his works busts and sculptures of a socialist suffragette (Winifred Horrabin), Belgian army officers, Yugoslav and Austrian politicians and doctors, President Bourgiba of Tunisia, American psychoanalysts, multiple children and parents of their more famous children (Barnett and Elsie Janner), actors, clergymen, musicians (even a relief of Kathleen Ferrier that has disappeared), a Beverley sister (Teddie), minor aristocrats and pretty young things. Nemon never stopped working wherever he lived, wherever he went. I find it extraordinary today to imagine just how many people in the twentieth century, my father's lifetime, wanted a model of their head – or more.

I have been helped in my quest by the 92-page memoir my father wrote during the last years of his life. Oddly, there is just one mention of having a wife and children. There are far more gaps than facts. And quite a few of the 'facts', I now realize, are inaccurate; not deliberately but because his memory became fogged by age and preoccupation. I quote from his memoir as it is full of wonderful stories and anecdotes about his sitters and memories of his childhood, his likes and dislikes. It has helped me find out who he really was and how he lived his life outside my range of vision and experience. He was a man whose works are seen by millions of people every day but of whom few have heard.

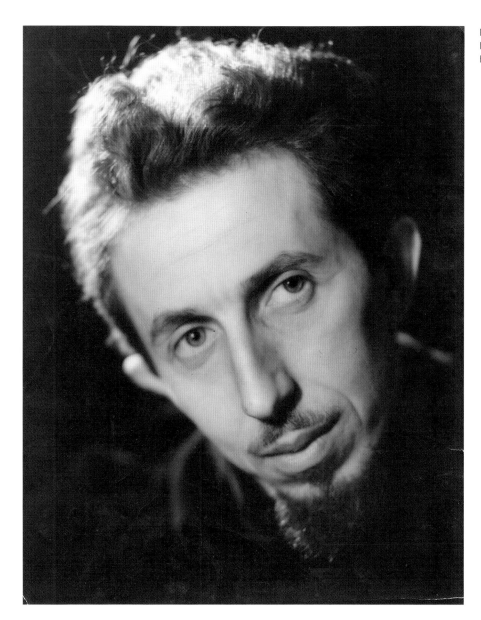

Nemon in the early
1940s photographed
by Baron

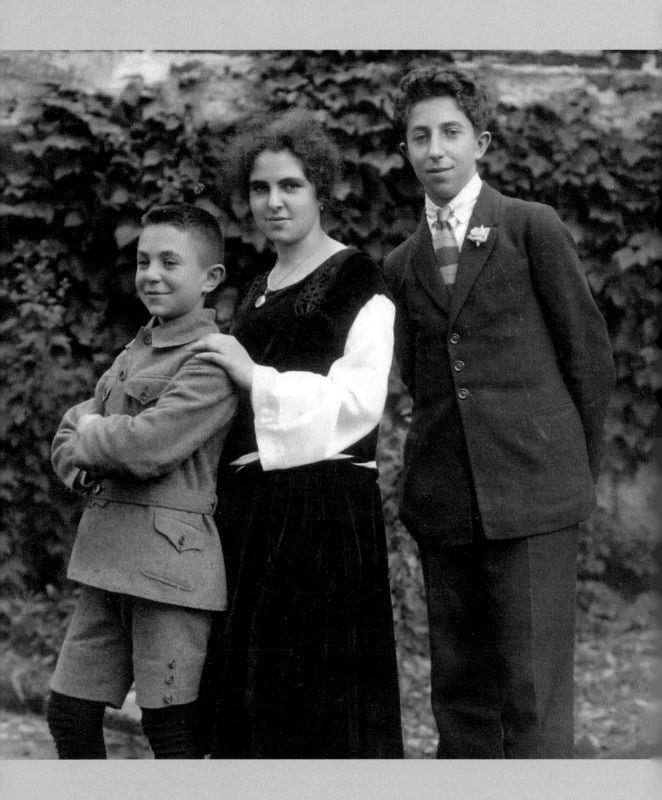

Deze, Bella and Oskar
Neumann, 1920

Osijek 1

BOARS HILL, WHERE I grew up, is surrounded by spectacular views down to Oxford's dreaming spires. In 2006 a member of the Boars Hill Association asked me if I would give a talk about Nemon, and I was ashamed to admit that I was not sure I knew enough about my father even to address a small group of residents.

She persisted, however, saying that the association was working its way through the famous people who had lived on Boars Hill – the archaeologist Sir Arthur Evans, the poets John Masefield and Robert Graves, the scientist and Nobel Prize winner Dorothy Hodgkin and the classicist Gilbert Murray. She reminded me of all the famous people my father had sculpted, including Winston Churchill and the Queen.

It seemed churlish to refuse, as I had many photographs of my father's works to illustrate a talk. In fact, my reaction was to find out more . . .

And where better to start than by going to Croatia to see at first hand – and for the first time – my father's homeland.

That summer I flew to Zagreb, then took a train to the coast to visit Ivo Adler, his cousin, and some of Nemon's few remaining relatives. I wondered whether people there would look like me and would I recognize myself in them? The answer was no. I felt no sense of recognition among the sharp-faced Mediterranean people on the Dalmatian coast.

But in Osijek itself, miles away to the east, on the border with Hungary, the story was different. As soon as I climbed down on to the train tracks and looked around I recognized myself in many of the women I saw. Little round faces, dark hair, brown eyes. My genes! It was odd to think that in different circumstances this might have been my home . . . and I might have had a place in the family grave sculpted by my father in the Jewish cemetery, where my great-grandfather Leopold Adler has been joined by more than twenty relatives killed in the Holocaust. The headstone is in the form of a book – Nemon's homage to Leopold's passion for reading.

So that is how, ever since, I have been unearthing the story of this precociously talented Jew from the outer reaches of the Austro-Hungarian Empire who

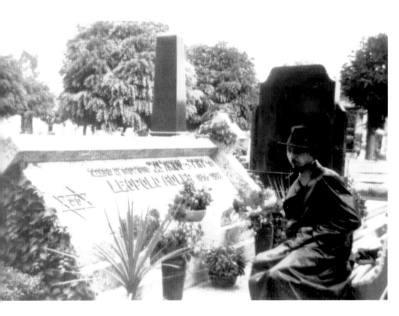

Nemon kneeling
by his grandfather
Leopold Adler's grave
in the Jewish cemetery
in Osijek

sculpted and became a friend of Winston Churchill, Sigmund Freud and a host
of royals, presidents and world-renowned figures but whose own name – the one
he gave to himself – remains virtually unknown. It is the story of a prodigious
and charismatic artist obscured by the iconic images he created, an outsider who
loved and was loved by many women – including my mother. It is a story of loss
as well as discovery, a frustrating, although also often rewarding, quest to track
down missing portraits, vanished studios, unknown friends, family rifts and the
ever-present hazards of being a European Jew in the twentieth century.

Oskar Neumann was a born sculptor. His talent was innate and immense – but
unlikely. He did not come from a family conspicuous for its artistic prowess. His
Hungarian father Moritz (Mavro) was the comfortably prosperous employee of
a paint and boot-polish factory in Osijek, a town tucked away in the easternmost
corner of Croatia (eastern Slavonia) – still, in 1906, when his first son was born, a
sliver of the Austro-Hungarian Empire. Oskar's mother was the nineteen-year-old
daughter of Leopold (Lavaslav) Adler, the owner of the factory. Leopold had
offered the 'promising chemist' Moritz Neumann a job and the hand of his
daughter Eugenie (Xenika). She was expected to say yes to this proposal. So was
Moritz. And so they did. He was seventeen years older than his bride. In 1903
they were married in a synagogue in nearby Požega, noted for being the first city
in Croatia to make Croatian the official language and today with no discernible
Jewish community. Požega was the birthplace of both Leopold and Eugenie.

My Aunt Bella was the first of Moritz and Eugenie's three children. My father
Oskar arrived two years later. His name was chosen not from the example of
some revered or distinguished ancestor, nor even after an eminent local figure, but
from a cry heard from the street outside. On 13 March 1906 Eugenie Neumann

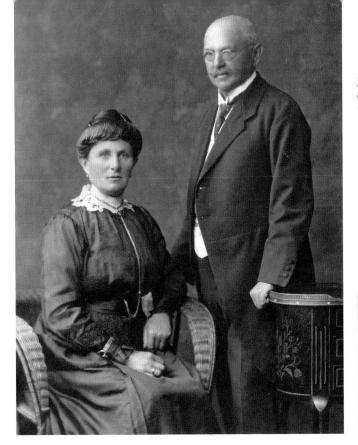

Johanna and Leopold Adler, Nemon's maternal grandparents

was about to give birth to her second child. Just as the midwife was beginning to despair at Eugenie's prolonged labour, Oskar, the horse who pulled the town tram, was passing by the window, and the driver shouted out, 'Come on, Oskar! Get a move on!' 'Come on, Oskar,' echoed the midwife – and the baby boy slipped out into her hands. She handed the baby to Eugenie, announcing, 'Here is Oskar!'

Oskar the horse pulling the tram in Osijek in 1906

When he was living in Brussels in 1930 the young but increasingly successful sculptor changed both his given and his family names. He concluded that Neumann was seen as too Germanic after the First World War and too Jewish, so he adopted the name 'Oscar Némon'. He then sloughed off his anglicized first name like a dry snakeskin and made the world aware he should be known and addressed simply as Nemon (even the acute accent was dropped when he came to England).

He remained attached to his home town all his life, despite his youthful impatience to move out and move on, to become a citizen of the world.

Osijek never quite regained the glamour and renown it enjoyed as the Roman city of Mursa, but its location on the right bank of the river Drava, just twenty-five kilometres from the Danube, allowed it to enjoy some moderate prosperity as a port and trading centre from the end of the twelfth century. For more than 150 years, from the early sixteenth century, it was part of the Ottoman Empire. By the early twentieth century it was thriving. It was a perfectly comfortable place in which to bring up a middle-class Jew. Indeed, the Adlers and the Neumanns were

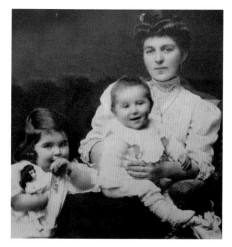

Eugenie Neumann with Bella and baby Oskar in 1906

Above right
Mavro Neumann and Eugenie Adler at the time of their engagement in 1903

part of a significant Jewish community first recorded after the Austrian conquest of Belgrade in 1688, when some five hundred Jewish prisoners were taken to Osijek. Jews, however, had no right of residence there until the late eighteenth century. The first synagogue was not built until 1867. Full emancipation was not granted to Jews in Croatia until six years after that, and the Osijek community became briefly the largest in the Croatian part of the Austro-Hungarian Province of Slavonia – not far short of two thousand individuals by the time baby Oskar joined them.

The Adler family was a large one. Leopold was the second of the eight children of Samuel and Julia Adler, and he and his wife Johanna also had eight children, of whom Eugenie was the eldest. Just two – the twins, Milan and Jula – survived the Holocaust. Jula married Rudi Spitz, the owner of a bronze foundry in Vienna (soon, although briefly, to be part of Oskar's life there), before he and his wife escaped to New York in 1939. The Neumanns were less numerous. Moritz was the second of the three sons born to Ignatz and Johana (née Sinković or Simkovitz or several variants).

His birthplace was Nagyvárad, a town also called Großwardein and now known as Oradea, in western Romania. Before he moved to Osijek to meet and marry the eldest of the Adler girls he had come to live in Monfalcone, near Trieste (then within the Austro-Hungarian Empire, now part of Italy).

I remember Osijek from that first visit in the summer of 2006 as still scarred with bullet-holes from the vicious fighting a decade earlier. But it had obviously once been a prosperous centre of trade and industry, where the fine arts and handicrafts were not neglected. I was proudly told that in the nineteenth century the town boasted a municipal school for draftsmen, a painters' circle, a museum and a theatre. Buildings and mansions in the Secessionist style still prettified a city that had some striking examples of eighteenth-century Austrian baroque,

although for the most part I found it rather dour. In the early twentieth century, while architecture flourished, the fine arts were in the doldrums. Exhibitions of any sort were rare, and most of the artists involved lived and worked in the capital, Zagreb. It was fortunate for the young Oskar Neumann that the years of the First World War saw something of an artistic revival in Croatia. Zagreb was still the centre of cultural life in the region, with its Spring Salons, but some of its influence spread to the rather conservative society of Osijek. I discovered there were at least twenty painters and sculptors living in Osijek in the second decade of the twentieth century, many of whom had trained at the Academy of Fine Arts in Zagreb where they had been exposed to wider European ideas and trends. Many of them also had day jobs teaching in the town's secondary schools, and a few doubled as critics and lecturers.

Between 1920 and 1924 ten art exhibitions were held in Osijek. The teenage Oskar, who was already thinking of himself – and working – as a sculptor, had every chance to get an insight into modern trends. But they were by no means the primary source of his inspiration. Very early on he conceived of himself as an artist – indeed a sculptor. The story goes that in his first year at secondary school he was caught carving the classroom chalk. 'But, professor,' he pleaded, 'this is how I'm going to earn my bread when I grow up.' Already he knew. From a very early age he was, literally, an artist to his fingertips.

The first nine years of Nemon's family life were remembered by him – truthfully, I believe – as happy and uneventful; the most notable happening was the birth in September 1909 of his younger brother Desider, known as Deze.

But in 1915, when Oskar was nine, his father Moritz suddenly died, a victim of tuberculosis. The fragility of family happiness was a crushing lesson to learn. His father's death sowed the seeds of self-doubt and a hard-to-shake-off anxiety that he would never be able to re-create his first years of innocence and financial security. As Nemon's life unfolded – indeed until his death at the age of seventy-nine – it is possible to detect traces of the effects of his premature exposure to loss and uncertainty. The most obvious was a lifetime of migraine headaches. A bizarre letter from Lady (Paquita) Morshead, the wife of the Royal Librarian Sir Owen Morshead, cites as one cause of these constant headaches the 'revulsion you felt at the things you saw and heard in your childhood'. Her diagnosis must surely be suspect, however, as she seemed more interested in the occult than practical medicine. In the same letter she proposed as other causes 'traces of shock in your pre-natal subconscious (and from what you told me of your surroundings it is hardly surprising that your mother should have, at some point, witnessed some scene of violence) which has also affected your spinal cord . . . and the childish diseases had left a very definite residue of poison in your cranial nerves'. The fact that Nemon sought out such an extremely alternative practitioner

Bella, Oskar and Deze
Neumann, Osijek, 1914

is more indicative of the lengths he would go to solve the problem of his migraines than the intrinsic value of the advice he was given. There is no corroborative evidence of his mother witnessing any scenes of violence . . . at least not until the years of the Second World War.

One practical consequence of Moritz's death in the middle of the First World War was that his widow had to go out to work. She started to do the accounts for the Adler family firm. The task of everyday care of the young family fell to her mother, Oskar's grandmother Johanna Adler. The relationship of young Oskar with Johanna was then, and remained until her murder at the hands of Yugoslav fascists, a very close one, although it appears from his memoir that in these early years at least she was not such a great fan of his sculpture. 'She was indifferent to my growing collection of works', he wrote, 'although deeply impressed by the ears of my sculptured heads and fascinated by the intricacy of the craftsmanship.'

It is also reasonable to conjecture that after the death of his father Oskar channelled more and more of his emotional energy into his love of sculpture, of modelling and moulding clay – mostly into human form. My grandmother had tried to enrol him and his older sister Bella into drawing lessons with a local painter Slavko Tomerlin, but the discipline seems to have bored him, and his time as a

pupil there was short. Sculpture soon took over his life. Had he been introduced to the work of the Greek satirical commentator Lucian of Samosata he might have had second thoughts: Lucian warns that, as a sculptor, 'you will be nothing but a workman, doing hard physical labour . . . you will be obscure, earning a meagre and miserable wage, a man of low esteem'. Never prone to self-doubt or worry about the practicalities of his chosen way of life, Oskar pressed on regardless.

At secondary school he moulded in clay and later exhibited a work he called *Distress* (*Bol* in Croatian). He did a self-portrait and (his teachers having come round to his defence) a bust of Professor Stijić. His school teachers – among them Max Melkus, an artist himself – remembered young Oskar fondly. None of these works survives.

Understandably, the boy's preoccupation with his art was not conducive to good academic results. One year, realizing he was about to fail his end-of-year examinations, he decided drastic measures were needed to stave off disaster. He purloined a fine eau de vie from the family cellar and took it to his teacher, saying that it was a present from his grandmother in gratitude for the marvellous teaching he had received. The teacher was duly grateful, and Oskar was given a pass.

Nor was he without sympathetic friends. Ivan Rein, a fellow Jew who became a well-known painter, was particularly close. But Oskar was not naturally gregarious. He revealed in his memoirs that his school nickname was 'Noli Me Tangere' – 'Don't touch me' – partly because of his shy, reclusive nature but also because he refused to join any circle or group of artists. All his life he considered

Self-portrait relief created by Oskar in his early teens

himself as something of an outsider . . . even, I could say, from his family. There are stories about his being bullied as a boy, with lads throwing bottles at him accompanied by anti-Semitic insults, but I can find no hard evidence of organized or sustained anti-Jewish sentiments in his childhood.

Oskar was far from self-pitying or submissive. On the contrary, those close to him in his early years recall his fierce ambition. When he was six, his teenage Aunt Jula was helping in the kitchen and spotted Oskar eating the currants out of an uncooked strudel. He reacted to her protests with the defiant words, 'One day I will eat with kings.' This is a story all surviving members of our family know by heart. Oskar seemed to intuit even then that his early experiments with clay were not a flash in the pan and would lead to fame if not fortune. The fortune was indeed to prove elusive, but the promise he made to himself – and his family – that he would 'eat with kings' turned out to be nothing less than the truth.

In his brief and far from comprehensive memoir written in his seventies Nemon related the story of an Osijek peasant boy, the same age as himself, who

was keen to attract attention to his gifts. He made a large equestrian statue to King Alexander and then discovered there was no conveyance big enough to transport it to Belgrade by land. So he installed the huge and ponderous masterpiece on a boat and rowed it down the Danube to Belgrade, arriving one summer evening like Lohengrin and his swan! This caused a great sensation and gave him the glory he sought.

His own quest for glory was motivated more, as he put it, by a desire to escape from the restricted environment of my Balkan market-town. It was not like being in the same sort of place in Italy, where the stimulus of great art was accessible to everyone. I think that the driving force behind me at that time was a desire for adventure and a realization that this skill in my hands could open the door for me to move away and find excitement and fulfilment in this way.

The first portrait bust for which he was paid was that of Nada Korski, the daughter of a rich local landowner. In 1923 Nada was eleven and Oskar was seventeen – not girlfriend and boyfriend, as I was first told in Osijek, but neighbours. Nada's own story is horrific and yet not untypical of Jews in this part of the world. Amazingly, she survived, and I met her, eighty-three years after my father sculpted her, in Croatia where she was living in a flat on the Istrian coast.

I was unwell when I arrived, and she suggested that I lie down on her sofa, saying that she had done exactly the same when my father last visited her just before he died. She told me about her sittings with Oskar, the 'shy and serious teenage sculptor'. When she got bored sitting still she would throw clay pellets into his bushy hair.

He would carry on regardless, brushing the clay out of his hair as he concentrated hard on his work. According to Nada, he 'wanted to extract my whole psyche'. Even after eight decades she could recall the intensity of the experience. 'He seemed to go deep into the anima and only then give it exterior form and shape.'

Nada was the youngest child and only daughter of a man called Kastenbaum (later changed to Korski to avoid having a Jewish name). They had a large house on Europa Avenue in Osijek, and I wondered whether the young Oscar went in there through the imposing entrance arch or sneaked in by the tradesman's door.

Her first husband, also Jewish, was killed by the local fascists during the Second World War, while her mother gassed herself. When her two elder brothers came back from exile in Switzerland after her suicide they were captured and killed. She then married an old friend, a Catholic, but he was exposed and killed as a collaborator. Her house was requisitioned twice, first by the Nazis and immediately after the war by the Communists – who in their slapdash intrusion threw the bust that Nemon had made of her (and was perched on the grand piano) into a basket of vegetables, so it was saved intact. Her third husband, an Estonian, was a lodger at the house who married Nada after his first wife and child had been killed by the Nazis.

A couple of decades later Nada the great survivor went to Vienna to claim compensation for at least part of her losses. Unable to repatriate the money, she invested in some elegant clothes and shoes. At the hotel where she worked as a receptionist her colleagues dubbed her 'the Millionairess'. One day Hedviga Bauer, a guest in a smart fur coat, checked in and was also dubbed 'the millionairess'. The two women were introduced, and Nada invited Hedviga back to her apartment, where they discovered that they both knew Nemon. Thanks to Hedviga, Nemon and Nada met again for an emotional reunion in 1965. When I met Nada for the first time I was struck by her resemblance to her portrait as an eleven-year-old, and she said I looked very like my seventeen-year-old father. He often visited Nada in Opatija, and they remained close friends for the next twenty years until his death.

As for the bust of Nada, which had so miraculously survived the wholesale destruction of war and the passage of years, it is now on display at the Jewish Community Centre in Osijek. Several of Nemon's other early works are also displayed in Osijek's art museum.

In his early years it is hard to find any instance of Oskar or his immediate family being disadvantaged as Jews; one of a minority certainly, but he was part of an ethnic group long established in this remote part of the Austro-Hungarian Empire that joined the new Kingdom of Serbs, Croats and Slovenes after the Great War (it became the Kingdom of Yugoslavia in 1929). Even though at the time of Oskar's birth Osijek had the second largest Jewish community in Croatia outside

Top
Nada Korski aged eleven, Nemon's first paid commission

Above
Nada Korski aged ninety-five holding a photograph of her bust made eighty-three years before

Zagreb, most of whom could broadly be described as middle class, older Jews could remember the slow progress of full integration. Their position was fragile, despite the wealth of many. Some individuals, through marriage or personal choice or under various kinds of pressure, including professional, merged into the majority Roman Catholic community.

In Nemon's memoir there is only the most cursory treatment of his Osijek years. He wrote more about being a Jew in turbulent times, about both prejudice and solidarity. Winston Churchill's manifest sympathy with the plight of the Jews in Europe was one powerful motif in their later mutual friendship in the 1950s and 1960s.

It is not easy to reconstruct the influences that might have had a bearing on Oskar's approach to his art. In a monograph by Oto Švajcer, a local critic, his friendship with the neo-classicist painter Đorđe Petrović is mentioned as particularly significant. Eight years Oskar's senior, Petrović studied in Vienna and Zagreb and came to Osijek in 1922 as a set designer for the Croatian National Theatre; he also practised as a painter and tried his hand at sculpture. For a while Oskar used Petrović's studio – which in turn led to a joint exhibition.

His very first exhibition, however, was with a slightly older Osijek-born contemporary, Dušan Slavíček. In 1923 Slavíček was still a student of painting and architecture in Prague. Their styles were far from matched, and it was the teenage Oskar Neumann who attracted the more favourable reviews. His fifteen sculptures included several portrait busts, one of which was a self-portrait, several medallions and his early work *Bol*. The art critic Gvido Jeny wrote in the local paper *Die Drau* on 29 December 1923: 'All the sculptures reveal a cultivated sense for shapes and a feel for expressions. The young artist showed that he has a tendency to go below the surface and to express the mental components.' In another review (in *Hrvatski List*, the Croatian Bulletin) Jeny repeated that he had reservations about *Bol*, declaring that 'the distress is missing' but predicted a bright future for the young sculptor. Jeny knew Oskar well, having taught for many years at Osijek's secondary school.

An anonymous reviewer in the Croatian magazine *Jug* (The South) gave Oskar an unqualified five-star rating that surely boosted his morale. This early critique of the young artist is remarkably perceptive.

> While his fellow students worked on resolving geometrical problems he measured and chiselled in his imagination his yearnings and desires, his moments of distress and joy, his youth and self-confidence. Unnoticed, he would quietly shut himself up in his studio, his new temple, and he would transfer his soul, his thoughts and his feelings to clay, gypsum and stone. Looking at his sculptures and medallions exhibited here we can glean an intelligent spirit, which is causing surprise

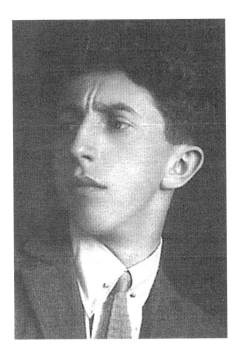

and pushes into the background Neumann the student. Self-taught, without influences of various schools of art and dogmas, he is looking for ways to express his aspirations with exceptional ease and in some of his sculptures managed to create the impression that we are faced with an artist-sculptor of great power and ability. Many older sculptors would be proud of the study *Distress*, with its facial expression and movement of the whole body.

Only six months later Oskar had another exhibition jointly in his home town with Đorđe Petrović. It was held in a garden pavilion. The two artists' intentions were defiant: 'to follow the latest trends in fine arts which started in Paris with the cubism of Pablo Picasso and to oppose the 'Spring Salon', academic painting and artistic snobbery'. Oskar showed eight sculptures in this second exhibition in June 1924, just three months after his eighteenth birthday. The catalogue lists them as a self-portrait, a portrait of Dr M. Stijić, a portrait of Nada Korski, a portrait of a man, a portrait of I. Rosenberg and sculptures entitled *The Shepherd* (*Pastir*) and *The Sphinx* (*Sfinga*), as well as one relief.

The reviewer in *Hrvatski List*, Professor Zilić, a secondary school teacher and occasional art critic, wrote:

Mr Neumann, from being a self-taught artist, is developing slowly but perceptibly. He may lack formal artistic education, but he is following his instincts, which proved successful particularly in the exhibits *Rosenberg* and the small portrait of Nada Korski. *The Shepherd* is a success although it suffers from being somewhat

squashed. I believe that following these successful attempts Neumann will go to work with a master.

The author of the catalogue mentioned the name of one man who would best qualify as Oskar's 'model in the world of sculpture': this was the internationally reputed sculptor Ivan Meštrović.

The influence exercised by Meštrović on the young sculptor is hard to gauge, but there are intriguing parallels between the two artists' lives and careers. Meštrović, born in a Croatian village in 1883, also started young. He was sixteen when he was talent-spotted and sent to be apprenticed to a master stonecutter in the Dalmatian town of Split. In his spare time he copied ancient works of art (plentiful in Split) and a year later was sent to study in Vienna at the Academy of Fine Arts. His first exhibited there at the age of eighteen with the Secession Group. In Vienna he met his first wife, Ruža Klein, who – with many other members of her family – was to die in the Holocaust. But in the early 1920s Meštrović was back – after spells in Paris, Belgrade and Rome – in Zagreb. By then he was famous on a world scale for his massive monumental sculptures and for sensitive portrait busts. It seems unlikely that he came to either of Oskar's early exhibitions, but I know the two men met.

In an interview Nemon gave to Vlastimir Kusik in Osijek in the early 1980s he said that he had taken some photographs of his work to Meštrović, who said he saw some 'hesitation' in his sculptures and advised him to 'find himself' not to imitate. (Nemon admitted to Kusik that he felt he never did develop a 'specific style' but tried always to be 'understandable'.) Oto Švajcer claimed that Oskar 'went to a master sculptor to receive advance training' – this must be Meštrović – and was advised that 'the roads lead to Paris. Go there and learn from the sculptors to become the best.' In fact, Oskar soon headed for Paris, briefly and unsuccessfully, but the important decision he made was to follow Meštrović's path at exactly the same age: he left his home country and set off to Vienna.

The proceeds of his exhibitions gave him confidence and limited funds – 'enough money for two months in my pocket and secreted about my person'. But he needed much more for a long-term period of study and work, and the fillip he received was a scholarship from the 'City Fathers' in Osijek, 'with the encouragement of an art expert . . . who decided that I showed sufficient promise to be given a grant'. Was this expert Ivan Meštrović? Or was it Professor Jeny, who had written positively about his exhibition and, Nemon claimed, who had good connections with the Freemasons? It is quite possible that Oskar's father Moritz was a Freemason, but I have no hard evidence for this. Certainly being a Jew does not preclude one from being a Freemason.

Throughout his life my father made many visits to his birthplace, both to

see his family – that was before the outbreak of war – and to prepare and install his work. He wrote in the summer of 1933 to his sister Bella about his feelings of intense identity with his first home, compared with his sense of alienation in Brussels.

> You cannot imagine when I was at home how much nostalgia I have to go back because I can tell you I am tired of feeling like a foreigner when there is still a place where there is a show of feeling for me. I am and always will be for everyone here a foreigner, and even if I marry I will always remain a foreigner.

A year later he was in Osijek to make a tombstone for his grandfather's grave, and three years after that he returned with his lover and fellow sculptor Jessie Stonor. In a press interview in 1939 he told a *Novosti* reporter that 'I saw again the wealth hidden in our people's physiognomies . . . I haven't seen anything like it even in the most noble circles abroad. I would stay at the steps leading to the church on Sundays and watch the faces of these peasant women. I discovered a whole gamut of expressions of noble pride in those faces.'

The local people and his family members also observed him on his visits back home. Jessie caused quite a stir, holding hands with an unmarried man and, more scandalously still, dressed in trousers. But Nemon – before and even more especially after the war when Croatians were miserably poor and oppressed – always breezed in spreading good cheer, bringing presents (good, practical things they lacked, such as decent clothes), a visitor from a freer and far richer planet. His nephew Ivo recalls an exotic figure wearing a shiny raincoat and a big hat and taking everyone to restaurants to eat food they had never tasted before. 'He cheered us up. He made us feel richer,' remembers Ivo. But Nemon never came with his wife and children. It seems he needed to keep separate his Balkan Jewish roots and the man of the world he had become.

On one visit he was invited to speak in the Town Hall, the meeting being held in one of his smaller rooms. As he approached the dais, people (including some family) were astonished to see him placing one foot carefully out to the side, then another, so that he seemed to be walking like a parody of Quasimodo. Then he straightened up and said, 'I was just testing the parquet. You see, this room wasn't always a municipal salon. It used to be part of my family's house, and I knew every single creaking floorboard.'

In 1970 Jelica Ambruš, the curator of the Osijek Gallery of Fine Arts, remembered talking to Nemon about his schoolfriend the painter Ivan Rein. Ambruš recalled Nemon speaking of the delight he felt in the fragrance of the lime trees that lined the street between his house and the secondary school. Some years later Nemon said in an interview with two local journalists, 'I must come

close to the source, to feel the breath and fragrance of this country and of these people whose myths I took with me to the world.' Perhaps he was being sensitive to his audience here, knowing that this was the sort of thing they wanted to hear, but he was never one to trim his views, and it is surely the case that his nostalgia was founded in real feelings of attachment – despite the death at the hands of the local fascists of so many family members and friends.

It was in their memory that my father made his last visit to Osijek in 1965. The occasion was the unveiling ceremony of his bronze statue *Mother and Child*, which he called *Humanity*. It was a gift to the Jewish community in Osijek (now much reduced) and stands in a park named after the sculptor. On its base is the inscription '*Sjeti se i ne zaboravi*' – 'Remember and never forget.' In his memoir Nemon describes it as a

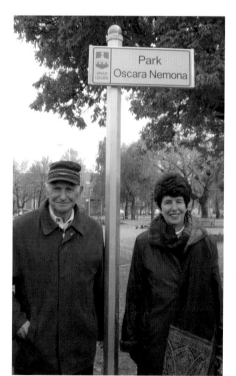

Dr Darko Fischer, representing the Jewish Community of Osijek, with Aurelia at the naming of the Oscar Nemon Park in Osijek, 2009

symbol of love and a warning . . . Through the figure of the mother, whose back is turned to one side while lifting up her child high and getting fully immersed into this child, I wished to express the perennial hope in a brighter future. The statue is not meant as a reproach. I tried to induce people to think about their doings, because whoever can cast a stone on a mother carrying a child in her arms is either a madman or a criminal.

Nemon wanted the statue to be much bigger, ten metres high, but the money for that was not forthcoming. It seems the powers that be in Osijek have limits on their willingness to record the time when many local people succumbed to a bout of mad criminality. He summed up his legacy to his birthplace with the words: 'The unveiling of this statue was the saddest moment in my life. Many personal elements have become part of the process of conceiving it.' Undoubtedly he was referring to his mother, murdered by Nazi sympathizers.

There remained something in Nemon of the folksy charm of Osijek. He loved to tell stories, often to illustrate a point or explain something in a way that was more allusive than literal. In his memoir, for example, he told the tale of a 'wooden statue of a saint that stood near a village green in my native country'.

The local people were in the habit of bowing to the statue as they walked past because it represented the patron saint of their church. One day, through some disaster, the statue was destroyed and had to be replaced. Fortunately, there

was a fine oak tree not far from where the statue had stood, which was able to provide suitable wood for a new statue. The tree was felled and the statue was made, so the villagers could resume paying it their reverent attention. However, one man deliberately refrained from bowing, and eventually curiosity drove the others to ask him for an explanation. 'I knew the tree so well,' was his nostalgic reply.

The moral, according to my father, was that 'the sculptor is the man who shapes statues because of his wonder at the forces that shape people and his realization that the price they must pay for the privilege of their humanity is . . . inevitable suffering'.

In 2009 the town of Osijek honoured Nemon by renaming the Tito Park the Oscara Nemona Park. This is the park where his statue *Humanity* stands, a stone's throw away from the house where he was born. I was lucky enough to be at the ceremony.

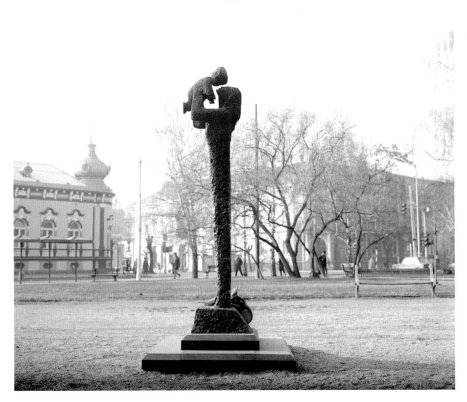

The sculpture *Humanity* in the Oscar Nemon Park, Osijek

Nemon aged seventeen
with one of his early works

Vienna and Paris 2

THE TEENAGE SCULPTOR Oskar Neumann was already enjoying a reputation in his native city and had been endorsed by the older and more famous Yugoslav sculptor Ivan Meštrović. So the Osijek City Fathers decided that they should lend a helping hand.

He was offered his grant to study abroad – won in competition with another young man whom he described in his memoir as 'tremendously gifted, very extrovert, his self-confidence in striking contrast with my shyness'. He chose not to go to the world's artistic hub, Paris, despite being tempted, but instead went to Vienna. There was a solid financial reason behind his decision. His Aunt Jula and her husband Rudi Spitz lived in Vienna, and Rudi owned a bronze foundry there.

Uncle Rudi was not entirely happy with his nephew's choice of career, but Oskar was undaunted. 'In spite of the fact that he was furious that I should have chosen this ridiculous pauper's profession,' Nemon wrote later in his memoir, 'I thought he might be helpful in casting my works for me.' But there was another setback when he arrived in the Austrian capital in September 1924. The course the City Fathers expected him to enrol in was full (possibly because they had filled their 'Jewish quota' – the so-called *Numerus Clausus* – but more likely because Oskar was too late in applying). Seventeen years earlier Adolf Hitler had taken the same examination to enter the Vienna Academy of Fine arts, but he, too, was rejected.

There were plenty of less fashionable academies to approach, but, according to Nemon's memoir, they 'were almost entirely lacking in pupils and there were plans afoot to turn them into public baths'. Instead, he turned to a maverick sculptor called Hanak who had a popular *atelier*. This was a man of peasant origins who appealed to Oskar because, after walking to Vienna, Hanak had seen a fine statue in the outskirts of the city that made such an impression on him that he immediately decided to be a 'maker of statues'; not only did this giant of a man have enormous enthusiasm, he was 'the epitome of self-expression', in complete contrast to the approach of the Academies. Hanak would not even allow his students of sculpture to draw.

Expressionism, a new and revolutionary approach to the arts, was catching

Above
Relief of four-year-old
Hans Hevesi, Vienna,
1924

on fast in Vienna, and Oskar was determined not to be left behind, even if the expressionists were 'preoccupied with gloom . . . reflecting everything that this part of the world had endured in terms of degradation and misery'. He witnessed this first hand at a concert that he attended, where 'an elderly music lover of the old school got to his feet in the middle of a Mahler symphony and shouted, "Stop that appalling shit!"' Another of my father's early experiences of the revulsion this trend provoked among conservatives was when he was invited one morning to a modern art dealer's gallery displaying a Kokoschka exhibition and finding the staff frantically cleaning the pictures which had been covered in stinking excrement. The gallery was owned and run by Max Hevesi, who befriended the young Yugoslav sculptor and invited him to make a relief of his four-year-old son Hans.

All the time I have been researching my father's life I have come across strange coincidences and been given leads that have taken me to unexpected places and people. In this case, it was a very circuitous route that I had to travel to track down stories of sitters and the portraits. A neighbour in Hampshire told me that Nemon had sculpted her grandfather H.E. (Harold) Norman in Dulwich in 1936 – a work I knew nothing about; it is a portrait bust that has completely disappeared despite

my best efforts to trace it. But it turned out that Norman, an Englishman who had lived in South Africa, was a friend of Max Hevesi, and in 1936 the young Hans was lodging with the Normans in their London home. Having been brought out of Vienna to the safety of London, Hans had joined the teenage sons of Harold Norman as a pupil at Dulwich College in south London while his father set up the Hazlitt Gallery in Mayfair.

Wanting to follow up Nemon's connection with Hans Hevesi, and indeed to see if he was still alive and remembered my father, I asked the archivist at Dulwich College if there was any trace of him. All she knew was that he had gone on to Magdalen College, Oxford. No one there knew much about him, except that he now called himself 'John'. But shortly afterwards I had another call from my Dulwich source to tell me that she had read an obituary of Hans/John Hevesi which stated that he had married a ballerina called Beryl Morina, who had written a book published by Woodstock Press in Winchester. A frail voice answered my call. It was Beryl Morina herself. She told me how in 1944 she had gone to a party and met a young sculptor who said, 'You are very beautiful, and you must come and sit for me.' This sounded like my father's way of approaching women, ostensibly for business but also, he hoped, for pleasure. The only condition was she had to pose with an imaginary lamb. She also had a small and very treasured plaster relief of her husband Hans as a child which had been smuggled out of Vienna long ago. And the sculptor turned out, once again, to be my father. Sadly, when I went to the Austrian capital, I discovered that the Hevesi Gallery is now a shop selling ladies' underwear.

Poster for an exhibition at Max Hevesi's art gallery in Vienna

Back in Vienna in 1924 contacts in the music world were leading to more positive results for my father. His first success was a relief of a famous Italian tenor working in the Austrian capital. As the newspaper *Die Stunde* reported:

Our youthful compatriot Mr Oscar Neumann, who has already come to prominence as a sculptor in his native country, has been living for several months as a student in Vienna and is working there in the studio of an eminent master. Mr Neumann recently made a portrait of the renowned Italian baritone Domenico Viglione Borghese, and this piece was so outstanding that it was reproduced at the Wiener Bühne (Viennese Art Centre). Mr Borghese introduced this very talented young sculptor to Mascagni who agreed to several sittings. The renowned composer's portrait was also a great success and will appear in a Viennese art magazine. As we have learnt, Mr Neumann has been awarded a scholarship to Italy and will very soon continue his studies there. Before his departure to Italy our youthful compatriot will exhibit several of his best works in the Wiener Sezession. We report with considerable pleasure the success of our still very young compatriot for whom we predict a great future as a sculptor.

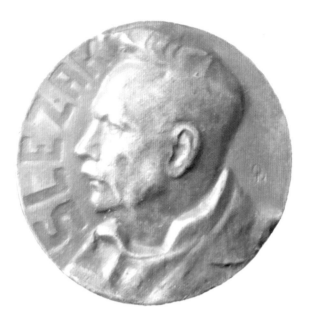

Nemon's 1920s medal
of the Viennese singer
Leo Slezak

The bust of Borghese is an astonishingly mature work for an eighteen-year-old, but where, though, is the bust of Mascagni? Sadly, it has disappeared. And Oskar was not on his way to Italy. However, he was on his way to more success. A friend managed to arrange commissions for him to undertake portraits of Richard Strauss and Leo Slezak, the latter a popular opera singer known for his spontaneous parodies that reduced opera choruses to helpless laughter. (Slezak once found himself in Wagner's *Lohengrin* waiting for a swan that broke down in the wings. Eventually he stepped forward to announce to a bemused audience, 'Don't worry, there'll be another swan along in a moment!')

When Oskar was invited to Slezak's house to start work on his bust he was shown into his music room – 'a vast, ornate, Baroque salon'. As the butler opened the door,

> I saw my model over in the far corner, sitting at the piano practising scales. I caught the words he was singing:
>
> > 'When I was a young boy
> > I used to piss and sing;
> > Now in my old age
> > I have to learn to sing.'

Oskar made an immediate comparison between the young Leo Slezak and himself – a young man 'doing sculpture fairly effortlessly, without any academic training, and becoming very successful. My works were being reproduced in papers and magazines and I felt as if I had arrived.'

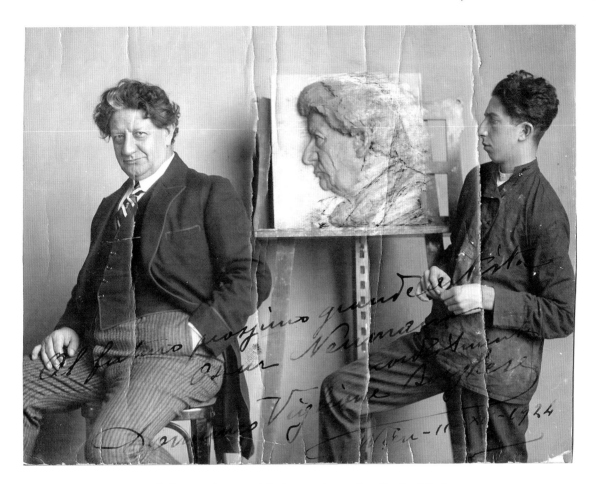

Another contact my father made was with the psychoanalyst Dr Paul Federn. This ardent disciple of Freud tried to secure a bust of the master to be done by his new young Yugoslav friend. But it was not to be. Freud refused at that time to sit for any artist, but he was to relent a few years later.

Vienna in 1924 was a troubled, gloomy city but also one desperate to bounce back from the appalling aftermath of the Great War. It was seething with revolution and artistic experiment. Even more traditional pursuits were thriving once more. That year saw the opening of the first Philharmonic Ball, for which Richard Strauss composed a famous fanfare played there ever since. Slezak performed at the ball as did Lotte Lehmann. All over the city and its suburbs massive modernist building projects were under way including new housing estates and high-rises. In 1924 Hans Karl Breslauer was directing his controversial expressionist film *The City of the Jews*, a dystopic, satiric vision of events that, in fact, soon came to pass. Art deco was flourishing. The Wiener Börse stock market was also booming, until its sudden collapse in March 1924.

The rollercoaster fortunes of the city upset the sensitive young sculptor. He was especially disturbed by a meeting he had set up with a rich art collector whom

Nemon aged eighteen making a relief of the Italian tenor Domenico Borghese, 1924

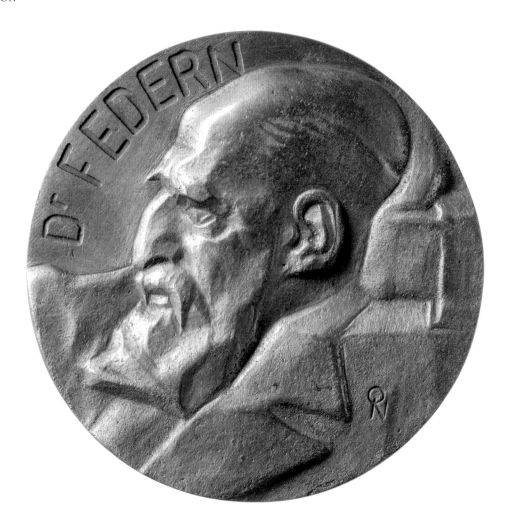

Medal of Paul Federn
© KUNSHISTORISCHES
MUSEUM, VIENNA

he hoped to sculpt. Over his breakfast tray the man blurted out that Oskar had arrived too late; he was bankrupt. He pointed to a gun on his desk and said, 'I'm just deliberating what to do. I've nothing left except that revolver, and it could well be the solution to all my problems.' Nemon stated in his memoir that he felt the whole of Vienna was suffering from

> an all-pervading attitude of despair. You could see children in their early teens being bought for dollars by tourists, and there was one rich American who went around the city by taxi, throwing dollars out of the window to the people, who scrambled and fought for them. In Vienna the despair, misery, degradation and ill-feeling were intense and people had no pride left. This was one of my main reasons for my decision to leave the city after a year and go further west.

According to the Croatian art historian, Vlastimir Kusik, in a newspaper interview with Nemon published in 2002, he was advised by the composer Arnold

Schoenberg to leave Vienna. So it was down to a whole number of promptings and personal disillusionment that my father decided to try his luck elsewhere.

Thus it was that in 1925 Oskar set out on that well-worn path for young artists and took the train to Paris. 'I had long dreamt of going to Paris,' he wrote in his memoir, 'and was now possessed by the desire to go there and feast my eyes on her great works of art.' But he knew no French and had no friends or contacts there, although he did have the money he had earned from his exhibitions in Osijek. Having made some enquiries among local people who had been to Paris themselves, he discovered that a group of Yugoslavs used to frequent a café in Montparnasse 'easily identifiable by the sign "Tabac" displayed outside'. Once in Montparnasse, however, he quickly realized that the 'Tabac' sign was outside almost every café. And although he put his head inside many he never heard anyone speaking his native language.

Stumped, he set off to find the Yugoslav Consulate. Here he had a 'very cool reception, being soundly berated as a fool for having come to Paris with no contacts and no knowledge of the French language'. But a young Yugoslav student overheard his tale of woe and offered to help. They went off together and found a cheap hotel in which they could share a room. Oskar was taken on a lightning tour of the city, ending up in a couple of well-known cafés frequented by the artistic and intellectual crowd – the Coupole (already an artists' haunt but three years short of its grand art deco makeover) and the Dôme (they were too late for Lenin and Gauguin but might have seen Hemingway).

According to Nemon's memoir, the next day the pair of friends went off to see the World Fair, the Paris Exposition Internationale des Arts Décoratifs et Industriels. It was a heady experience for the young artist but one to which he now felt attuned. Already he was separating himself from the 'casual visitor' and 'average onlooker' for whom the abstract shapes and revolutionary ideals, he felt, must have been 'disconcerting and incoherent'.

He remembered admiring the 'poetic vision' of the Russian artists 'toppling the old idols and introducing new values', a 'vindication of those who had been working for the overthrow of the old structure and who had spent long years of study to broaden their vision – that intelligent and cultured handful who wrought the Russian Revolution'. All this chimed with the conversation in the artists' cafés that 'reflected strongly my own embryonic ideas about art and about man', the importance of the 'primal Negro vision, despised until then, that came into its own under the hands of Picasso, and Matisse brought in the influence of Moroccan folklore'. Oskar was revelling in what he saw as 'outward chaos, but it was a chaos of beginnings', reminding him that 'even in my little backwater in the Balkans we numbered among us a convinced Dadaist; we were proud to be the harbingers of a new world, and the creative urge of the artist surged upwards to

the unconquerable hope that this marvellous world would be the means of unity for all men'.

Meanwhile, full of emotion and 'conjuring up daydreams of success in the world that I had glimpsed', Oskar collapsed into bed in a romantic haze . . . only to wake up 'alone, without my possessions and without my companion'. He had been fleeced, left with just the few bits of cash he had hidden in one of his socks. Frightened of distressing his mother – who believed Paris was a wicked city and now with good reason – he trudged to the station only to find that his money would take him as far as Milan but no further. He decided to go there and then contact his mother. Milan 'would be nearer and a source of fewer temptations'. He described what happened next:

We were packed like sardines in the third-class compartments. The crush, the noise and general confusion were almost more than I could take in my overwrought state. At last, only about an hour outside Milan, I found a compartment in which there were only a middle-aged man and his wife and son. There was one small space left in a corner. I squeezed myself into this and sat with my head in my hands, saying as I sat down, 'What a dog's life this is!'

After a few moments, the man touched me on the shoulder and asked me in Serbo-Croat, 'What's the matter?' I replied very rudely, telling him not to speak to me, as I did not care if I never heard my mother-tongue spoken again. After some time he made another attempt, asking me very kindly and sympathetically whether he could help in any way. This time I told him my story and he listened attentively, asking me several questions about my home and family.

The train drew into Milan about midnight, and I was in a state of great uncertainty about what I could do next, penniless and stranded. As we got to our feet my companion suddenly opened his wallet and handed me a large sum of money – more than I had taken to Paris with me in the first place.

His wife looked very shocked. I told him I did not need so much, but I would be very grateful for the loan of sufficient money to get me home, which my mother would repay as soon as I arrived. I asked him who he was, but he dismissed my question saying, 'It doesn't matter.' He was travelling third class, so he could not have had much money to spare, and his wife's face was enough to tell me that this was a very great sum for him to part with in this way.

After I had refused the offer of so much money, he said to me, 'Take it – use it to go back to Paris and have the visit you planned there.' I found the whole paradox of this situation, combined with my recent disillusionment, quite unendurable. I insisted on knowing his name and he gave it to me.

It turned out, when the prodigal son finally got home, that his mother recognized the name of his benefactor. She had actually known him in her youth, and he had later become a professor in the Law Faculty at Zagreb University. She was reminded of the charitable practice years before, when well-to-do people such as her father provided meals or assistance to poor local boys – and this man had been one of the grateful recipients of her father's generosity. From time to time, when resources permitted, my father would demonstrate similar benevolence to those less fortunate.

Oskar spent a month in Italy on his way back to Osijek, musing on art and life in Milan before meditating on the steps of the Accademia di Belle Arti in Venice, determining with increasing conviction not to be shackled by the heritage of the past. He confessed to being under the influence of 'Nietzsche's philosophy of rejection of the old ways. We young people were utterly opposed to the attitude of the professors of art in the academies, whom we nicknamed "the fire-extinguishers" for the way they clamped down on any attempt at new artistic expression.'

Clearly this was only the beginning of his quest to find his own way of expressing his artistic feelings and pursuing his ambitions. At the same time, he was aware of his lack of funds and, as a widow's son, of his duty to give her support. He was aware, too, of the pressure of family and friends to find a much more lucrative and stable profession than that of sculpture.

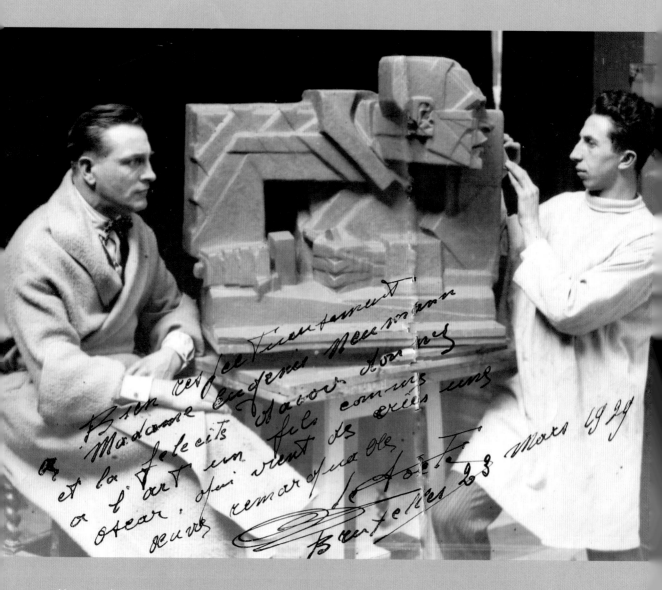

Nemon working on the
sculpture of his associate
Pierre de Soete in
Brussels in 1929

Brussels 3

O N 7 OCTOBER 1925 the nineteen-year-old Oscar Neumann – no longer Oskar and now almost 'Nemon'– arrived in the Belgian capital armed with a street plan and found his way to the Grande Place, where he was immediately enchanted by the stone tracery that he compared to Brussels lace. He then walked the half-mile to the Académie Royale des Beaux-Arts et Ecole des Arts Décoratifs and attempted to enrol as a student. He nearly failed, as he recounted in his memoir.

> As I walked from the Grande Place to the Academy I was conscious of German being spoken all round me, and I was greatly relieved. I had a fair knowledge of German but still no French. The man behind the desk was a stern, solemn-looking man, and I was disconcerted when he addressed me in French. I replied in German that I wanted to be enrolled as a student in the Academy, whereupon he got rapidly to his feet and turned me out of the door with imprecations of which I caught the sense and general purport, even if I did not understand the actual words.

Oscar had a better idea: to enlist the help of a secretary at the Yugoslav Consulate. She went with him back to the Academy and explained to the hostile gatekeeper that 'far from being a "dog of a German" this young man was one of that heroic race of Slavs, one of those fighters for freedom and rights – a Serb'. It finally dawned on him (from Croatia rather than Serbia but no matter) that what he had been hearing was Flemish, not German.

Nemon was his usual enigmatic self when it came to explaining in his memoir why after leaving Vienna he made the decision to study and work in Belgium. He wrote, 'Somehow I was not keen to return to Paris, although it was such a great artistic centre, so I chose Brussels, which was not too far away from it.'

It was the start of more than a decade in which he used Brussels as his home base. By the mid to late 1930s my father was often being referred to as a 'Belgian' rather than a 'Yugoslav' sculptor.

But when he arrived there in 1925 Belgium had still not recovered financially from the First World War. It was a country in debt – Germany refused to pay

war reparations – and was still rebuilding the damage wreaked by the fighting on Belgian soil. Inflation was high (although no one needed a wheelbarrow of currency to buy a loaf of bread). A left-wing socialist government had been elected and was desperately trying to stabilize the economy.

Oscar's first tests at the Academy went well. He was given a classical head to copy and did it five times larger than the original, so big that 'I could get a hand right into its mouth'. That went down well with the faculty assessors, and he was promoted instantly to the life class. The second test, which involved copying a nude model in a 'grotesque' position – very important because success in this would allow him to skip three whole years of study – nearly proved disastrous, as he described in his memoir.

> The other students reckoned that no one did any work for the first month, and the model was in full agreement with them. I managed to set up my armature [the framework to give a sculpture stability] but could rarely get the model to pose properly or for any length of time. One day the situation reached crisis point. The model would not cooperate, and if I got her into position she would wait until I had returned to my work and then drop the pose at once. I had had enough and, taking a lump of clay that was to hand, I threw it at her. My aim was good, and she fell off the rostrum on to the floor.
>
> The other students came at me in a mob, screaming 'Assassin! Assassin! Let's catch the savage from the Balkans.' They seized hold of me and dragged me off to the Secretariat. As we got to the door it opened and the Professor of Sculpture emerged. He stopped short at the sight of the mob, who were clearly after my blood. A jumble of explanations poured out, and he took the situation in hand. It was the sort of thing that appealed to him; he was a man who had a touch of the sadist in him. He came down entirely on my side and declared that if anyone was thrown out it would not be me but the model. He directed us back to the studio, dealt with the model's hysterics, got her properly posed and made it abundantly clear that there was to be no more of that sort of nonsense. For some time I could not be said to be among the most popular of the students.

The incident had one positive repercussion. The same model appeared one day at his new lodgings next to the Grande Place in the centre of town bearing the gift of a cake as a token of reconciliation. From then on she not only taught him French but, following a familiar pattern with his sitters, 'our relationship developed into an intimate friendship'. In his letters home – and there are many at this period of his life, to his mother, his sister Bella and to his brother Deze – there is no mention of this particular means of improving his language skills; instead a stream of advice from an ever-wiser and more mature son and brother. All through his life

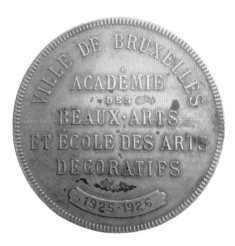

Nemon was discreet about his many lovers, especially those who brought him commissions.

In a letter to my Aunt Bella on 10 January 1926 he told her in a triumphant tone of his successes at the Academy. He said he had been chosen by a jury as a winner and made a 'professor' – which seemed to mean that his work was being considered as on the level of his professors. He said he had to copy antique statues (he was most proud of his Venus de Milo), but more important in his own eyes was his first life-size statue of a man 'in a particularly beautiful pose'. Modelling bodies he now described as 'the main thing in sculpting', and his early experience at the Academy set out – or certainly confirmed – the artistic route he would travel throughout his life.

At the end of his first year he was awarded first prize in both the 'antique head' and 'live model' categories, under the tutelage of Professors Dubois and Matton. It might be thought that his studies at the Academy were proving fruitful, but in his memoir Nemon had nothing good to say about them. The Academy, he wrote, 'did not contribute anything to my formation. I was disenchanted with its approach and saw no sense in continuing to attend its courses.' Yet he did keep them up for a couple of years, as he was still winning prizes in April 1927. It did not, however, improve his financial position. Although he endeavoured to send money back to his mother, there was a despairing note in 1926 instructing Aunt Bella to tell Mama to put the stamp on the front of the letter, otherwise he had to pay a fine.

In the summer and autumn of 1926 Oscar spent some time back in Yugoslavia, mostly at his mother's house but also visiting Zagreb, where he completed a well-received relief (made into a medal), this time of the Bishop of Đakovo portrayed in front of the twin spires of Đakovo Cathedral. This was later exhibited in Brussels – at the 1932 Exhibition at the Palais des Beaux Arts. I remember when I was travelling by train from Zagreb to Osijek for the first time, I saw out of the

Gold medal awarded to Nemon in 1925 by the Académie Royale des Beaux-Arts, Brussels
PHOTOGRAPH BY PARIS MAY

Above
Relief of Archibishop
Askamovitch of
Đakovo, Croatia:
'You've made me look
like a Turk and a brute.'

Above right
Medal depicting
Charles Lindbergh
when he visited
Brussels after his epic
solo flight to Paris
in 1927

window the same twin spires of Đakovo Cathedral and wanting the train to stop so I could discover if the medal was somewhere in the building. I still do not know where it has ended up. The Bishop himself was less than happy with his portrait, however. He complained that the young sculptor had made him look like 'a brute and a Turk' – the sensitivities of a Catholic bishop in the Balkans would have long historical causes to regard this with special distaste. The Bishop urged him to soften the hard lines of the relief. Characteristically, he refused.

Making reliefs was something Oscar loved doing. Some were portraits but many more were of women in various poses, a horse and rider or sunflowers and other subjects. He was to enjoy doing them throughout his life, almost as an emotional relief.

At some point he started to work in a studio with a group of other young sculptors – known as 'Les Nègres'. This didn't last long, although he wrote later that it 'helped me to develop a greater self-assertion, vitally important if one were to survive in the atmosphere of fierce competition that prevailed'. What brought him immediate public attention was the plaquette (a bronze medal struck from a relief) that he did of the intrepid American aviator Charles Lindbergh, who made the first solo transatlantic flight in 1927. There was a worldwide tender from the City of Washington for a suitable memorial, and the American ambassador in Belgium invited him to submit something on the occasion of Lindbergh's visit to Brussels. A Croatian newspaper reported in July 1927 that their young compatriot stood to win a million-dinar prize. This does not seem to have materialized, although the plaque did attract a great deal of praise, not just in his homeland. It is now in the British Museum's medal collection.

Not long ago I discovered that my father had sculpted Dr Gustav Alexander

during a brief visit to Vienna in 1927. But who was he? He turned out to be a Viennese otologist who was shot dead by a deranged patient in 1932. His son Leopold Alexander was also a doctor and worked in a Boston hospital in the 1940s. Rather amazingly, Nemon's bust of Dr Gustav Alexander survived the perilous journey across the Atlantic during the Second World War and now belongs to his great-grandson Dr Ian Grable who lives in Chicago.

Dr Gustav Alexander posing for his bust in Vienna, 1927

When he first arrived in Brussels the young student's lodgings were in the Avenue de la Renaissance, a wide street that runs along the north side of the Jubelpark to the west of the centre of town. He stayed there a year, before moving to the rue de Toulouse a little closer to the centre. Later in 1927 he took the bold step of renting a studio of his own. It was in a building owned by another sculptor, Pierre de Soete, an established Belgian sculptor twenty years older than Oscar, most famous for his motor-racing trophies and mascots and a former student at the Brussels Academy. This studio was in 9 rue de Ligne, a rarity among the houses in which Nemon lived in Brussels in that it has been neither destroyed nor developed.

Perhaps in lieu of rent for the studio, he made a portrait of his friend, landlord and fellow sculptor; unusually, it was in a style both expressionist and cubist, with de Soete's massive squared-off head atop a hollow rectangular base cut into blocks and diagonal shapes. As the critic from the *Clairette de Charleroi* wrote, 'C'est peut-être très ressemblant mais...'

Warrior relief, 1920s

The following summer, 1928, he was back in his homeland again, where he was commissioned to make a sculpture of three Croatian martyrs for the local *Oblastausschuss* or regional council. There is no evidence, however, that this was followed through. More controversial was his attempt in August that year to sculpt a *Denkplatte* or memorial plaque for the Osijek Chamber of Commerce. Perhaps naïvely he included models of a hammer and a sickle. This did not go down at all well with the conservative burghers of his home town. This time the work was completed.

Back in Brussels Oscar was relieved that a few more commissions were coming in. It was not enough, however, to make him prosperous nor even to pay the rent of his workshop/studio. A compromise was reached: he was allowed to move down to the cellar, a damp and miserable space but free. At the same time he was promising to send at least 500 dinars a month to his mother in Osijek, a promise that was difficult to keep . . . and he was getting depressed by his relationships with friends and clients.

This was clearly an expressionist period for him, although it was not to last, at least not in this cubist variant. He made a relief, or *plaquette sportive*, called *Victoribus Honos* – Honour to the Victors. In the centre of an upturned rectangle is a kind of cubist victor surrounded by eight figurines representing a runner, a footballer, a cyclist, a boxer, a tennis player, a javelin thrower, a rower and a fencer. The Royal Museum in Brussels owns the medal.

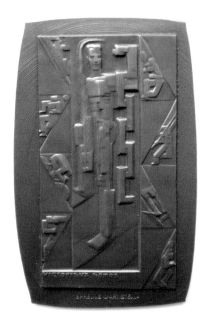

Above
Plaque celebrating seventy-five years of the Osijek Chamber of Commerce, 1928

Above right
Victoribus Honos medallion, 1929, from the Medal Department of the Bibliothèque Royale, Brussels

In a letter to his sister Bella in Vienna dated 20 September 1930 Oscar wrote that he had started to make 'portraits directly in medallions and plaques for a normal price but which becomes very interesting with the quantity of copies and the number of commissions'. He obviously found it tedious work finishing them off, doing the casting and the final chiselling, so he tried to get Bella to come and help him, telling her she could learn how to do it in a couple of days.

I will send you the medallion and you will make a negative (twice) in a material very similar to plaster, and then in this mould you pour a metal which can melt on gas at 300 to 400 degrees – you pour it into the negative and then take it out and

clean it, that is, you chisel it finely which is not difficult with a bit of patience. All this I will teach you how to do as soon as I come to Vienna. This casting does not stink and does not require extra space, because I do all this in my *atelier* without drawing any attention.

In early November 1930 Oscar (the name 'Nemon' is now just about to be adopted but not quite yet) held an exhibition in the Galerie de la Toison d'Or (it had been scheduled for the Kodak Gallery but moved at the last minute). He exhibited jointly with the Russian-born figurative painter Leonide Frechkop, then in a rather gloomy phase. He complained to Bella in another letter that Frechkop was 'an amazing painter, which made it more difficult for me as he had forty-five paintings and I had only seven sculptures, in a separate room of course'.

The critics, such as the one from the *Journal de Charleroi*, tended to prefer Oscar's traditional heads (notably of children) to the '*oeuvres décoratives de la jeune école allemande et viennoise*', while commenting favourably on his 'modern touches'.

Marguerite Devigne of *L'Horizon* praised his 'energetic' style. Other critics used words such as 'implacable' and 'lively'. *Le Soir* commended his 'psychological truth'. The exhibition was the last to mix purely representational busts with expressionist and symbolic work (with titles such as *Négateur* and *Créateur*). He also exhibited several medals – an art form that was particularly popular at this time. One was of Marshal Foch (which went on sale later at the Etablissement Paul Fich in Brussels for the price of 25 Belgian francs, for the benefit of the Foch monument in the rue de Ligne). Another was of Monsieur Gottschalk – later to be a friend and then an enemy of Nemon's – who in public life was President of the BIT, the Belgian Chamber of Commerce. The Cabinet des Médailles bought the lot.

Oscar's relationship with Madame Gottschalk was particularly fraught. I was intrigued when I learnt this from my father's letters to his sister Bella (finally translated for me from the Croatian) because for eight years I had been trying in vain to discover the name of a boy known in the exhibition catalogue only as 'Guy G'. I had only a photograph of the bust of a small boy with slightly hooded eyes and a wistful expression. But, knowing that Oscar was always short of money and often failed to pay his rent, and given that his landlady was Madame Gottschalk, I wonder if perhaps he had done the bust of her son in lieu of rent – and that therefore 'Guy G' was in fact Guy Gottschalk. The other clue was that the 1932 exhibition featured a medallion of 'M. Max Gottschalk'. Then a friend of mine in Australia found a photograph on an American website of a Max Gottschalk and his two sons Robert and Guy. It had been put there by a distant relative of theirs who put me in touch with other members of the family living in Israel and Belgium.

Left
Nemon's medal of the French First World War hero, Marshal Ferdinand Foch, 1930

Above
Medal of the French radio pioneer General G.-A. Ferrié, 1930

The Viennese obstetrician Dr Joseph Novak, 1930

They told me that Max and his family had moved to the USA before the Second World War and that Guy had become a psychiatrist and died, unmarried, in 1985.

Oscar wrote to Bella that the Belgian Minister of Science and Education as well as the Croatian Ambassador would be making official visits to the show. But he also told her not to worry about some unspecified 'nonsense that the newspapers have been stirring up'. He reminded her of the Croatian proverb that 'lightning doesn't strike a stinging nettle' – in other words, bad things don't happen to bad people. Probably this was not a reference to his professional self, as the critics had been more than kind.

So began what Nemon later referred to as 'the springtime of my life'. He claimed to have made friends with – and even lodged with – the surrealist painter René Magritte and a mutual friend, Marcel Lecomte, who dabbled in surrealism, Dadaism and metaphysics – although I can substantiate neither friendship in any of the letters or archives I have researched. The young sculptor had commissions from many members of the Belgian Establishment – soldiers, politicians and lawyers, such as Pierre Graux (now in the Palais de Justice) and Henri Simont (now in the Supreme Court).

This was also the time, as we shall see in the next chapter, that he travelled to Vienna to sculpt Sigmund Freud. In March 1932 another exhibition was arranged in the Palais des Beaux-Arts. Of the twenty-four busts and nine medals listed in Nemon's show entitled '*Têtes*' or Heads, at the top of the list is the bust of Freud.

This was picked up by most critics who came to the show. *Le Soir* ran a fulsome piece pointing up not just 'O. Nemon's precise likenesses' but also his 'pitiless

Une Visite a l'Atelier du Sculpteur Némon

Above left
Bust of an unknown child, Brussels, 1932

Above
Three-year-old Guy Gottschalk, son of Nemon's landlady in Belgium, 1930

Left
Favourable press review of Nemon's 1930 exhibition

Dans un coin de l'atelier du sculpteur Némon, nous découvrons quelques têtes d'enfants aussi émouvantes que parfaites. L'artiste s'anime, nous parle, nous confie sa vie d'ambitions, d'espoirs et de luttes.

Singulier contraste entre ce jeune visage et les paroles sévères et douloureuses de l'homme.

D'origine yougoslave, l'artiste quitta son pays pour s'installer à Bruxelles en 1925. Puis, après plusieurs années de travail dans l'effacement, fit un séjour à Vienne. C'est vers cette époque qu'il connut un succès frénétique avec le buste de Freud, qu'il venait de réaliser.

Sa renommée va rapidement d'Europe Centrale en France. Paris l'accueille et le fête.

Il se reconnaît dans son maître Despiau et son admiration pour lui reste sensible dans ses œuvres.

Revenu en Belgique, il reprend la lutte âpre et créatrice. Ses productions abondent.

Outre certaines compositions dans lesquelles s'accentuent ses recherches, il réalise principalement des bustes dont l'expression, sans être purement réaliste, est cependant précise. Il synthétise dans un visage plusieurs visages propres à la même personne.

Vers quelle plénitude la maturité va-t-elle donc mener cet artiste, lui qui, si jeune, a pu réaliser une œuvre aussi parfaite.

Nemon with the statue
he called *The Bridge*
in his Brussels studio
in 1935

psychological insight' – Freud's bust, for example, showing the 'bitter truth of psychoanalysis', while his children's and women's portraits were full of charm. *L'Etoile Belge* called his work astonishing and singled out his ability to transform mere copies into 'poetry', an opinion endorsed by the critic from *L'Horizon*, who stressed how much more difficult it is for a sculptor to pull this off than a painter.

At the end of the piece *L'Horizon* reported that Nemon was planning an exhibition later in 1932 of large-scale works, and the reviewer said he looked forward to seeing them. But did those plans ever materialize? In particular, was he intending to show in public a massive – but now lost – work enigmatically entitled *The Bridge*?

It is a large sculpture of a couple lying in a passionate embrace – which Nemon had photographed with himself lying slumped in front of it . . . no doubt to reveal its scale. There is also a photograph of a kind of Pietà, with four crouching mourners beside a corpse – again this work has not survived. Most of these were probably done well after 1932. I have tried for years to find out what happened to them but with no success. There have been unsubstantiated reports of German soldiers smashing them up during the war and even a rumour that they were destroyed by a jealous husband.

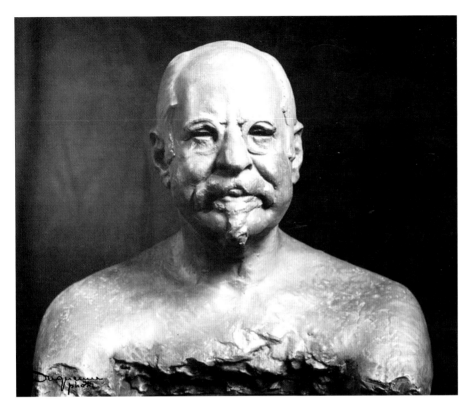

Medal of the Belgian
politician Emile
Vandervelde, 1932

Bust of Emile
Vandervelde,
Brussels, 1932

What is certain, however, is that on 3 June 1932 the politician Emile Vandervelde, Chairman of the Executive of the Labour and Socialist International as well as an eminent member of the Belgian Parliament, wrote to Nemon agreeing to pose for his portrait bust during July over as many sittings as required. In fact, the sculptor made both a bust and a relief. He wrote in his memoir:

He looked very like a mandarin with his drooping moustaches and narrow eyes, but in build he was tall and massive and his voice was deep and sonorous. He was a man of immense culture, a rich man who believed in Socialism. My sittings with him were a great delight, and they took place at a critical time in Belgium's history. Just before my sculpture was completed, the General Strike broke out. Vandervelde was expected to resolve this dramatic crisis. One particular and memorable Thursday the news spread that he had appeared on a balcony in front of a huge crowd clamouring for action. But, because Vandervelde was theoretically a revolutionary and fundamentally opposed to violence, he had attempted to check them and had in consequence been stoned by the mob.

Nemon could see there was no possibility of a sitting that afternoon, but it was a very warm summer's day and he decided to go along to Vandervelde's house to change the damp cloths he had put on the clay head. He arrived at the time the

sitting had been fixed and apologized to the butler for coming, even though his subject was otherwise detained. But while he was changing the cloths Vandervelde burst in, apologizing for being a few minutes late.

> I was staggered that he had come at all and asked him if he wished to postpone the sitting. 'Why, no!' he exclaimed. 'Let me just wash my hands and I'll be with you in a moment.' Later on I asked him why he had not given the call to action that the crowd had been expecting. He replied, 'If I had done so, Belgium would have been in flames – and that is what I most abhor.' Also I learnt later that he had got his chauffeur to drive him back at breakneck speed from the industrial area where he had been speaking in order not to miss his sitting.

One other story Nemon told about Vandervelde related to the fact that the great revolutionary was a teetotaller – in a country famous for its enthusiastic beer drinkers.

> At a meeting in one district with a reputation for excessive emphasis on these aspects of Belgian life, he gave an impassioned speech on the evils of drinking. His audience was so overwhelmed by the picture he drew of the calamitous fate awaiting the drunkard that, when the meeting was over, such an orgy of drinking took place as had never been known in that district before.

Other commissions were now coming in; for instance, a bust that he finished in November 1932 of Dr Trollic, the General Inspector of Hygiene in the Congo, for which he was paid 6,000 Belgian francs. Nemon's springtime was still in full bloom, even if at times a mood of depression got the better of him, and he wrote in a letter to his sister Bella in January 1933 that he was worried that 'all doors are closed to me' – a foretaste of the discrimination he was later to experience in sections of English society.

One door that did open to him happened as a result of an odd coincidence that led to a deep and lasting friendship . . . and indirectly to some celebrated, if not always very financially rewarding, commissions culminating in a valuable introduction to the Belgian Royal Family. It began with an insistent ring on the front door bell as he was resting in his insalubrious cellar that doubled as studio and bedsit. He told the story in his memoir.

> On the doorstep was a vivacious young woman who hailed me cheerfully that she had been ringing for ages and wanted to know where on earth her friend, who lived in one of the studios upstairs, had got to. On discovering her friend was out, she came back, and we chatted for some time in the courtyard. She was

quite young and extremely witty and animated. She was of Flemish origin, from Antwerp – very feminine yet with a direct fearless attitude to life.

Although he claimed this brief encounter did not make much impression at the time, his life in the cellar was soon enlivened by a 'strange mystery'.

One day, on returning to my penitentiary after doing the rounds in the hope of a commission, I found at my door a basket full of the most welcome food – butter, cheese, fruit and preserves, enough for a whole week. I knew no one of such generosity and hoped only that it was not a mistake and that the food was meant for someone else.

His cellar faced on to the street, with narrow horizontal windows set high in the wall at pavement level, very typical of Brussels architecture. At about three o'clock one morning he was woken by the sound of knocking on one of the windows, followed by a woman's voice. He leapt out of bed and went outside.

To my amazement, it was my young lady of the courtyard. 'I wanted to check you really do live in that cellar,' she said. 'I couldn't believe it when my friend told me of your plight. I was coming back from a ball and wanted to see for myself.' She was appalled at the conditions I was in and determined to do something about getting me out at once.

Her name was Simonne Rikkers.

According to Nemon, she was seventeen and only just out of convent school (although, in fact, she must have been at least nineteen since she was born on 16 February 1909 in Antwerp) and had just married a man called Hottlet. She claimed (again, in Nemon's version – although others have cast doubt on this) that her father had drowned in the *Titanic* disaster. Marriage had liberated her in more ways than one, because she had come into some money that had been put in trust until she had a husband. Nemon immediately became one of her beneficiaries 'both materially and socially'. Simonne (her name was occasionally also spelt with one 'n' in the conventional French way) was well connected, especially in the art world. She introduced him to influential people in Brussels and elsewhere in Belgium: to Auguste Vermeylen, an art historian, for instance, who was also Rector of the University of Ghent, and, later on but even

Simonne Rikkers in 1930

Simonne Dear with her bust, 1937

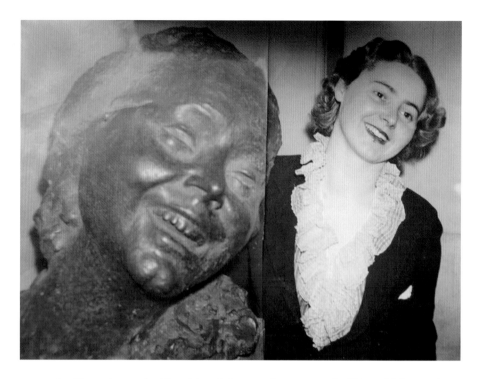

more significantly, to the Flemish adviser on the arts to the King. This was how Nemon eventually came to sculpt the bust of King Albert.

Simonne and Nemon continued their intense friendship. She gave all her letters and archives to the Royal Library in Brussels, including the letters he wrote to her from 1935. I was overjoyed when I found these and even more excited when I found that Simonne had kept letters from my Croatian grandmother and my Aunt Bella.

It was this discovery that led me to learn more about Simonne, who seems to

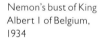

Nemon's bust of King Albert I of Belgium, 1934

David Dear's friend the Dutchman Koos van der Leeuw

have been a friend of Koos van der Leeuw, a wealthy Dutchman and a follower, perhaps even a close friend, of Sigmund Freud. Koos befriended a teenage Australian boy called David Dear, who was to play a significant role in the lives of both Simonne and Nemon.

In 1926 Koos took the seventeen-year-old David to London. How they met up with Nemon is unclear, but probably Freud was the common factor between Koos and the man who had become in the early 1930s Freud's sculptor. If that meeting happened in Vienna it is equally probable that back in Brussels Nemon introduced David Dear to Simonne Rikkers/Hottlet.

Events would have turned out differently if on 23 August 1934 Koos van der Leeuw had not been killed when he flew his De Havilland Leopard Moth into the side of Inporoto Mountain in Tanganyika. Koos was on his way to Vienna to see Sigmund Freud, who called him 'the Flying Dutchman'. The plane was registered in Koos's and David's joint names, and in the terms of older man's will David Dear inherited all his money.

David Dear married Simonne in London in the summer of 1935. Nemon was closely involved with both of them. In the spring of 1935 he wrote to her that 'wings have put you down on the hospitable ground of your friend from England', and at the time of the marriage he wrote, 'What a thief David is. He deserves to have war declared on him, as the Spartans did to the Trojans.' A few months later, in January 1936, he wrote to Simonne that he 'had just met someone who had provided precious psychological information on Koos'. This was probably the

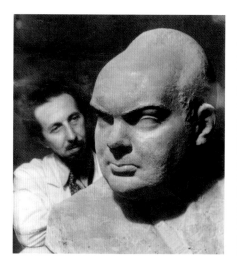

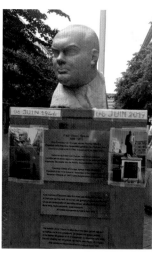

The bust of Paul-Henri
Spaak outside the Gare
du Midi in Brussels
PHOTOGRAPH BY
ALICE HILLER

Paul-Henri Spaak,
Prime Minister of
Belgium, 1947–9

time when Nemon was making his posthumous bust of Koos (which now belongs to David Dear's daughter in Australia) and was trying to understand him more profoundly.

Many of the details of Nemon's life and thoughts can be gleaned from the frequent letters and postcards he and Simonne exchanged up until his death in 1985. He had done a bust of Simonne, probably in 1935. When it was later exhibited at the Yugoslav Legation in 1937 a headline writer captioned a picture of Simonne laughing next to it in the same pose – 'Beside Herself With Laughter'.

Their correspondence and friendship lasted through her marriages – to David Dear and, much later, in April 1965 to Paul-Henri Spaak, the socialist Prime Minister of Belgium both before and after the Second World War. Spaak was also a prime mover in the founding of the European Common Market and chairman of the first General Assembly of the United Nations. (Spaak had also played for the Belgian tennis team in the 1922 Davis Cup.) Nemon was a fervent admirer, remembering Spaak's humility as well as his great oratory that once brought an Albert Hall meeting to its feet – even though he spoke in French. He also remembered the story Spaak told when Molotov was delivering one of his long speeches at the United Nations, and Spaak was spotted deeply absorbed in the literature in front of him. Nemon asked what had so caught his attention and received the confession, 'I was lost in an Agatha Christie.' He sculpted Spaak in 1945. One of Nemon's busts can be seen in the European Parliament in Brussels and another one greets travellers as they emerge from the station at the Gare du Midi in Brussels.

Meanwhile Simonne's success in getting Nemon introduced to members of high society guided him towards the Belgian Royal Family. In less rarefied circles his career continued on an up-and-down path.

On 16 January 1933 he wrote to Bella:

Luce Deladier [a friend] came back from Paris yesterday and told me that she's received a little parcel from you, which impressed her very much, and I can tell you that you've found a great friend in her, equally as great as is her husband an enemy to me. There's been a lot of comedy there lately and in particular in that Yugoslavian exhibition where I categorically refused to exhibit. Monsieur le Ministre de la Défense Nationale Devèze asked at the official opening, to which I wasn't even invited, 'Luce, why is it that your great friend is not exhibiting? It would be a huge honour for him!' That is how Monsieur Devèze interprets it. But what a thing it is for me that I had refused, for today I am left with a clear conscience. I was able to easily attack this exhibition, with every right.

It is hard to detect his true motives. Although he told his sister that he was getting the support of some Yugoslav friends in Brussels, his refusal seems like that of an aggrieved outsider. He went on, 'Meštrović hasn't caught on in the slightest, and I can tell you that he hasn't harmed me one bit. I shaved off my beard yesterday, but I'm already growing it back today. All doors closed to me, but work is assured, and you and mother can count on 500 dinars a month.' There was much going on in his mind at the start of 1933.

His next letter to his sister confirmed his agitated state. 'Circumstances', he wrote, 'have become gloomy and intolerable.' He complained that he could have made a lot of money 'if only Deladier had lifted a finger to help'. He said Deladier would pay dearly for this refusal,

since he has to listen to his wife who was already ready to leave him on two occasions. He doesn't inform his wife about anything – she isn't much interested in his business, in any case. Can you imagine that, when he has someone like Vandervelde and Defence Minister Devèze as best friends? And as for Mme Gottschalk, a deadly silence pervades – I may have told you that I had effectively thrown her out of the studio about two months ago. Tomorrow I shall go to Paris, and I'll write to Desider from there. As far as my finances are concerned, everything is coming along nicely, and I hope that there'll be more of that to come – almost everything depends on Paris.

Clearly he was anxious not to worry his family too much about his income, especially as his mother was at least in part supported by the contributions he managed to send home.

One other commission he got was a bust of August Vermeylen, to whom he had been introduced by Simonne. Both Simonne and the sculptor are mentioned in Vermeylen's diaries.

The mid-1930s were altogether an odd time for him. On the one hand, he

The Belgian lawyer Henri Simont, aged thirty, sculpted in 1930; the bust was given to Simont by a grateful client.

The art historian August Vermeylen, Simonne's lover in the 1930s

was getting commissions, working away not just on portrait busts but on some large figurative statues, including the massive *Bridge*, and on a grand project he called a Universal System of Ethics, involving the construction of a massive temple. On the other hand, various friendships – with the influential Gottschalk family, for instance – were souring, and he was not successful in accumulating enough money for himself, especially with the burden of the support he was giving his Yugoslav family. Life, which had promised so much in Brussels, was getting more difficult. From 1934 he encountered growing professional resentment and widespread anti-Jewish feeling, not just from the usual suspects but even from other Jews as well. A letter to Bella described how a very wealthy Dutch Jew who had brought huge assets to Belgium twenty years before had still not been able to get the Belgian Senate to grant him citizenship and had 'gone completely berserk like a wounded hound' when he found out that the King was going to intercede on the sculptor's behalf to get him citizenship. In his memoir Nemon said that this man's jealousy did him a lot of harm – adding that 'these rich Jews knew how to be frightfully vulgar'.

In a letter to Simonne in August 1935 (when she had just married her second husband David Dear and moved to London) he complained of being 'confronted' by 'creditors camping in front of my house'. She was about to visit him in Brussels, no doubt to offer him comfort but also to take delivery of the bust he had done of her laughing face.

He must at this stage have already been thinking of moving to London. He may indeed have arranged this already with Simonne (although how much David was in the picture cannot be gleaned from letters – if there was connivance

behind his back, they were too discreet to leave any traces). Simonne's life – and possibly therefore his own – had been changed enormously by the death of Koos van der Leeuw, which had the effect of making David instantly and immensely rich. It is surely not wholly unconnected that within a year David and Simonne were married in London and setting up home there – a house into which within another year Nemon had moved, occupying a separate flat-cum-studio generously provided by the Dears.

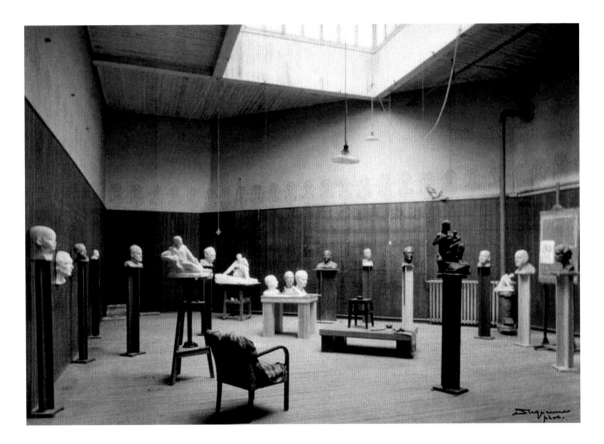

Nemon's studio in the rue Thérésienne, Brussels, 1935

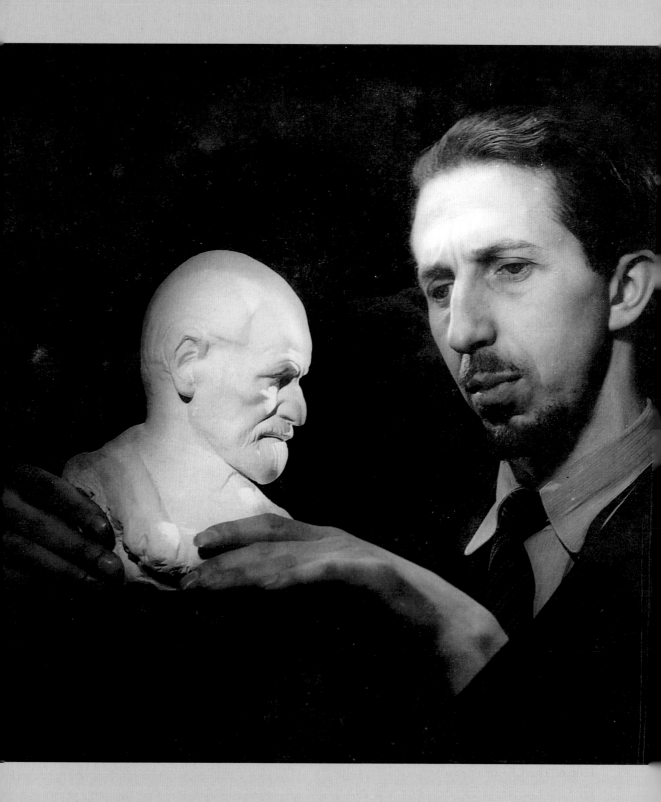

Nemon with one of his
busts of Freud

Freud 4

EARLY IN 1931 a telegram from Vienna arrived out of the blue that would have a profound influence on Nemon's career. It was from Dr Paul Federn, an ardent but not always appreciated disciple of Freud whom Nemon had met several years earlier in the Austrian capital and who had been trying and failing, before and since, to get Freud to agree to sit for a sculpture. Now, it seemed, the time had come. The telegram read simply, 'Come at once!'

A quarter of a century earlier, in May 1906 (the year of Nemon's birth), at a dinner to celebrate Freud's fiftieth birthday, Federn had been struck by the coincidence that a quote from Sophocles – who described Oedipus as 'he who solved the famous riddle and was a man most mighty' – on the medallion presented to the already eminent psychoanalyst was the same as that inscribed beneath the bust of Sophocles in the Great Hall of the University of Vienna. When Federn pointed this out to him, Freud noted that he had dreamt that one day his own bust would be up there among the world's great intellectuals. Federn seized on this happy coincidence to press his case for a bust of Freud to be sculpted. The psychoanalyst adamantly refused, citing partly humility but also the hurt caused by the contempt he had suffered earlier at the hands of the university.

Twenty-five years later Federn tried again. Through Freud's daughter Anna he arranged an increasingly hard-to-obtain appointment with the great man. According to Nemon in his memoir, the conversation went like this:

Federn: 'Professor, I have three requests. The first is to ask for your daughter's hand in marriage.'

Freud: 'Are you mad? You are a married man already with three young children.'

Federn: 'The second request is this. I wish to be made President of the Psycho-analytic Society.'

Freud: 'You are mad. I myself am the President.'

Federn: 'Third, I want that bust of you.'

Freud (laughing): 'NO! I've already told you. No.'

Federn: 'I've made three requests, and you have rejected them all. Is that the action of a gentleman?'

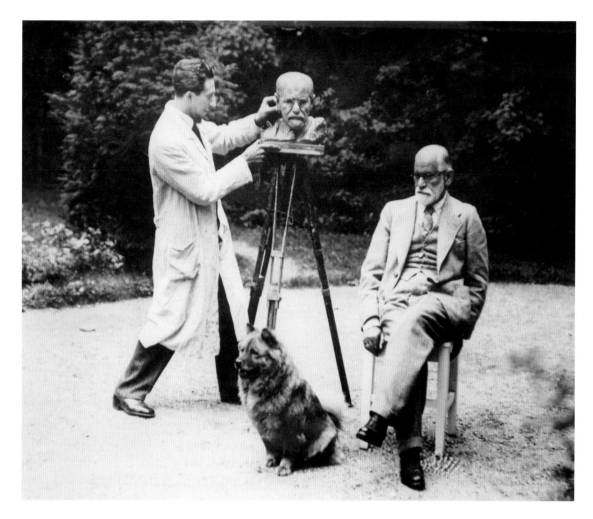

Nemon sculpting
Freud in his garden
in Vienna, 1931

Freud: 'What will it involve if I agree?'
Federn: 'The artist has only to come and see you.'

As soon as he reached Vienna Nemon went to Freud's consulting-room in his summer residence outside the Austrian capital clutching, on Federn's advice, photographs of his work as well as paper and pencil to start making an instant sketch. He recalled the meeting:

Nemon's sketch
of Freud

> Professor Freud stood up behind his desk as I entered. I moved forward and bowed to him. Our eyes met. He said sharply, 'Well, you've seen me.'
>
> I knew nothing of the exchange between Freud and Federn that had precipitated this remark, and, being at that time young and filled with the indomitable pride of youth, I felt rather insulted. I began to see why Federn had stressed so strongly that I was not to leave without having achieved anything, and on the spur of the moment I found myself saying, 'No, sir, I have not seen you.'

[Freud's diary entries in handwriting]

Then the Professor, with a considerateness that I was to learn was part of his nature, asked, 'Is it too dark for you in here?' for the room was in the customary demi-darkness of a psychoanalyst's consulting-room. He suggested we go out into the garden, although even this was rather overshadowed by a number of trees. He thoughtfully led me to the end of an avenue where there was more light, and I took the photographs of my work out of my pocket and asked the Professor to look through them while I made my sketches.

I worked quickly, but when I came to the beard my pencil broke, and I had not provided myself with another. The Professor had by that time looked through only a few of my photographs, and I had to resort to tact: I told him I had been travelling from Brussels for twenty-four hours in order to see him and that I would be most grateful if he could spare a few minutes the next morning to look at a sculpture that I would have worked on overnight.

Freud's diary from 29 October 1931; 'Three busts from Nemon'
FREUD MUSEUM, LONDON

Nemon sketching Freud in Vienna

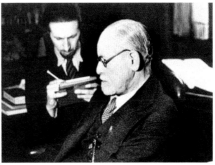

The plea worked, and the pair met several times, always for brief sessions between patients. Nemon remembered Freud as being 'usually reserved and uncommunicative', but one day Freud remarked, 'You know, you're following the oldest profession of all.' When Nemon replied that he had always assumed architecture to be the oldest profession, Freud said, 'Didn't you know that God made men out of clay?'

In a speech at the unveiling of Nemon's small statue of Freud in New York in 1947 Paul Federn recalled a different version of the first meeting between the father of psychoanalysis and the sculptor: how he had introduced Freud to Nemon in the garden of his summer home in the Viennese suburb of Pötzleinsdorf. According to his account, Nemon was left alone to show the Professor a collection of photographs of his work. Freud immediately became interested in what the artist had to say and liked the originality of his work as well as the man himself. Next day the first sitting began.

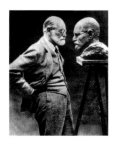

Freud examining one of the three busts Nemon made of him in 1931

Nemon returned to Brussels with his sketches. After six months he had finished three busts, one carved in wood, another cut in stone and the last cast in bronze.

The first person to see the finished sculpture was Freud's maid Paola, who exclaimed, 'Oh, doesn't the Professor look cross!' When Nemon told Freud what his first critic had made of the bust, Freud retorted, 'Oh, but I *am* angry. I am angry with humanity!'

In a letter Freud wrote to Max Eitingon on 3 August 1939 Freud was more emollient, although at first commenting on Nemon's appearance as 'a Slavic, eastern Jew, Khazar or Kalmuck or something like that' then continuing:

> Federn, who is usually highly inept in discovering unacclaimed geniuses, forced him on me. But this time there is something, or rather a lot, in it. The head which the gaunt, goatee-bearded artist has fashioned from the dirt – like the good lord – is a very good and astonishingly life-like impression of me.

He couldn't resist a bit of a dig. 'He has kept quiet about how he intends valuing the work, but I didn't order it from him.'

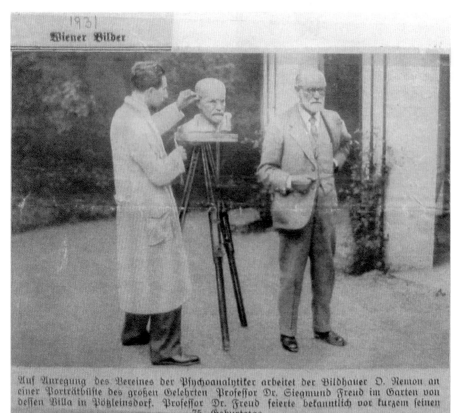

Above

The wooden carved bust Freud kept and which is now in the Freud Museum, London

Left

Nemon sculpting Freud in Vienna in 1931

On 1 November 1931 Freud wrote to Federn, who had just brought along the three busts to ask Freud to choose one among them to keep as a gift from the Viennese Society.

> The choice was not an easy one. Although the busts were made by the same hand and represent the same person, the artist gave each of them an individual charm and distinction not shown by the others and not easily relinquished. Finally, since, however, I cannot have three heads like Cerberus, I decided in favour of the one made in wood. With its vivacious and friendly expression it promises to become a pleasant roommate. To you who found the artist and upheld him as well as to the Society which presents me with this, my double, I must express my hearty thanks.

This wooden head is the one that still sits in Freud's Hampstead house – now the Freud Museum.

The dog, which Nemon recalled as being a Chinese chow, had been another useful way of creating a friendly relationship. He would lie in the consulting-room, and whenever he wanted to go out Freud would get up, open the door and bow to the chow ceremoniously. He said to Nemon one day that he would do better modelling the dog rather than himself – 'You would have a very fine example of graciousness and dignity.' Nemon, in fact, was later to sculpt the two chows belonging to Princess Marie Bonaparte, Topsy and Tatoun; the sculpture of Topsy is owned by the Ashmolean Museum in Oxford.

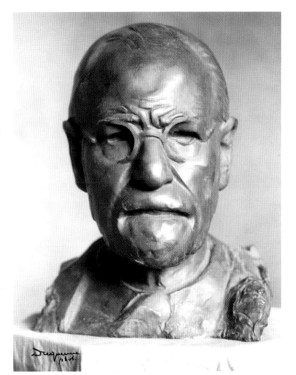

Nemon's bust of Freud cast in bronze in 1931
PHOTOGRAPH
BY DUQUENNE

I presume it was Freud who introduced Nemon to Sándor Ferenczi, the distinguished Hungarian psychoanalyst and disciple whom Nemon sculpted in Budapest in 1931.

Nemon continued to visit Freud in Vienna over the following years. His first bust, meanwhile, remained in Brussels. One day Queen Astrid came to his studio, brought there by August Vermeylen. Vermeylen pointed out the bust of Professor Freud, but the Queen looked blank. 'The famous psychologist, indeed the founder of psychology as a science,' prompted the Rector, embarrassed. Nemon concluded that she must have been brought up in a decidedly restricted sphere.

On a later visit to Vienna Nemon went to see Freud, who was quietly playing cards with his family when his visitor arrived. Freud's daughter Anna remarked that she had heard the young King

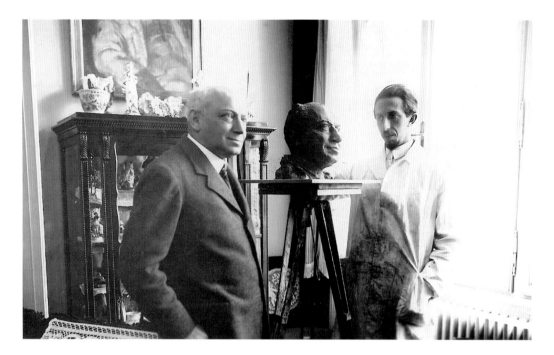

Nemon sculpting Freud's disciple Sándor Ferenczi in 1931 at his home in Budapest

and Queen were popular in Belgium, at which her father looked up and with heavy irony said, 'You don't mean to say that the country has still a reigning monarchy?' As for Freud's disparaging of Queen Astrid, Nemon commented in his memoir, 'The wheel had come full circle.' He recalled another snatch of conversation from this same visit:

> I asked Freud what he thought of the Surrealist movement. He replied, 'I receive a publication from them every week, each one more lavish in its format than the last, but when I've read the dedication there's nothing else even faintly comprehensible to me.' Yet the Surrealists looked on Freud as their spiritual father!

Freud's scepticism extended apparently to his understanding of Marxism. When given a long theoretical briefing by an eminent Marxist scholar, Nemon recalled, the lecturer concluded by saying that the path to world communism would, in the first part, entail hardship, misery and deprivation, while the second part would be paradise on earth. Freud replied, 'Yes, yes. You have convinced me – but only where the first part is concerned.'

Nemon's more active concern was about Freud's safety. Vienna was becoming increasingly dangerous for Jews, as war seemed imminent and inevitable. Fortunately, others, including their mutual friend Princess Marie Bonaparte, were also concerned and active not only in inducing Freud to change his mind about leaving but creating for him in London a living and working environment that matched the style and comfort of his Viennese home.

Less well known is Nemon's account in his memoir of a visit to New York after the Second World War for the unveiling of the model of the statue of Freud that was originally intended to have been presented to the Viennese Psychoanalytical Society in 1936.

> Before the war the German population of New York had gathered together on the East Side. It was therefore logical that the site for the skyscraper headquarters of the great National Socialism movement should be located there. The building had reached the seventh floor when war broke out, and all building operations were of course suspended.
>
> After the war the unfinished building was put on the market and bought by the Psycho-Analytic Society of New York. It was completed, and I did a sculpture of Freud for the focal point in the main hall. On arriving, I went to have a look at the site and make arrangements for the necessary plinth. The superintendent advised me to get hold of a German carpenter with a very good reputation who had done work for the building in previous years.
>
> He produced a fine base, and on the day it was erected he and I were chatting together and he confided in me that he had been commissioned to make a plinth on that very spot just before the war – to support a statue of Hitler! The irony was devastating. Hitler and Freud: the Jew exterminator and the Jew who died in exile, a victim of the obsession of the Fuhrer; the paranoid and the psychologist who traced so exactly the path of the twentieth century.

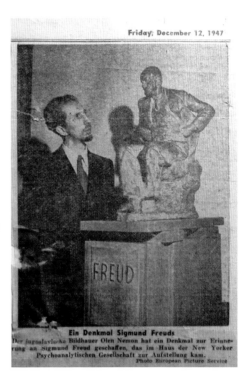

Friday, December 12, 1947

Ein Denkmal Sigmund Freuds
Der jugoslavische Bildhauer Oleh Nemon hat ein Denkmal zur Erinnerung an Sigmund Freud geschaffen, das im Haus der New Yorker Psychoanalytischen Gesellschaft zur Aufstellung kam.
Photo European Picture Service

Press cutting from 1947 announcing the unveiling of the Freud statue in New York

One of the consequences of Nemon's association with Freud – his unique access as a sculptor, his understanding of psychoanalysis, even his friendship with the great man – was that he gained acceptance in the notoriously prickly world of psychotherapy. In the spring of 1939 he succeeded in persuading the particularly touchy – and often depressed – child psychiatrist and analyst Melanie Klein to sit for him. They met at the analyst's house in St John's Wood (just south of the 'home of psychoanalysis', Hampstead). This was a difficult commission from the start. Nemon recalled later that 'Melanie had a noticeable tendency to pomposity and was easily capable of self-righteous behaviour. Perhaps these qualities were manifest in my work and caused her some discomfort.' The 'discomfort' he was referring to was more a matter of intense hostility to the finished work. Although there is film footage (probably taken by Nemon's lover Jessie Stonor) of the sculptor and his sitter laughing and chatting in Klein's garden, the resulting bust, twice life

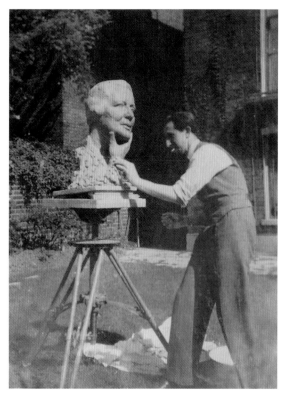

size, was received by the sitter very badly. Klein's biographer Phyllis Grosskurth writes that she 'loathed the head, which she hid in the attic for some years before destroying it'. Perhaps Nemon had captured some aspect of her personality that she was upset to see so graphically reproduced.

There is, however, a coda to this story. In 2016 two full-profile but damaged reliefs of Klein were found among the possessions of one of her pupils and patients, Hanna Segal. They were probably done at the same time as the large bust and given to Segal after Klein's death in 1960. These reliefs, currently in the process of being restored, are the only surviving figurative portraits of her made during her lifetime.

It would seem that Nemon's statues, busts and reliefs had almost unanimous acceptance – even praise – from his subjects . . . except for some psychoanalyst followers of Freud. These were to include not just Klein and (later) René Laforgue but even Paul Federn himself. After seeing the bust Nemon had made of him in the summer of 1949 Federn wrote an extraordinary letter to the artist that illustrates the ambivalence aroused in professional psychoanalysts towards someone who had so much of the psychoanalyst in him, both in manner and his ability to probe gently the feelings of others; indeed he was often mistaken for a disciple of Freud. Federn wrote on 6 July 1949 when he was already on his sickbed and had not long to live:

Dear Nemon

I want to thank you very much for the great dedication and effort you made with my immortalization. But – you must not be angry with me – I won't leave you in peace yet. The head was exquisite three weeks before you finished it, then your spirit of wanting to be more than true, mixed with some self-destruction, spitefulness and arrogance, got into you. You have made the bust into something ridiculous, cheery and wise but on the whole into an unpleasant head of a Jew.

I want to go into more detail:

(1) My long neck is part of me; you have stuck my head into my neck, squeezed it into it.

(2) The lopsided position of my head which reflects truly my hearing in only one ear is in real life consciously controlled by me and makes the bust look conceited and awful.

(3) My upper lip is missing in your work, not in my head (my face is long). My face is squashed even more while it should be long.

(4) My mouth is sensual and ready to talk, not as in your work wooden – silent.

(5) You have made a nice fellow out of a scientist, doctor and [illegible].

Nemon in 1969 with the plaster cast of his statue of Freud

PHOTOGRAPH BY FALCON STUART

As you have got me fully in your head you could still change that in London. Don't cast the statue in this form under any circumstances! Maybe you would change it when you return in October . . .

I know how difficult I made it for you with few sittings and with this dentist business, but the main point lies with a subconscious animosity on your side towards me.

But for heaven's sake don't be offended or angered – the medallion which you made eighteen years ago immortalizes you and me for ever in a strong and true way.

I do not know how Nemon reacted to all this. I cannot imagine he was not offended or angered. Perhaps he was a little mollified by a note Federn scribbled in the margin of his letter. 'Most people who received a bust found it excellent.' Perhaps Nemon was enough of a psychoanalyst himself to be able to take the dying's Federn's criticisms with some understanding and equanimity.

As for the massive seated figure, a little in the spirit of Rodin's *Thinker*, that is Nemon's best-known sculpture of Freud. It is still situated outside the Tavistock Institute at the bottom of Fitzjohn's Avenue in Hampstead. It is a kind of memorial to Nemon's fascination with Sigmund Freud.

On 24 January 1936 Nemon wrote from the Hôtel de France in Vienna to his friend Simonne. He had just had his fourth one-hour sitting with Freud and was feeling ecstatic after their long conversations.

Quel être énorme! No one has moved me so deeply as he does or convinced me of his greatness with his knowledge and insight. I have been enriched by knowing that such a man exists on this earth. He deserves to have his bust cast in gold.

It was, of course, never cast in gold, and even casting it in bronze involved a fascinating chain of events, with a contemporary twist.

In the late 1960s Donald Winnicott, the eminent Freudian and President of the British Psychoanalytic Society, decided he wanted to erect a bronze casting of the statue that was languishing (in plaster) in Nemon's London studio. Originally it had been intended to unveil a bronze version in Vienna in May 1936, on the occasion of Freud's eightieth birthday, but events took over. In 1964 Penelope Balogh (later Lady Balogh), a psychotherapist and a biographer of Freud, was advised that the only way to preserve the statue was to hand the project of raising the necessary funds to Winnicott himself. So the Freud Statue Committee was

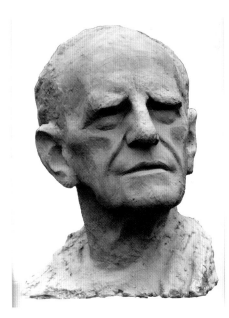

Bust of Donald
Winnicott now
in the Institute of
Psychoanalysis, London
PHOTOGRAPH BY
FALCON STUART

Donald Winnicott sitting
for Nemon at his studio
in St James's Palace; the
statue of Freud can be
seen on the right.

D.W. WINNICOTT
ARCHIVE, IN THE CARE
OF THE WELLCOME
LIBRARY, LONDON,
COURTESY OF THE
WINNICOTT TRUST;
PHOTOGRAPH BY
FALCON STUART

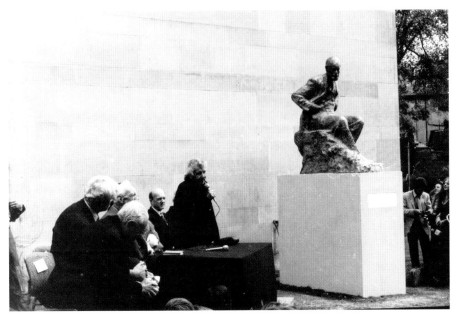

Anna Freud unveiling
the statue of her father
at Swiss Cottage in 1970
with Donald Winnicott
sitting beside her; the
statue was moved to its
present position at the
junction of Fitzjohn's
Avenue and Belsize
Lane, London, in 1998.
FREUD MUSEUM,
LONDON

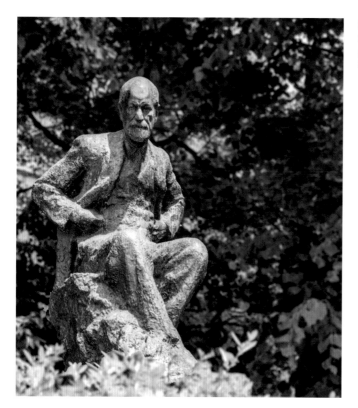

Statue of Sigmund Freud
installed in Hampstead
PHOTOGRAPH BY
CLIVE ROBINSON

formed. Nemon was closely involved, describing Winnicott as having 'a passion for rescuing which was fully applied to me'. In fact, they became close – Winnicott sometimes spent Saturday mornings in Nemon's studio playing with clay.

A total of £11,000 was raised, and on a bitterly cold October day in 1970 the statue was unveiled by Freud's daughter Anna before the great and good of the psychoanalytic world. Winnicott, possibly weakened by his efforts and by having to stand outside so long in the cold, died just three months later.

In June 2018 Freud was brought back to Vienna in the form of a new bronze casting of the Hampstead statue. The Dean of the Vienna Medical University (where Freud qualified as a young neurologist) gave his approval – and funds – and Dr Stephan Doering of the Vienna Psychoanalytical Society was active in promoting this prestigious and symbolically important project. Freud's return to the Austrian capital is a beacon of hope after the dark days of the 1930s.

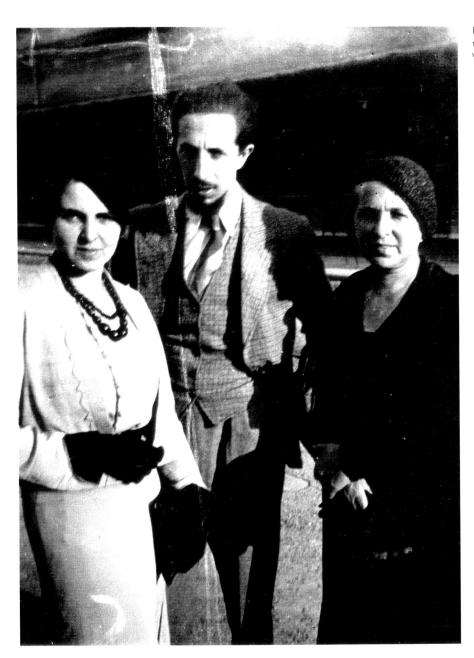

Bella and Nemon with their mother Eugenie in Vienna in the 1930s

Humanity, Nemon's
Holocaust memorial
and his most poignant
statue, 1960

Art and Craft 5

I N THE SUMMER of 1933 Nemon conceived a grand project. It is hard to grasp exactly what my father's motives were. Perhaps he was frustrated by the mundane life of a portrait sculptor. Perhaps he was influenced by the romantic idealism of Simonne and other left-wing friends. Perhaps he was thinking of the dangers posed by the impact Hitler was having as the new Chancellor of Germany. Among his motives was surely an attempt to satisfy his own deeply idealistic nature. Equally surely, it was a wildly impractical, over-ambitious project. Nemon wanted to found a 'System of Universal Ethics' to ensure a 'more profound and more efficient cooperation among men'. His formal proposal, sent out to hundreds of people on a list he had drawn up himself, was printed in capitals on a slim brochure with the general title 'Towards a Moral Conviction'.

> The social organization of a humanity disappointed by totalitarian experiences whether based on the principles of materialism, Communism or racialism. Maximum of respect for individual liberty in so far as it is not contrary to the interests of the community. Creation of economic conditions in which man will be encouraged to give to the utmost of his moral value. Disciplinary service of work in youth, leaving man free in maturity for the expression of his individuality and in old age assuring his needs.

This is a pretty clear counter to the salvo of measures announced in the first months of the new government in Nazi Germany. But what exactly could a lone Jewish sculptor do? Nemon's answer was to back up his pious proclamations with building a *Temple of Universal Ethics*. He made a model for a hundred-metre-high edifice based on three triangular slabs representing the 'three branches of humanity, Shem,

Nemon with a model of his *Temple of Universal Ethics*, London, 1938

THE edifice destined as the home of the Universal Centre of Ethics will symbolise the union of the branches of humanity.

Proposal.

ENGLAND SUGGESTS ITSELF AS THE MOST PROPITIOUS TERRITORY IN WHICH TO ERECT THE CENTRE. HER RACIAL AND CULTURAL HERITAGE IS SUFFICIENTLY SUPPLE TO EMBRACE THE MULTIPLE ELEMENTS WHICH MUST COMBINE TO MAKE THIS MOVEMENT A SOLID SUCCESS, AND ITS ERECTION SHOULD PROVE A TIMELY REAFFIRMATION OF HER AFFINITIES WITH THE CULTURE OF THE WHOLE WORLD.

...TOWARDS MORAL CONVICTION

A new version of the proposal for a *Temple of Universal Ethics*; leaflet printed to seek support for the idea in England in 1938

Ham and Japhet'. The temple was destined for Jerusalem, but he preferred England as a home for the centre on the grounds that 'her racial and cultural heritage is sufficiently supple to embrace the multiple elements which must combine to make this movement a solid success'.

In the summer of 1939, after he had moved to England, Nemon returned to the idea. He sent out hundreds of printed brochures with a tear-off section to elicit responses. He must have been disappointed.

Nemon was not the first artist to try to marry idealism with art. Modigliani, for example, planned a 'Temple of Humanity' a couple of years before the outbreak of the First World War. As for Nemon – sincere though his ambition to save humanity was – there was also a need for personal recognition on a wider scale, a desire to break out from the confines of a portrait sculptor whose clients were limited to those who could afford his fees, however modest. This was a dilemma he faced all his life. After the war, when he was married, he would still regret that his lofty ambitions had not been realized.

He knew that being a 'mere' portrait sculptor could not completely satisfy him, confining him as it did to copying what already existed. And in so far as my mother paid attention to his sculptures – except for their unprofitability – she was ambivalent herself about his commitment to the narrow field of portrait sculpture ... even to the famous. When in November 1948 she learnt that he was not going to do a bust of Jung she consoled herself by writing to Nemon in Basel, 'Not doing

Jung must bring to mind the irony of your doing the heads of the famous at all; one way or another such fame is stained with the blood of the innocents.' As if that were not hurtful enough, she wondered 'whether doing famous heads is a step down for creative genius although a step up for the boy from the backwoods'. It is a pity I do not have Nemon's response. As an afterthought she wrote that she had just received a letter from their bank saying her occupation was 'wife of Oscar Nemon'. Her comment was: 'So now you know my legal occupation, but as you are so seldom here I am always just one of the unemployed!'

He might – and did – feel angry at such barbs. But he knew she supported the ambitious Temple of Ethics scheme, and she would refer to it many times in the long letters she wrote to him before, during and after the war. It was his failure to achieve fame and fortune with his portrait sculpture that upset her most. But, of course, he was never going to give up. Patricia once made a desultory attempt to get him to do some more menial work, just to raise a little more cash. He was in Pleasant Land in the summer of 1951, and she, as usual, was with her children, staying with her parents in Norfolk. She wrote suggesting that he go into partnership with a builder she knew. In addition, she had fantasized in a dream that 'someone in the family discovered a secret method of making wood as hard as steel'. She must have known she was on a losing wicket, because she added, 'I know it is rather unromantic when you see yourself as a builder of Temples of Humanity to suggest you put up chicken houses for your neighbours.'

From his earliest days, as a teenager in Osijek in love with making images from clay, Nemon was thoughtful and ambitious about the role of an artist. In the preface to his memoir he wrote that 'even God himself indulged in this craft, using clay for the fashioning of man and for thousands of years man has been imitating God, as children in their innocence have always played at being "grown-ups"'. Entwined women relief

Horse and rider relief

Seated women relief

He believed that this was an 'impulse common to many men'. But he was always looking beyond the mere portrayal of likenesses. A professional sculptor should be an artist not merely a craftsman.

But he was in essence a loner and not a joiner – very different from the combative, gregarious, publicly ambitious, Brooklyn-born fellow sculptor of a previous generation, Jacob Epstein, with his schemes for artists' colonies and membership of artists' clubs. Nemon was always a one-to-one person, putting his potential sitters at ease with his uniquely soft voice and his reassuring manner. He charmed them all. He was gentle and witty. His art was indeed almost that of a psychoanalyst, extracting the essence of a person in the way he moulded their features. But, from time to time, he hankered after a role beyond the figurative artist, beyond the portraitist. His early bas-reliefs and plaques would sometimes veer towards the abstract. He flirted with expressionism during his brief time in Vienna. In his Brussels studio he made the monumental sculpture *The Bridge*, a twenty-foot-long couple making love – a work probably destroyed by the Nazis. Motherhood was a theme he investigated several times. His *Humanity* was his legacy to the victims of the Holocaust – a tall, thin image of a woman holding her child above her head and looking into its eyes.

Kneeling woman relief

He was quoted in the *Jewish Chronicle* as saying about *Humanity*, 'Our race, with its philosophy of humanitarianism and its heed for the sanctity of human life, has contributed to the "debestialization" of mankind. And so I decided that my sculpture must not be an accusing image, but, on the contrary, one of elation, one symbolizing the eternal striving of the Jew towards humanity.' The article points out that the figure does not look especially Jewish. It has no look of tragedy or martyrdom. Nemon endorsed this view. 'The image of the child appeals to everyone. This design does not promote the heroes or the suffering of Jewry; its message is universal.'

About ten years before he died Nemon sculpted a figure he called *Heredity*. It represents a kneeling mother, her child on her knee, their heads touching. He saw it as symbolizing the passing on to the next generation of the wisdom of the ages, a key element in the traditions of Judaism. But he never tried to push the boundaries as Epstein did, for example, with his Vorticist *Rock Drill*.

Nemon was hostile to what he called the 'committee approach' to art: it was 'like making a single meal of all the courses – a tasteless, insipid mess'. He liked to tell the story of a well-known sculptor who reluctantly accepted a commission for a war memorial in a small English town but who despised the philistinism of the local councillors. He took the project over to France, but a delegation from England tracked him down to see how things were going. Observing the almost completed sculpture, they waxed eloquent at its beauty – at which the sculptor took a hammer and destroyed his work, unable to stand their 'empty and unperceptive praise'. Nemon's moral of this story is that 'the greatest threat to the artist's integrity is the demand of the public for what it can understand and accept'.

Why was he so prickly, so upset by public acceptance . . . so dismissive of the opinion of ordinary people? He was no snob, for all his closeness to royalty and to his many eminent sitters. He clearly carried in his mind the image of the lonely, despised artist suffering for the purity of his art. Yet Nemon was never able to escape from the confines of being a portrait sculptor, even while he brought to the fashioning of clay a constant and personal uncompromising vision. He accepted payment, however inadequate, always hoping that one commission would lead to another, one payday to an even better one . . . without, however, pressing actively for that to happen. Perhaps if he had made enough money he would have returned to abstraction, to a wider expression of his art. But it was not to be an option for him.

Nor did he seek the support of fellow artists. He kept himself aloof from

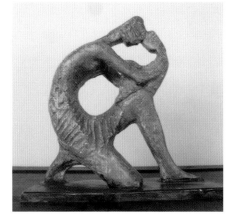

Heredity: the passing on of knowledge from one generation to the next

artistic circles or clubs. At the same time he did not consider himself a man of the people. He wrote in his memoir what seems today a harsh position to adopt for one whose work was very much on public display. 'The arts are not meant for the masses; people have to be educated in developing a faculty of appreciation.' For all that he qualified his first statement, this was not a mind-set that recognized any link between the vision of the artist and the eye of the beholder.

His ambivalence is reflected in the comic account in his memoir of a visit to a foundry he made with Clare Sheridan, a cousin of Winston Churchill and a sculptor as well as an art critic. She reacted with disgust to the 'endless cheap plaster statues stacked deep on shelves all round the walls' and declared that the foundry owner should be sent to prison for debasing public taste. She insisted, against Nemon's advice, on confronting the foundry owner himself.

> She addressed him aggressively, refusing to shake hands and beginning at once to harangue him about the 'monstrosities' he was manufacturing and selling to the public by the thousand – ugly, repulsive travesties. He replied, 'Madam, I am a businessman. That is what the public wants, so that is what I give them. I have no vocation to preach aesthetics or morality; I leave that to others. I have tried different approaches but with no success. Now I do what I know will meet public demand and am very successful. As a matter of immediate concern, Madam, I have a VC from the last war and am also a boxing champion. Will you go, or do I have to throw you out?' This, to Clare Sheridan, who was built on the lines of a Wagnerian heroine, was quite a comment!

Another story he used to tell relates to his first visit to Paris. A painter was among friends in an artists' café, and he began absent-mindedly sketching a woman tourist at a nearby table. Her husband saw what was happening and said angrily that he had not given the painter his permission. The artist defended his right to draw whomsoever or whatsoever he pleased.

> 'Well, what are you going to do with it now?' the man demanded.
> 'I haven't thought about it.'
> 'Would you sell it then?'
> 'Yes, if you want it.'
> 'How much?'
> The artist considered for a moment, then named an outrageous sum.
> 'What? For that bit of paper?'
> 'That's my price if you really want to buy it.'
> 'All right. Here's the money.'

The artist gave him the drawing and the husband immediately tore it into tiny fragments, whereupon the artist did exactly the same with the money in his hand and threw it into the husband's face.

This is the kind of story that chimed with his image of a true artist – proud and impoverished. Suffering for art was something Nemon easily identified with. He would tell a story of an art student in Paris who was too poor to be able to afford heating in his icy garret where he modelled his statues. One night the intense cold woke him up, and he was terrified the water in the clay might freeze and expand, causing the statue to disintegrate. So he heaped all his bedclothes on to it and, in the morning, was found lying beside his shrouded statue frozen to death.

Nemon thought a great deal about artistic styles and movements. For instance, when he and Jessie Stonor travelled together to France to visit the 1937 World Fair, he was not impressed by the Soviet Pavilion.

Inside the building was the epitome of mediocrity, with everything second-rate and banal. The pavilion was a clear confirmation of the death of artistic expression, and one did not need to walk far to find another example of the breath of destruction that is the usual gift of a totalitarian regime to the artist. Next door was the German pavilion, and here the only difference was in a section devoted to machines of destruction. There was a total absence of artistic expression. On leaving the fair I asked myself whether state control inevitably brought about such incredibly uninspired results. I had taken considerable delight in exploring the national differences of the various pavilions, noting the way in which each country expressed its own hostility and rivalry and undercurrent which was to grow more and more pronounced and which was to culminate in the Second World War.

My father had undoubtedly been influenced by the contrast he observed in the art displayed in the Soviet pavilions first in 1925 and then in 1937. He admired the earlier work but believed that 'the casual onlooker was out of his depth in a breadth of vision and execution beyond his comprehension'. For him Socialist Realism, no less than the kind of fascist art that was acceptable to the Nazi regime, was a betrayal of the first idealistic impulse. The questioning of how an artist relates to a totalitarian regime – and the regime to the artist – remained, of course, a lively one from the early days of the Soviet Union through the years of Hitler and Stalin (and the latter's heirs). Nemon was no exception in wrestling with its implications. He wrote in his memoir the story of Count Troubetskoy who became Director of the Moscow Academy of Art in the early days of Bolshevik rule.

Students flocked in their hundreds to enrol. An enormous weeding out was necessary. And, as a preliminary test, each candidate was asked what he would choose to draw for his entrance examination. Seventy-five per cent expressed no preference, saying that they would draw whatever they were given, and they were eliminated without further consideration. Independence of thought and individuality of approach were highly praised in those early days of Soviet society, but, with the development of the Socialist State over the years, this was gradually suffocated.

All his life Nemon stuck to his preference for independence of thought and individuality of approach, just as from his earliest years he consistently conceived of himself as a breaker of traditions, at the same time identifying with the modernists' reverence for the primitive. He admired Picasso and his 'primal Negro vision' and Matisse, who 'brought in the influence of Moroccan folklore'. 'There was outward chaos,' he wrote in his memoir, 'but it was a chaos of beginnings. The modernists and the ultra-modernists – the "crazy ones" – created the most abstract and formless shapes, and this was a characteristic common to all peoples interested in the arts.' The role of the artist in the world, he believed, was 'unity for all men'. The idealist in him never gave way to the cynic, however dire the circumstances in which he – and the rest of the world – found themselves.

That is not to say he neglected craftsmanship. On the contrary, he almost obsessively moulded and remoulded his clay figures to the point that he could barely bring himself to finish a work . . . certainly on time. He was a perfectionist. He saw himself as 'imitating God', using clay for the 'fashioning of man'. His encounter with Sigmund Freud reinforced his belief that he was following the oldest profession of all. He wrote in the preface to his memoir:

> I suppose there has only once in the history of all mankind been one really successful imitator – God's own son, Christ Himself, as there is a story in one of the apocryphal Gospels of how, as a child, Christ made birds out of clay and when He clapped His hands they spread their wings and flew away.

I have, of course, my own memories of my father's encounters with clay. Its wet smell and the powdery whiff of plaster of Paris take me back to his studio on Boars Hill when I was a child. I would often stand and watch as he mixed the plaster of Paris with water to the consistency of thick cream. This was then put on to a clay bust, which was the first stage of making the mould from which the plaster head would be cast. He used to flick the plaster on to the clay head, waiting for it to set a little before he added more plaster. When his hands weren't covered in clay they were covered in white plaster.

Nemon sketching Lady
Churchill at her home
in Hyde Park Gate,
London, 1964

Nemon with the future
Israeli Foreign Minister
Abba Eban, 1946

Above

Teddie Beverley, one of the famous singing Beverley Sisters, posing for Nemon in his Pimlico Road studio, 1960s

PHOTOGRAPH BY FALCON STUART

He always asked his sitters for a great many sittings, as he needed to get the feeling of their character. He often asked my brother to take photographs of them and would refer to these often – many of Falcon's photographs are still covered in clay. For the more famous people Nemon would tear pictures out of magazines and newspapers so that he could get a good idea of what they looked like in different situations and would visit photography libraries of newspapers and buy any prints he found useful.

Before Nemon started his busts he sketched his sitters and took measurements of their heads, which he recorded on a drawing of them. If he was making a bust smaller or larger than life size he would measure his sitter's face with calipers which could reproduce the exact dimensions in a different size.

His first bust of a new sitter was often made in Plasticine, the size of a tennis ball stuck on to a wooden stick. This little head was very transportable and meant that he could take it along when he visited his subjects in their own homes.

In one photograph Nemon is working on a small head of Abba Eban, the future Israeli Foreign Minister in 1946. When I met Eban's widow Suzy in Israel she told me how much she liked the finished bust, which is now in the Foreign Ministry in Jerusalem.

My father also made a small head of Teddie Beverley, one of the famous singing Beverley Sisters, in his Pimlico Road studio.

After making a Plasticine head he would make a larger, often life-size head out of clay and work on it in his studio where people would come for sittings. These clay heads had to be kept wet. If they dried out they were impossible to manipulate

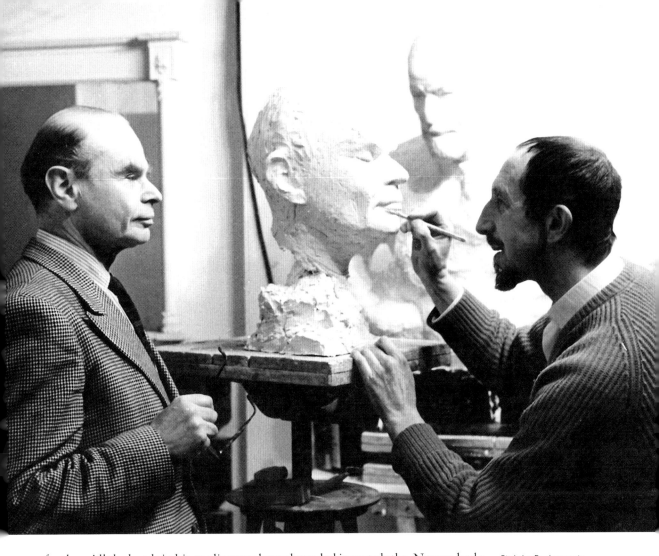

further. All the heads in his studio were kept shrouded in wet cloths. Nemon had a large dustbin of discarded clay heads which had dried out, rather like after a busy day at the guillotine. He would reconstitute the clay with water when he needed to.

When my father sculpted the Queen he worked in the Yellow Drawing-Room in Buckingham Palace, and when he sculpted Churchill he worked at No. 10 Downing Street. This meant that his most eminent or important sitters did not have to waste time travelling to his studio.

Nemon would work with his hands to make small adjustments to his clay busts, but he also had a great many tools he would use when he wanted to make larger alterations to his works. Once he was satisfied with his clay head he cast it in plaster, a messy activity I enjoyed helping with as a child. But he was not always happy with the plaster cast, so he would alter it either by sticking little bits of Plasticine on it or scraping away elements with one of his tools.

When at last the plaster bust was deemed to be finished – or people were breathing down his neck because an unveiling was imminent – the bust or statue was taken to a foundry to be cast in bronze.

Some of this administrative work was shared with my brother Falcon. Although Nemon consulted him a great deal, liked to have him by his side even when travelling and involved him in important decisions, Falcon did not find it easy, mostly because Nemon never thought of his commissions in financial terms – constantly over-running and destroying any small profit margin he had managed to negotiate.

Nemon retained a kind of semi-religious view of the sculptor-artist, the fashioner of men. Sir John Rothenstein, the Director of the Tate Gallery, wrote in his memoir that Nemon was 'one of the very few living academic sculptors able to infuse life into their creations'. His mission was to create not just an image but an essence, a truth, and Nemon was generous in imbuing others with the secrets of his art.

The Irish-born abstract sculptor John Gibbons produces works with complex forms and shapes that are both allusive and full of implicit drama. In 1971, while still a student at Cork School of Art, he was taken on as an assistant in Nemon's London studio and worked there for four years. He told the writer Paul Moorhouse that he regarded his training as a crucial stage in his development.

Below left
Sir Martin Charteris in the garden of St James's Palace with some of Nemon's works, including the legs of Field-Marshal Montgomery.

Below right
Nemon and Sir Martin Charteris discuss Nemon's bust of Queen Elizabeth II

Nemon gave Gibbons a grounding in the traditional skills of the sculptor. In addition to making armatures and modelling figures in clay, he also learnt carving, casting, mould-making and enlarging. In many ways Nemon was a tough taskmaster, and the demands he made on Gibbons to sharpen his visual sense were exacting. Through Nemon, Gibbons came to appreciate the importance of detail. One of his tasks was to undertake the modelling of certain areas, such as hands, drapery or decoration. From the beginning he was made to realize that detail had to relate harmoniously to the entire sculpture. Each small element had to express

the overall character of the piece. He also understood that attention to detail was not an isolated or subsidiary activity but opened up ways of exploring a subject.

Nigel Boonham was Nemon's assistant (paid £1 an hour) for two years from 1977 to 1979. Nemon had some money from the Field-Marshal Montgomery statue and was able to afford to pay for long-term help for the first time. Boonham was as much a biochemist as an artist when he first applied, running a project that involved amino acids at the Maudsley Institute in south London at the same time as attending a sculpture course at Woolwich Art College. At first he was keen on welded abstractions but turned to modelling heads of great medical figures from the past, such as William Harvey. His teacher John Rivera suggested he apply for the job as Nemon's assistant. 'I was told to take away a bust of Kathleen Ferrier and work it up. But I thought it was already a fine piece, so I just tinkered with it. When I took it back, Nemon thought I had done a brilliant job.' The only other applicant was given a far harder task of doing a new life-size bust but decided to do one twice as large; the young man was rejected (Nemon had perhaps forgotten that he had done much the same thing with the sculpture he was made to do in his first days as a student in Brussels).

Boonham remembers the first time he went to the Friary Court studio in St James's Palace – in 1968 Nemon had acquired the right to use this studio

The former Prime Minister Harold Macmillan in front of Nemon's busts of a Nigerian couple in 1977

PHOTOGRAPH BY FALCON STUART

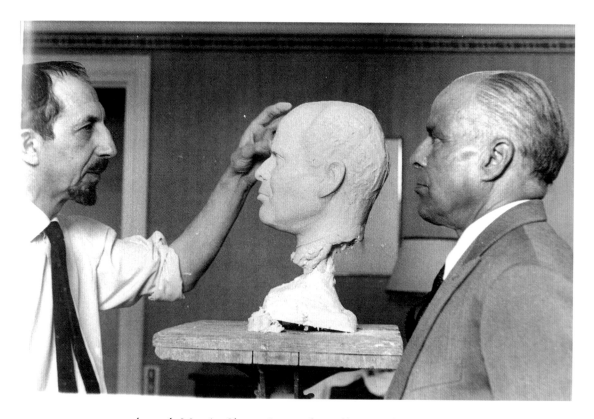

President Habib
Bourgiba of Tunisia
posing for Nemon in
the 1960s
PHOTOGRAPH BY
FALCON STUART

through Martin Charteris, another of his pupils, who was Private Secretary to the Queen. 'It was a huge space but rather damp. There were only a few pieces visible. Many others were hidden away behind a curtain – it was only near the end of my two years that I got to see them at all.' It was hard, physical work. Nemon liked to use heavy brown clay – gault clay – from a field near Farnham in Surrey. Boonham's job involved working on all the stages of the complex process from modelling (using Plasticine as well as clay) to casting and preparing for the foundry. He would take photographs, make detailed measurements, strike poses and run errands.

Mostly there was a constant stream of new heads and busts to work on – including those of a Nigerian couple (never finished because never fully paid for) and various courtiers and officials (in the ultimately unsuccessful hope of currying favour to let him keep his 'royal' studio). And it was during this time that Nemon modelled his bust of Margaret Thatcher.

My father tried to persuade an attractive American woman he met at dinner at Edwina Sandys' house to sit for him in the nude. Susan Donnell remembers the occasion well.

The charming stranger sat next to me, and I enjoyed his wit and humour. It was not until after dinner that I found out I had been entertained by the famous

sculptor Oscar Nemon. The next morning I was really surprised when Mr Nemon called and said he would like to sculpt me. I liked the idea immediately. I liked it even better when I found that I was to go to his grace-and-favour studio in St James's Palace and park my shiny new car in the courtyard. I loved the studio that opened out into the Queen Mother's garden. But, most of all, I was dazzled by the marvellous heads of the outstanding men in the world that filled it. One threaded one's way carefully past Eisenhower, Churchill and others to the end of the room where a chair was arranged so that one could look out to the garden and admire the trees that King Charles had planted the year before he lost his head in 1649. Oscar immediately made one feel at ease. An hour's sitting went by in a flash filled with his amusing stories and interesting titbits about his famous clients. About halfway through my sitting I asked why there were no women's heads in the studio. He said he had a few but he found that for the most part women's features were not as defined as men's. 'But', he said, 'I will have some out for you when you come in next time.' When I walked in ten days later lined up at the working end of the studio were, in the following order, Lady Thatcher, the Queen Mother and Her Majesty the Queen, all very handsome and lifelike.

But my father had another agenda in mind, as Susan Donnell recalls.

Field-Marshal Montgomery with Nemon, 1970s
PHOTOGRAPH BY FALCON STUART

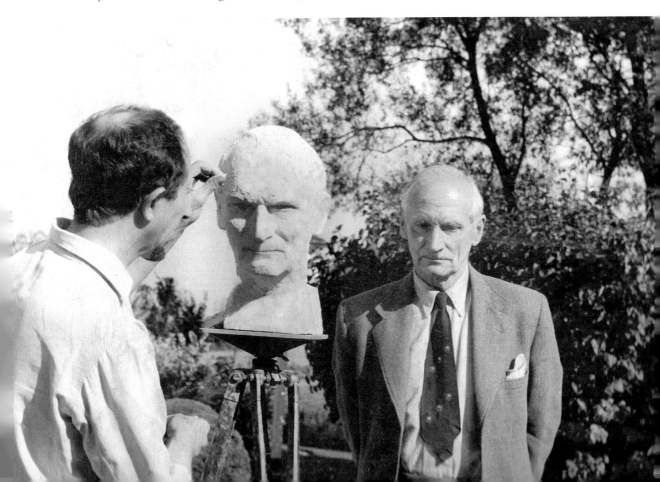

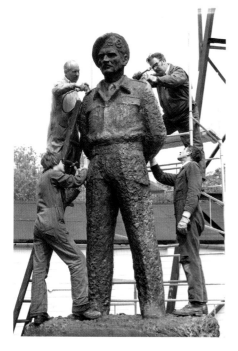

Workers at the Morris Singer Foundry, Basingstoke, put the finishing touches to the statue of Field-Marshal Montgomery.
PHOTOGRAPH BY DAVID A. BERNE

Towards the end of my sitting Oscar said he had not done a nude for a very long time, and would I consider sitting for him. I had been highly flattered to be chosen to sit for him – and it would be a nice thank-you, but I couldn't bring myself to oblige, so I declined. Ten days later he suggested that I be photographed and that he could sculpt me from that. I said I hoped he would understand but that I would still feel uncomfortable about it. Oscar did not give up easily, so he asked if I were photographed in a bikini, would that be feasible. We agreed on this, and a very lovely reclining statue was done. I took it home. My husband liked it, but what about my mother arriving shortly from Virginia? She was very conservative. My mother's first reaction was astonishment, but I explained that the figure had been done by England's most famous sculptor and that it was a fine work of art – I added, 'and of course basically it is really your work of art!' We collapsed in laughter, and she admired it ever since.

The Montgomery commission was also one that Nigel Boonham was employed to work on – although only rarely. It was a job, however, that put an end to his work with Nemon. Once my father asked him to make a series of five heads – and promptly 'ruined them all'. This was the last straw for his young and somewhat put-upon assistant. 'Good enough' was not acceptable to Nemon. He could not bear to think that his work would be anything but 'perfect', at least in his own eyes. This led to endless agonizing and constant reworking. Deadlines were always in danger of being overrun – and indeed were overrun. For Nemon, this was the price a true artist had to pay. For his assistant it finally got too much to bear, although Boonham, now a successful portrait sculptor in his own right, is to this day in awe of Nemon's genius. 'He was above all an idealist. He wanted his portraits to tell the true story of his sitter. He admired narrative sculpture, especially ancient Egyptian.' Of the large seated statue of Sigmund Freud, Boonham later wrote, 'Here is the Platonic reality, a man's psychic presence distilled with great clarity in inanimate physical bronze.'

This is in essence what Nemon never stopped trying to achieve. Sometimes his subjects found it hard to recognize the truth of what he had done. The French psychiatrist and psychoanalyst René Laforgue wrote in 1955, reflecting on the bust Nemon did of him in the 1930s (and now in the Fondation Martin Bodmer in Geneva), 'It is funny to see a sculptor take possession of your head, making it look naïvely in the air, slightly inspired. And then having to pretend that this head belongs to you. I don't recognize myself in this masterpiece. Yet Nemon made

the best portrait ever of Freud as well as the one of Churchill. Maybe I am not connected to myself? Who knows . . .'

Perhaps the contribution to the art of sculpture that was most peculiar to Nemon was the identification of artist and psychoanalyst. Even before he met and befriended Sigmund Freud he had shown this ability to see into and interpret the inner person. Many people who met him casually, without knowing what he did, assumed that he was a psychoanalyst – partly from the way he looked outwardly, his gestures, his manner; partly from the way he looked deep into people, as if through their eyes into their mind, an effect that was almost hypnotic, reinforced by his soft, accented voice. His sculptures were as much an identification as a representation.

The statue of
Field-Marshal
Montgomery in
Whitehall, London,
unveiled by the Queen
Mother in 1980

Patricia Villiers-Stuart
aged twenty-six in 1936

England 6

WHEN VOLTAIRE FLED from authoritarian Europe to breathe the fresh air of Anglo-Saxon freedom he could scarcely have felt less liberated than my father did when he first embarked on a journey across the English Channel. The unpleasantness of the social and political life in Brussels – not least its simmering anti-Semitism – was beginning to get him down. I can find no evidence he was actively persecuted, but even at the level of professional jealousy – who is this Jew insinuating his way into royal favour? – life in Brussels was clearly becoming less and less attractive. And then circumstances conspired to make England – by which he understood, at the start at least, London – the destination of choice. I cannot help thinking, however, that if he had happened to come across Jacob Epstein he might well have been more aware of the treatment, a generation earlier, meted out, even in 'liberal' Anglo-Saxon culture, to rebellious and pushy Jewish sculptors.

Nemon made a first short trip across the Channel to England in the autumn, or possibly August, of 1935. Simonne and her new husband David Dear were just moving in to 11 Lyall Street, and he probably stayed with them. He wrote to Simonne on his return to Brussels in early November, anxious to finish a bust of the Princess de Mérode that had already taken him a month and a half, saying he had been happy to see their 'joyous little newly-wed life'. In his next letter he said, rather ambiguously, 'I must leave Brussels to achieve my aims.' It is not clear if he was referring to potential commissions or the even more pressing need to escape his debts. In yet another letter to Simonne – their correspondence was always frequent and at this point in their lives positively compendious – he referred to a lucky escape while he was in London from being attacked in the night by 'some ex-Army officer', adding that he would explain all this in person. It might well have had to do with an attempt at forcible debt collection, because in the same letter Nemon made a list of the amounts he owed and mentioned his fear of 'imminent catastrophe' and the 'darkness that surrounds me'. Or perhaps his urge to flee Brussels had something to do with a woman called Marthe and their 'grotesque and contradictory situation' – a dilemma he never explained; it is a hint of another romantic excursion.

Nemon with his sculpture of Wickham Steed, the editor of *The Times*, in 1936

His gloomy mood had changed by 6 December when he wrote to Simonne about the 'terrific reception' of his bust of Dr Wahrweger. He wrote with some pride that the reception 'transformed the occasion into a spiritualist seance, trying to persuade us that the late president was still in the room'. This acclaim prompted a bout of optimism. 'Actually I love life,' Nemon wrote. 'I understand pain and joy. But my temperament does not let me get too ecstatic and I contemplate life as a happy observer. All in all, I am rootless and find my vital elements in the complexity of the circumstances. Like all anxious people I am interested in the future and admit like all of them that anxiety is a most precious commodity because it makes us hope and hope brings life.' And on that note he rushed off to Basel, Zagreb (where he had a 'black-out' that he put down to his disorganized and frantic life), Belgrade and finally Vienna, where Freud had agreed on more sittings.

At the end of February 1936 Nemon was back in London, writing from the Mount Royal Hotel. This is the time he must have contacted Dr Ernest Jones, the psychoanalyst and friend of Freud, because they needed to come to an agreement

A clean-shaven Nemon with his bust of King Albert I of Belgium in England in 1936

over the money Nemon would receive for his bust of Freud. Dr Jones thought £200 excessive, and Nemon suggested maybe he could throw in a medal or small head to make up the difference. Jones was soon to prove an important intermediary who, unwittingly, later determined the course of Nemon's private life and was responsible for my own existence.

Meanwhile, during one of these early cross-Channel sorties Nemon met the historian and former editor of *The Times*, Wickham Steed. My father knew barely any English but managed to complain to Steed that small boys 'bleating like goats' would follow him in the street wherever he went, making him wonder, 'Where is this English politeness I've heard so much about?' Steed gave him what he considered an unsatisfactory answer, that they were just 'high-spirited kids', but Nemon felt hurt and insulted. Next time he came to London he shaved off his goatee beard in the train, and once off the train at Victoria Station he managed to walk about undisturbed – 'no bleating!' Shortly afterwards he was invited to dinner by Steed. As Nemon recalled in his memoir:

> As I entered his drawing-room he came towards me with hand outstretched, then took a good look at me in the light. His hand dropped and he uttered the one word: 'Coward!' I found this incident very revealing, and I began to understand the depth of English respect for non-conformity and personal integrity. ['Coward' because the beard had gone.]

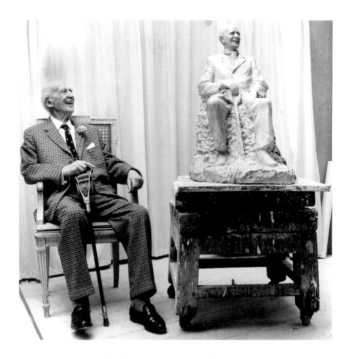

Sir Harry Brittain aged
one hundred in 1973
PHOTOGRAPH BY
CHARLES EDRIDGE

Nemon took this criticism to heart as he was a non-conformist with an obstinate streak of integrity. His bust of Wickham Steed was his first commission in England, and a letter to the Home Office in early September 1936 confirms that he had been working on the bust in Bournemouth at the end of August. He also arranged to do a relief head (in front of a microphone as if making a radio broadcast) of Sir Harry Brittain and was later to do a statue of him in the early 1970s. Another pre-war commission was a bust of Irene Ward who was, like Brittain. a Member of Parliament.

Sir Harry's daughter Alida Harvie wrote that in October 1936 her father was 'sitting for his first bronze sculptured likeness being undertaken by Mr Oscar Nemon, then newly arrived from Yugoslavia, now at the top of his profession . . . My father was eventually able to help this gifted young man to achieve British naturalization.'

Despite these commissions and connections this was a tentative and uncertain time in my father's life. With hindsight, it seems he was wise to escape from the dangers of being a Jew in Nazi-influenced warmongering Europe. In fact, I believe he was floundering, tempted by the bright lights and new challenges offered in England but travelling back and forth to his Brussels haunts, where his studio was still full of his work, including the massive *Bridge*, and also travelling to Yugoslavia and Vienna, attracted by new friendships and lovers, trying to follow wherever his talents might lead him to fame and fortune.

A rare element of stability was the studio Simonne and David Dear created for him in their Lyall Street house. In October 1936 Dear wrote to the Home

Office to support Nemon's application for a residence permit in Great Britain. His Yugoslav passport had already come under scrutiny when he landed in Dover on 30 July three months earlier, declaring himself to be a student and claiming that he had £100 in an English bank account. He was warned not to try to work until he had Home Office permission. Thus was his file opened in the Aliens Department, where he was registered as 'N. 2072'. This number was to recur again and again in the files of the Home Office, of the Metropolitan Police . . . and, in due course, the files of MI5.

Nemon's problem was not first or foremost a professional one – although

Patricia aged five with her father Lieutenant-Colonel Patrick Villiers-Stuart, her mother Constance and her grandmother Frances Fielden at their home in Norfolk, 1915

he was constantly haggling with the authorities over extensions to his permission to stay in his newly adopted home. What brought him under close scrutiny and almost caused him to be deported (an action that in the autumn of 1939 could well have proved fatal) was his relationship with a woman. This was Patricia Villiers-Stuart, sole heiress to a substantial Norfolk estate, the only daughter of an Anglo-Irish aristocrat. She would become my mother and, eventually, his wife.

She was born in 1910. Her father, Lieutenant-Colonel Patrick Villiers-Stuart of the Royal Fusiliers, had married Constance (Connie) Fielden in 1908. Connie's parents, who by then had settled in Norfolk, were from a prosperous Quaker mill-owning family, and Patrick was from an aristocratic family from County Waterford in Ireland. Connie was in her early thirties and would inherit Beachamwell Hall and its estate. Patrick, however, as the sixth son, would inherit little.

Shortly after my mother's birth Connie set off to India to join her husband, whose regiment had been posted there. The infant Patricia was left at home with her grandmother and nanny who turned out to be both neglectful and addicted to alcohol. Connie's great love was garden design, which included advising Edwin Lutyens on the design of the garden for Government House in New Delhi. While in India she wrote the defining work *Gardens of the Great Mughals*, which she illustrated with her own fine watercolours. It is important to reflect on the single-mindedness and strong personality of my grandmother. A marriage that brought money and social class together gave her the opportunity to develop her

Patricia Villiers-Stuart
aged twenty

artistic skills at the highest level and a Victorian attitude to leaving her infant for some three years. She was a formidable woman who, in an unheard-of move, even made a private – indeed intimate – visit to her husband in Salonika in the middle of the Great War. Throughout her life she took no prisoners. It is against this backdrop that the beautiful and gifted Patricia came out as a débutante in 1927.

The first meeting between the impoverished, charismatic Yugoslav-Jewish artist and the rebellious, highly strung and intelligent lover of art (and artists) took place as a result of their each receiving an invitation to a party given by the Freudian psychoanalyst Dr Ernest Jones, whose connection with Nemon was Freud. As for Patricia, she was his patient. The precise date of this party is unknown.

What is certain is that it followed very soon after her 'nervous breakdown' – an incident where she suddenly began imagining all the blood was draining out of her body. Since she was at the time travelling in a rich suitor's Rolls-Royce to Scotland for the opening of the shooting season, the date must have been around the 'glorious twelfth', in other words early August 1936. The first surviving letter from Patricia to Nemon dates from late November that year. Somewhere between those dates Dr Jones invited his patient, still groggy presumably from the sleep therapy he had prescribed for her, to attend a party he was hosting – possibly overstepping the professional barrier between a doctor and those in his care.

The effect that the softly spoken, tousled-haired artist with the penetrating eyes and gentle touch had on this young woman's highly strung, brilliant but susceptible mind was instantaneous – and so powerful it never left her for the rest of her life. But for Nemon, although the attraction was there, it would seem that he was more aware of the inconvenient side to their romance; his attention was otherwise engaged, and he was a little alarmed by the intensity of this new young woman's attention.

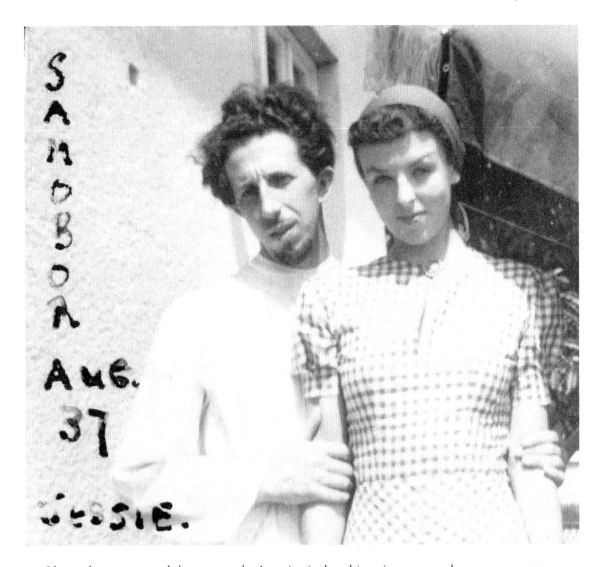

I have always assumed that my mother's main rival at this point was another young, beautiful and intelligent member of the English upper class, also attracted to the arts and to Nemon in particular. She was Jessie (or Jess or Jessica or even Peggy to her family) Stonor. Jessie was the second daughter of the second son of the Lord Camoys of the day. She was born in the same year as Patricia, 1910, and brought up with her cousins at Stonor Park near Henley. She married a deep-voiced actor called Valentine Dyall. After the marriage broke down she lived with Nemon for a short time in 1937, even though Patricia and Nemon were certainly lovers by then.

I do not know whether he met her first and Jessie afterwards or the other way round. What is sure is that Nemon was both attracted to but also wary of Patricia. Her love for him was intensified by the satisfaction it gave her that her conservative (and overtly anti-Semitic) parents were appalled by her

Nemon with Jessie Stonor in Samobor, Yugoslavia, in 1937

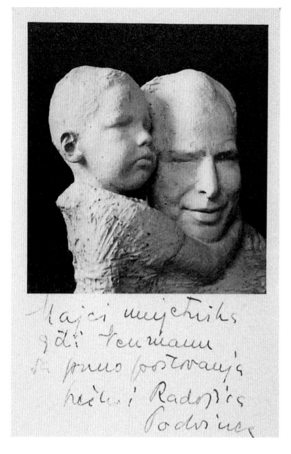

Nemon's ear surgeon, Dr Srećko Podvinec, with his son Radojica, 1938

rebelliousness. Her arranged suitors had all been from the upper echelons of society, designed to follow their own example of blending blue blood with the more solid advantage of wealth. She had, after all, 'come out' as a débutante at considerable expense. While she had her own artistic leanings, these took second place to her mother's ambition to marry off her daughter well.

Jessie's appeal to Nemon was deeply intertwined with their common love for sculpture. It is probable that they first met when Jessie came to an exhibition of the artist in London – or at least made a visit to his studio. Or perhaps they met in the studio of Princess Louise in St James's Palace. She appears to have done a small model (letting 'her idle fingers play with a lump of clay', according to a press interview she gave a couple of years later), which was admired by the more experienced artist – 'Good gracious, you've got talent' was my father's reported reaction. 'So she went to Jugoslavia and studied sculpture under Nemon.'

They stayed a month, visiting his mother, brother and grandmother Johanna Adler, and staying in the pretty hilltop town of Samobor, near Zagreb. They caused a sensation with her trousers and other Western European styles. This was the time when Nemon had an excruciating ear infection. Before the days of penicillin (its imminence was about to play a major role in his and Patricia's life) there was no alternative to an operation. Luckily an old friend from Osijek, Dr Srećko Podvinec, an ear, nose and throat surgeon, was available, and so he operated on the diseased mastoid and Jessie nursed Nemon back to health.

The busts Nemon did of Dr Podvinec and his young son Roy were almost certainly done to pay for – or partly pay for – the operation. He wrote to Simonne to tell her about it.

I have finally learnt the reason for my troubles and to my stupefaction I have to submit myself to the surgeon's knife. Towards the end of the month at the latest an operation on my right ear will have to be done. Our best surgeon would like to take charge of this seemingly difficult task. The treatment will last six weeks after the operation of which fourteen days will be spent in bed at the sanatorium.

The whole procedure will be very expensive and up till now I have half the money, 10,000 dinars or £45. For the other half, I have to say, I'm in the dark. Marie Bonaparte has asked me to make a little statue of her for which she will pay me 10,000 French francs, and she has already given me half. At home money has become short, and there I am a little bit disappointed as to my operation. But I am not desperate. Take nevertheless your winged horses and you will perhaps find me some gold, if not do you think I might count on something towards the end of the month. Do not alarm yourself on my behalf. If you don't manage anything within the limits of your possibilities, then so be it!

Patricia has written several times to me. What shall I do? Jess is at Samobor an hour away from Zagreb where she is working quite well but has no money.

Sincere greetings to your husband as well and I remain faithfully

Your Ténèbre

Patricia's letters to her lover when he was in Zagreb and Belgrade with Jessie were indeed getting desperate. Patricia got to know Simonne Dear quite well and confided in her. In June 1937 she wrote, 'Could you possibly be very kind and tell me if you know his whereabouts and also his home address. I wrote to him that I'd be able to come to Zagreb when I leave here [Salzburg] in the middle of July, but I suppose he doesn't think that a good plan . . . I'm just so miserable.' At some later point, possibly as early as the autumn of 1937, she wrote to 'Dearest Simonne' that 'I know I could only belong to Némon, whether he has any use for me or not . . . I would be interested to hear if you have any news of this cruel Némon!'

All this time Nemon and Jessie were becoming more and more obsessed with each other. Jessie's diary for 1938, which survived stuffed with letters from him, photographs of the pair of them, notes and telegrams and newspaper cuttings, opens with passionate and explicit letters from her lover in Paris (staying at Le Royal Hotel while he was sculpting Princess Marie Bonaparte and her dogs); while her diary entries complain of loneliness (in her new, cold, unfurnished flat in Joubert Mansions in London's West End), his letters speak of 'burning myself on the ardour of your body'. He signs himself with loving but semi-nonsensical names such as 'Rigolo Gigolo' or 'Mix, Max and Minimax'. In the spring she compares Nemon favourably – he is 'incredible, a genius and a darling' – with various 'dreary' and 'conceited' suitors and 'ugly' or 'vain' members of her family and London high society. In July 1938 he wrote to his 'brave little girl' in a mixture of French and German, sending kisses from her 'good boy' and from his family, of whom Jessie was fond. She was soon on her way to Zagreb to meet them all.

All the same, it was Patricia who seemed to have the real measure of the lover they shared. My mother was an extremely intelligent woman, clever and shrewd enough to see exactly the kind of man she was taking on, a man who was never

going to be a conventional or even a faithful companion. Jessie was less willing to forgive, turn a blind eye or understand Nemon's need to go his own way when he felt like it. It was Patricia who would eventually capture her man – but the net she used had many cunningly contrived holes in it, enabling him to escape but also to return.

Nemon had met his match. For all his wanderings from place to place, whether it was a dank studio or camping out with friends or hotels abroad, he kept over a thousand of Patricia's letters from the late 1930s to the 1960s. She wrote beautifully, in pencil with a neat, easy-to-read hand. She used, at the last count, eighty-seven different salutations, and similarly she signed her letters according to her mood. He often used the envelopes to draw sketches on and jot down appointment times. Many letters were over 4,000 words long. The record was 7,500. There were three early letters which, when the letter was removed from the envelope, white plaster of Paris spilt out. Nemon was obviously reading them while modelling.

Their physical love was especially intense in the 1940s, Nemon being, as she wrote, my 'one really enjoyable bed activity'. There was a touching comment on one letter from Patricia saying how strange it was not to have a Sunday with him, no one to read the newspapers with. When he had a London studio he usually returned to Oxford at weekends whenever my mother was there. But was Patricia in Oxford all the time, while Nemon was in London during the week, going to Oxford at the weekends? If so, why was he not there on Sundays?

Her letters were far more than just love letters. Although they carried the intensity of separation, they were the forum where Patricia laid out her ideas. She was exceptionally well read, devouring and criticizing Jung, Freud, Federn, Beregson, Morrish, Ouspensky and a hundred more. Reading these letters, one is constantly running to the internet for help. Although she kept none of Nemon's letters, one has somehow survived. His salutation is 'my very beloved Enlightener'. This perhaps tells us a great deal about their relationship. In many ways the couple were pushing against conventional thinking, feeding off each other as intellectual sparring partners. While I am not sure to what extent Nemon responded in kind, he did open his heart to Patricia, who took great strength from it. She gave him an unshakeable base, an intellectual equal who may have helped him come to terms with his inner conflicts . . . and a home with children. She also coped with her very difficult mother, although it did affect her health, as well as grasping the reality of an impoverished life at Pleasant Land.

Meanwhile, in the late 1930s Nemon's position as a foreigner in England was becoming increasingly precarious – although he was as yet unaware of this. At this stage he had no inkling that high society was his enemy. Indeed, during his time in Britain high society was to be both a threat to his existence in the country

as well as a source of his income and reputation. Files from the Home Office, the Metropolitan and Berkshire police forces and MI5 reveal a story of conspiracy – and cock-up – that might have provided a script for an adventure with Peter Sellers as Inspector Clouseau if it hadn't been potentially fatal for my father.

His persecution began in September 1938 when a letter from a firm of London solicitors was received by the Home Office. A minute dated a couple of weeks later reads:

> Call. 5th instant. Mr Hugh Farrer regarding this alien who is now residing at 20, Jubilee Place, S.W.3. Messrs. Farrer and Co. have been approached by Col. Villiers-Stuart, D.S.O., whose only child, a daughter of twenty-four years of age, appears to have become infatuated by Neumann. Neumann is said to fascinate a certain type of woman and has lived with a number of women since being here. At present he is said to be living with the wife of an actor. Col. Villiers-Stuart is said to be worth between £50,000 and £60,000, all of which will go eventually to his daughter, and he fears that if Neumann becomes aware of this he might entice the daughter into matrimony.
>
> The difficulties of dealing with such cases were explained to Mr Farrer. It would appear difficult to take any action – the stay of Neumann has been extended until 5.6.39 unless it becomes evident that Neumann is living as a parasite on women.
>
> An intercepted letter from Neumann to Miss Villiers-Stuart suggested that they should go together to Paris for a holiday.
>
> We might get some information from the Immigration Officer if we ask him to examine Neumann thoroughly when next the latter returns to the United Kingdom.
>
> Messrs. Farrer are placing their case before us in writing.

Nemon with his bust of Harold E. Norman in Dulwich, London, in 1938
© THE NORMAN FAMILY

The suggestion that Nemon might marry my mother for her money was absurd; not only did he go out of his way to avoid such a commitment he was not interested in wealth other than from his own skills as an artist.

On the last day of October a Mr C.B. McAlpine wrote to Messrs Farrer in Lincoln's Inn Fields that he was 'directed by the Secretary of State to say that he regrets that he does not feel able to take any action in this matter'. It would appear that the plotters had fallen at the first hurdle . . . but, undaunted, they got up and carried right on.

Nemon showing Madame Jean Guiotte her bust at his exhibition in the Galerie Manteau, Brussels, 1939

Nemon meanwhile was carrying on with his work, regardless and unaware. In December 1938 he was negotiating sittings in London with Harold Norman, a pioneer of the probation service who looked after Max Hevesi's son. Sadly, this bust appears to be lost. The following month Nemon held an exhibition of his work at the Galerie Louis Manteau on the Boulevard de Waterloo in Brussels.

He still kept good relations with the Yugoslav government, because the exhibition, which opened on 21 January 1939, was announced as '*sous le patronage de Son Excellence M. Branko Lazarevitch, Ministre de Yougoslavie*'. In March 1939 he was sculpting the Earl of Feversham, who was not only Minister of Agriculture but a trustee of the Clark Hall Fellowship (a probation charity) of which Harold Norman was secretary. Nemon was always a good networker.

After a delay of six months and roughly coinciding with Nemon's need to renew his residence permit, the high-society plotters came back on the offensive. On 25 May 1939 Farrers wrote again to the Home Office 'For the attention of Mr Ernest Cooper, the Under-Secretary of State'. They reminded him of their first letter 'giving such particulars as our Client, Colonel Patrick Villiers-Stuart had regarding a Yugo-Slavian Jew, Oscar Neumann'. They said they now had further information that they wished to 'communicate to you if possible with a view to the permission at present given to Mr Neumann to reside in this country in future being refused'. They asked if Mr Hugh Farrer could come in person to 'lay this information before you'.

Ten days later Nemon – unaware that his being a Jew might have anything to do with his case – reapplied for an extension, giving David Dear again as a reference and repeating his plea that he was a 'creative artist therefore not running into competition with anyone . . . I have several orders on hand which I especially wish to terminate not wanting to cause disappointment.'

exposition
O . NEMON
du **21** au **31 janvier 1939**

*L'ouverture aura lieu samedi le 21 janvier, à 15 h.,
sous le patronage de Son Excellence M. BRANKO
LAZAREVITCH, Ministre de Yougoslavie.*

*En semaine de 10 à 12 1/2 et de 14 à 18 heures.
Le dimanche de 10 1/2 à 12 1/2 heures.*

GALERIE LOUIS MANTEAU
62, Boulevard de Waterloo, Bruxelles - Tél. 12.75.46

Exhibition catalogue,
Galerie Manteau, 1939

Poster for the Galerie
Manteau exhibition

Then on 13 June an anonymous official at the Home Office minuted another phone call made by Hugh Farrer, this time reporting a call to the solicitor from Colonel Villiers-Stuart himself with news that he had heard that Neumann 'was contemplating returning to Zagreb to arrange for his mother and sister to go to America. On a previous occasion when Neumann left the country his daughter Patricia had given him £100.' The Colonel said he was afraid that all her money 'will find its way to Neumann'.

The submission is that Neumann has used his artistic abilities to influence Miss Stuart and other young women interested in 'art' and she and they are lending or paying him money for his association.

Col. Stuart is very concerned for his daughter and is convinced that Neumann is an adventurer and ought not to be allowed to prey in this country.

Mr Farrer understands very well that the Home Office could not ask the man to go on the information at present known, but would welcome further inquiry, provided Col. Stuart's name is kept out if his daughter is approached.

The family had a second barrel to fire. This time it was Brigadier General Charles Law, Patricia's great-uncle, who pulled the trigger. He called in to the Home Office to tell them that Nemon was (according to the minute in the Aliens file) '(a) a charlatan, (b) had obtained influence over his niece and (c) was thoroughly undesirable'.

Far from telling Farrers and their sundry complainants to take a running jump, as they had (although more politely) after the first sackful of slurs, the Home Office decided to launch a fact-finding mission. On 14 June an officer from the Walton Street Station of the Metropolitan Police submitted a three-page report. He had made, he said, 'careful and discreet enquiries'. But his first item of information contained an error that would have important, although quite unforeseeable consequences. He listed Nemon's address as '11 Lisle Street, W1'. The correct address, 11 Lyall Street, SW1, does appear a little later in the report, but the damage had been done. The officer went on to say that Nemon first came to the UK on 21 February 1937 (whereas he had crossed the Channel several times before then). The report then lists some of the busts he was sculpting – 'in this direction he is well connected, and is a clever sculptor', mentioning among his prospective patrons the 'Duchess of Kent, Queen of Greece and the Earl of Feversham, son-in-law of Lord Halifax – Foreign Secretary'. Their average price for a bust was assessed at £100, so that 'his financial position is believed to be sound'.

Now the officer dealt with Brigadier General Law. 'I can find no reason whatever', he roundly declared, 'for the suggestion that Nemon is a charlatan, in fact judging by his work and patronage, such an expression could not have been more misused.' Law, he continued, 'knows very little of Nemon and his work and of course is ignorant of the fact that his niece is being modelled by Nemon'. Turning to the allegations made by Colonel Villiers-Stuart, the officer declared that he had actually seen the bust the sculptor was making of his daughter, so a payment was justified.

Yet all this was still not enough for the dogged Home Office. A decision was made to write to David Fincham, who was just about to administer the Tate Gallery when its chief, John Rothenstein, took off for the USA. Fincham was non-committal in his reply about my father, saying that he was 'not acquainted with his work, although I recollect having seen a photograph or two. I understand

he spent some time in Belgium during the last two years . . . He carried out a bust, I believe, of the late Queen of the Belgians. I am afraid this is all I know about him.'

By the end of June the case against Nemon seemed pretty much closed. The calumniators had done their best – and failed – although General Law was still trying in July 1937, writing to say that Nemon 'consorted with women of the lowest type'. But the Home Office was dismissive of such general accusations, and common sense seems to have prevailed. It admitted there was no substance in the allegations against him. Nemon might be an alien Jew, but he had done nothing demonstrably wrong . . . indeed his talents as a 'sculptor of some distinction' were explicitly recognized in a Home Office minute. A letter was sent out to Farrers telling them that no action would be taken. However, doubts clearly remained in some suspicious, perhaps even paranoid, Home Office minds. Buried at the bottom of one minute, for Home Office eyes only, there appeared the ominous phrase 'MI5 should be consulted.'

As for Nemon, still wholly ignorant about what was going on behind the scenes, he had only a sense of relief that he continued to be allowed to stay in the United Kingdom. He did not know then and never did know that his case was under review.

It was not until 1 December 1939 that the time bomb exploded. The Second World War was three months old. Paranoia about German spies was rampant. In this climate an MI5 secret-service agent by the name of Sinclair sent a note to a Mr Crane at the Home Office to put on record a conversation they had just had.

SECRET

We spoke re this:

Our attention has recently been drawn to an alien of Yugoslav nationality named Oscar NEUMANN, by profession a sculptor and the subject of HO file N. 2072.

The name of NEUMANN, who also uses the alias of NEMON, has been reported to us as being connected directly or indirectly with the German SS and to be engaged in espionage in this country.

Our source, which is a delicate one, is located abroad, and would appear to be quite uninterested as far as NEUMANN is concerned.

While we are not at present in a position to confirm the allegations, we nevertheless consider the source to be sufficiently reliable to warrant our regarding NEUMANN as being not above suspicion and as a person whose continued presence in this country is not to be encouraged.

This Kafkaesque document – who in the world can be said to be 'not above suspicion' and what is a 'delicate' and 'uninterested' source? – turned the tide

against the foreign sculptor, a Jew but with a German-sounding name who used an alias. But did the non-resident source really have evidence that a Jew of all people was conniving with the SS? Whatever the truth, in quick order a decision was made by the Home Office to deport the undesirable artist and putative spy (although where to is not specified). A minute signed on 14 December 1939 by two officials called Oliver and Drew noted that 'in view of MI5 report and the confidential statement from Mr Fincham [but had David Fincham really provided damning information in addition to the anodyne letter he certainly did send to the Home Office?], coupled with the sundry indications that the man is an undesirable adventurer, there seems to be good ground to curtail his visit'.

So Nemon's fate was sealed. With war now broken out and thousands of cases being cursorily examined by harassed officials, a man even rumoured to be an 'undesirable adventurer' never stood a chance . . . even if his adventures were strictly confined to affairs with women. Except that he now had an improbable piece of luck. The man charged with sending out the fatal letter of expulsion turned out to be less the implacable deliverer of harsh justice and more the Home Office's precursor of Clouseau. He sent the letter to the wrong address, to 11 Lisle Street rather than Lyall Street. As a result, my father never received the letter.

Patricia was also oblivious of the close call that so nearly lost her the man she loved. She continued to see him, despite her parents' open and vocal disapproval. In 1938 she enrolled in the fashionable but serious art school Heatherleys, near the Wallace Collection in London. Also at Heatherleys was Elizabeth Milburn, who was to become her greatest friend. Elizabeth remembered their time together in the late 1930s and wrote to me about her visits to the parental home in Norfolk, Beachamwell Hall.

> I became great friends with your grandmother. We liked all the same things. I was very useful because I liked doing all the things that Patricia didn't! Arranging flowers, messing about in the garden. I got on very well with your grandfather, too, and also loved to take his cocker spaniel Sunset for a walk after lunch. Because of this friendship with your grandmother I heard all about your terrible father! Mrs Villiers-Stuart did not know that he was a successful sculptor; she thought he was a psychoanalyst. Your grandmother had a deep hatred for Nemon.

Nemon found it hard to understand why Patricia's parents were so against him when he felt he had helped their daughter recover from her mental illness.

She was keen to meet Nemon's family. As a result, in August 1939 she had a close call of her own. She made up her mind to go to Yugoslavia to see them. She and a girlfriend drove to Yugoslavia in the friend's car. Patricia met Eugenie Neumann, Nemon's kind and welcoming mother, his sister Bella and brother

Beachamwell Hall, Patricia's family home in Norfolk

Deze. But, with war looming ever closer, Patricia and her friend had to make a hasty retreat back to England. Luckily, the friend had an Austrian passport, which they used at the borders where the countries were sympathetic to Germany. They just reached Calais in time to catch the last car ferry back to England, this time using Patricia's British passport.

Nemon returned to England by train a few days later, just managing to catch the boat before all civilian travel was halted. On the advice of a friend – who possibly knew more about the threat to Nemon's ability to stay in England than he divulged – the elusive alien went to ground, to the Surrey parish of Abinger. Three days after Christmas the error made in misaddressing the envelope was discovered in the Home Office. The instruction went out to dispatch the letter to 11 Lyall Street. But the bird had flown the coop. And presumably the Home Office Aliens Department and MI5 got on with more important matters . . . while Nemon found – if he were ever to need one – an unlikely new friend and potential protector.

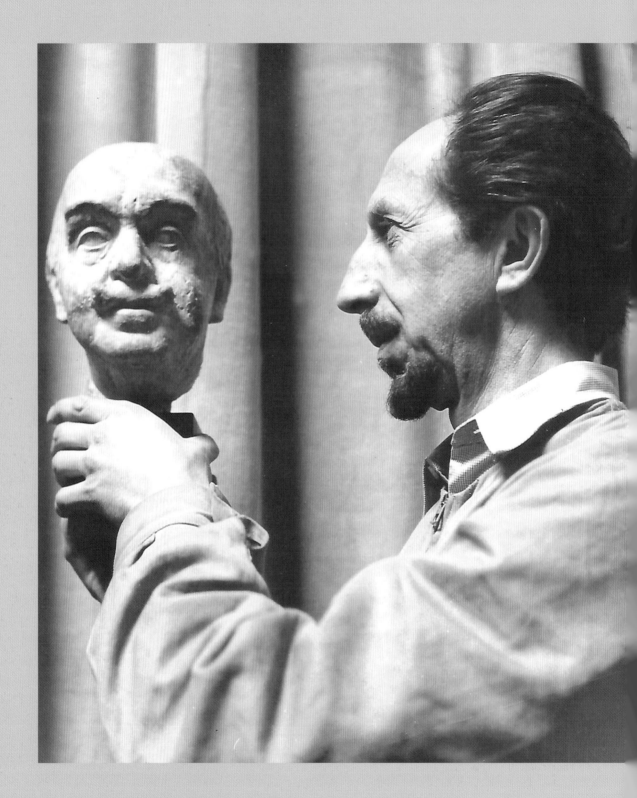

Max Beerbohm sculpted
by Nemon in Abinger,
Surrey, in 1939

The Early War Years 7

THERE WERE, NEMON claimed in his memoir, positive reasons to get out of London after the outbreak of war and find a rural retreat. 'I revelled in the beauty of the scenery and felt that, in the more peaceful rhythm of life outside London, I might really begin to get to know something of England and the English – and, not least, to come to grips with the language, with which I had made no progress so far.'

So he arrived at what he described as the 'little village of Abinger, with its famous hammer, nestling under the North Downs'. He checked in at the only pub, the Abinger Arms, and started to look for someone to teach him English. The local schoolteacher turned him down, claiming that she was too committed to the war effort and, besides, had no French so couldn't really help him. But she did know a lady in the village who spoke French. Soon this woman – her name, Lady something, meant nothing to him – got in touch. Of course, they talked only French together, often about her previous life in the theatre. She mentioned that her husband might make a better teacher of English. Nemon recalled the husband in his memoir.

In appearance he was almost a stage version of a retired colonel – very well groomed, very correct, very stereotyped in his mannerisms. He did not know any foreign language. Although he had spent the greater part of his life in Italy, he had never learnt Italian because of a sense of loyalty to his mother-tongue. Indeed, on his honeymoon in Paris, he had threatened to turn round and come home if his wife did not stop using French to the porters!

When we began our lessons together, he said to me, 'I shall draw you the outline of an object and then tell you its English name.' He drew a cow – an extremely comic one – and said, 'This is a cow.' This continued for some time until, one day when he had drawn a particularly funny caricature of a neighbour, I burst out, 'But, good heavens! You've got terrific talent for this sort of thing: you could sell your cartoons to any paper and make an enormous sum of money.' [The man I had come to know as] Sir Max and his wife lived very simply, and I, in my ignorance, thought he might jump at my idea.

Max Beerbohm's
sketch of Nemon which
he drew in Abinger,
Surrey, in 1939
© BERLIN ASSOCIATES

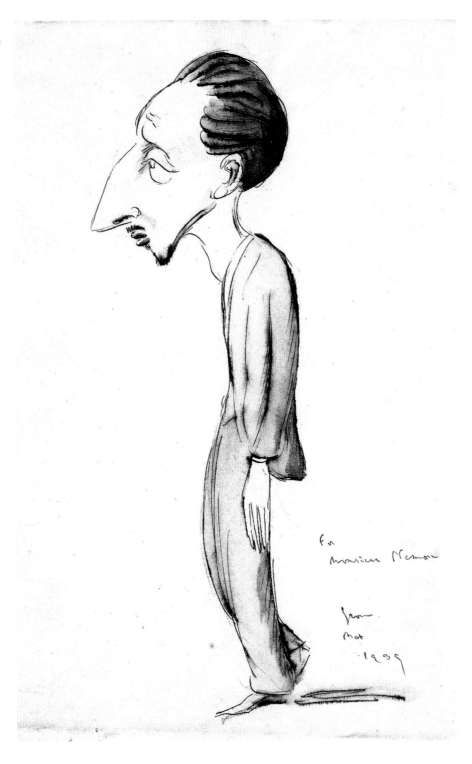

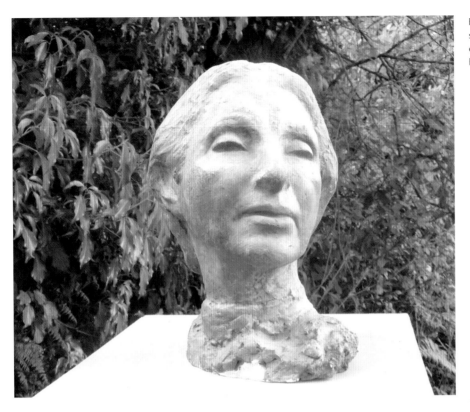

Florence Beerbohm sculpted by Nemon in exchange for teaching him English, 1939

The truth of his teacher's identity still did not dawn on him.

I learnt the full enormity of my misconception only on the occasion of the visit of Gerhardt Hauptmann's secretary. She and I travelled up to London together and she was talking about Hauptmann (the German novelist and playwright who in fact began as a sculptor) and their friendship [with my teacher]. I expressed surprise that their paths should have crossed – rejoicing that for once there was an opportunity to talk easily with someone in a language that was familiar to me. She looked at me for a moment, and then said, 'Don't you know who is Max Beerbohm? He is one of the most famous satirists and caricaturists in England and one of the most respected critics in the English literary world.'

My father always struggled with his attempts to become more of an insider in English cultural life. He almost enjoyed mocking his own ignorance. For now, he enjoyed realizing that this Beerbohm fellow was taking a kind of masochistic satisfaction in hearing this young Yugoslav so mutilate the English language. 'He used to imitate my mumbling accent to his wife', he remembered, 'with tremendous glee.'

As for the secretary in the train, it turned out she had met Nemon in Dresden in 1931, when he was creating a sculpture (now missing) of Richard Strauss.

Beerbohm himself had a great admiration for her. She was a quicksilver combination of devilry and childlike innocence: tall, athletic, eager and adventurous. Beerbohm's villa in Rapallo was built right out over the sea, so that there was a sheer drop from the windows on one side. Sir Max was a very timid person and almost had a heart attack one day when Elizabeth (the secretary) appeared in the house in a bathing costume, climbed on to the window-sill near him and dived off into the sea. He was a perfect target for her teasing – serious to the point of solemnity and looking always for a deeper meaning in her more frivolous utterances.

Perhaps Nemon had his eye on her himself. If so, he lost the competition. It was Beerbohm who later married her. In fact, Sir Max was altogether a puzzle to the sculptor, unused to English eccentricity on this scale, puzzled as to why such an intelligent man would watch where his wife hid her fashion magazines, sneak off with them and add beards and moustaches to the cover-girls and models. In his memoir Nemon recalled, almost with horror, stories of how Beerbohm published a book of local Surrey proverbs, and no one dared to point out that the distilled country wisdom was the fantastical product of his own fertile mind; or how he sent to *The Times* a crossword he devised, which stumped everyone who tried to solve it . . . because there was no solution! Nemon thought Beerbohm's sense of humour derived from despair about life – 'the despair of not finding a solution balanced by the fact that, if a total solution were found, life would be without the impetus of constantly seeking for its significance'.

To thank Sir Max for his English lessons Nemon did a bust of him. When asked to come to London to view it, Beerbohm declined. 'I will come to London next one hour before I die. I was born there and I'd like to die there, but I cannot live there.' The bust is now in Merton College, Oxford.

I discovered that Nemon had also sculpted Lady (Florence) Beerbohm when I read a 1956 press cutting about an auction in aid of the Campaign for the Abolition of Capital Punishment. In Nemon's studio there are many busts of unknown people, and I had often wondered who the bust of a sixtyish middle-European-looking woman might be; could this be Florence Beerbohm (née Kahn)? From looking at photographs of the young Florence Kahn I have determined that the bust is definitely the one Nemon made of Florence Beerbohm in 1939 to thank her for teaching him English.

Accounts differ as to exactly when or where he met Violette Cunnington in Abinger. This is the story told by Ian Colvin in his book *Flight 777*.

A small, emaciated man peered out of the narrow windows of the inn at Abinger Hammer. You would not have taken him for anyone of importance at first glance,

Leslie Howard (far left) and Violette Cunnington in Nemon's London studio in 1942
PHOTOGRAPH COURTESY OF GIOVANNI DI VERDUNO

unless you noticed the extreme sensitivity of his hands. Moreover, the depth from the top of his head to the tip of his pointed beard, the dark shadows that ran from his temples down his cheek, the sardonic lip and inquiring eyes gave him in certain lights the appearance of an unkempt Velasquez. This was the Yugoslav sculptor Oskar Nemon – not yet a famous man, then leading a precarious existence in Chelsea and Oxford, and occasionally passing a quiet week-end at the Abinger Arms in the green Surrey hills.

He was watching the road with an amused look for a phenomenon rare in wartime England: a strikingly beautiful woman who often used to drive past unescorted in an open American roadster at week-ends. But this time she parked the car and came into the inn, so that he could appraise her more closely. She was perhaps five foot six in height, light-haired, oval of face, with extremely quick, intelligent eyes. His amused look changed to one of professional interest. Before long he asked her to sit for a portrait bust.

Violette Cunnington was the official mistress – his wife knew of her – of the dashing actor Leslie Howard. In the autumn of 1942 she died of pneumonia. Howard was utterly distraught – Nemon described in his memoir the actor's love for Violette as 'the flaming passion of an eighteen-year old . . . He was inconsolable and wrote her a 10,000-word letter which finished, "Violette, I shall be with you soon."'

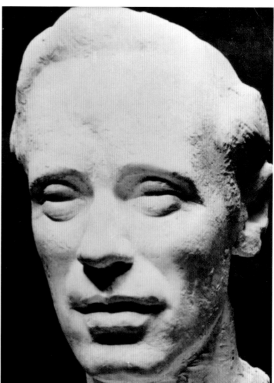

Top
Leslie Howard's mistress Violette Cunnington, 1939

Above
Leslie Howard with his bust at Nemon's exhibition at Yugoslav House, London, in 1943

Above right
Plaster bust of Leslie Howard, 1943

Leslie Howard wrote to Nemon on 9 January 1943 that 'I am now trying to find all the photos and other records of her and I remember you made a little bust of her – or think you did. Could you let me know if you have it and when I could see it? I am searching for anything which will give me an impression of her. Perhaps you could do something from memory knowing her lovely personality.' He then commissioned Nemon to make a memorial for the two of them for a Garden of Remembrance.

In a letter to Nemon on 25 February Leslie Howard wrote that 'the garden is not bad, and has a charming rose pergola which could be improved. A statue of some sort would be quite lovely there. It would be near to one at all times, and could be seen by Violette's friends in a personal way, instead of in a more or less public institution. All this we could discuss if you come up and stay for a day.'

It seems the bust was completed, but then, as Nemon later recalled, 'Howard went off to Spain, on a mission, intending to finalize arrangements about the memorial on his return. His plane was mistaken by the Germans for the one in which Winston Churchill was believed to be returning from the Middle East and there were no survivors.' The busts of both Leslie Howard and his lover were removed from Nemon's studio by Leslie Howard's solicitor in September 1944

Child's Head

OSCAR NEMON: Born at Osiek in Slavonia (Yugoslavia),
1906. After leaving school lived mainly in Belgium and France,
where he has left works in Museums, Galleries and Private Collec-
tions. Since 1939 has lived and worked in Great Britain.

SCULPTURES

1.	His Majesty King Peter II
2.	Mr Milan Grol
3.	Sigmund Freud
4.	Leslie Howard
5.	Mr Vetcheslav Vilder
6.	Mr Radoyé Knezhevitch
7.	Her Majesty Queen Marie
8.	Lord Charles Spencer Churchill
9.	Captain Leonard Green
10.	Baroness C. de C.
11.	Dr Miha Krek
12.	Mr R. G. D. Laffan
13.	Mrs Jean Guinotte
14.	Miss Sophie Cosyns
15.	Mr T. V. Giurgievitch
16.	Dr O. L.
17.	Miss Irene Johnston
18.	Mr Voislav Vuchkovitch
19.	Falcon

and have both disappeared, despite my efforts to track them down.

It might seem strange that there are so few references to the war either in Nemon's later memoir or in the letters to him or from him. His main concerns were about getting money to his family in Yugoslavia if there should be an embargo, and he tried to arrange for a couple of uncles to see that his mother and sister had enough money to get by (he volunteered to pay them back after the war). He actually wrote to his mother on 6 November 1939 (on notepaper headed 'Abinger Hatch Hotel') saying that he wanted to visit her in Zagreb 'in the summer or spring'.

His status as a Yugoslav national continued to make him vulnerable in the early war years. Having failed to get Nemon deported (and probably killed), Patricia's parents tried another tactic. Violet Hardcout, a friend of Patricia's mother, was asked to spy on Patricia and Nemon and come up with some incriminating evidence. When Patricia left the family home of Beachamwell, in deepest Norfolk, to catch a train to meet Nemon in London, Violet was asked to follow her discreetly. Nemon met Patricia at Liverpool Street Station and they fell into each others' arms. Violet decided they were so in love that she could not attempt to blacken Nemon's name.

Catalogue from Nemon's exhibition of busts held at Yugoslav House, London, in 1943. The exhibition was opened by Queen Marie of Yugoslavia.

Elizabeth Milburn was also intrigued by Patricia's devotion to my father and longed to meet him. It was Nemon who introduced himself to Elizabeth by asking if he could meet her in her flat in London. 'One day', she wrote to me, 'Nemon rang me up. He wanted to see me. Naturally I said, "Yes of course, I'd love to see you."' The letter went on:

> When Nemon stepped into the room I thought as if he came straight out of a Gothic cathedral. He had a magical charm. Those great hypnotic eyes, that subtle smile. He sat down on the bed and I sat down on the chair. Then I saw he was in great despair. Most of our conversation was about your grandmother. Nemon was deeply upset that she would not accept him. I had to explain that she was so very different from him, how she belonged to a different, very conventional age and that if he did know her he would probably long to get away. He pointed out that she did not understand how important he had been to her wayward daughter. I never for a moment thought of Patricia as wayward. Of course she was unusual, talented, exceptionally attractive with an unexpected determination in anything she wanted to do. Being an only child her desires were not ignored. She was very brilliant at school and restless of the conventions of her time. I did my best to cheer Nemon up, pointing out how fortunate he was to have so fascinating and brilliant a woman so deeply in love with him. He left calmed and thoughtful and clasped my hands with deep understanding.

Once safely back in England from her trip to Yugoslavia just before the war broke out, Patricia stayed with friends in London. She continued with her art classes at the Heatherley School of Fine Art, meeting Nemon at his new studio in Kinnerton Street, between Belgrave Square and Knightsbridge, which he had recently taken over from the French impressionist painter Paul Maze. Maze himself had decided to leave London for the safety of a home in the Hampshire countryside.

As the bombing of London grew more intense Patricia returned to stay with her parents in Norfolk. In the early summer of 1940 she discovered she was pregnant. She was expecting the baby of someone she adored, but for Nemon this seemed like a catastrophe. He did not want to be tied down to a life of domesticity. He was already supporting his mother and brother in Yugoslavia and was reluctant to take on more responsibilities. He urged her to have an abortion, but Patricia was determined to keep the baby. They discussed what to do next, and she must have been very hurt that Nemon did not want to marry her or even, it seems, take any responsibility for the baby. She also felt unable to tell her parents the news that she was to become an unmarried mother. Through the summer she agonized about how to impart this unwelcome news. Nemon was not especially supportive and

seems to have put his head in the sand. Perhaps it was just as well that she did not know that he was trying at this very moment to get a visa to emigrate to the USA. When she was two months pregnant Patricia wrote to her lover from Beachamwell Hall on 20 August 1940:

> My darling
>
> As the war seems to be getting busier I have decided to say nothing at present. I'm sure they would say it was impossible to make any plans until the middle or end of September, and I should have to spend such a disagreeable time here. But so near to telling has made me realize how difficult it's going to be, and I can't make up my mind what line to take. It seems so wrong to lie about anything as important as this, especially as they are sure to realize it's a lie sooner or later. If I say political circumstances have made anything legal impossible, they will say nonsense, England is bound to win and that anyhow I can keep my nationality and that any racial danger is so small in this country as not to count. If I refuse to say who else is concerned, I'm sure they will reply that they will take it to be you and will try to force something legal; of course you could stoutly deny anything to do with me. Perhaps this would be the best way because it isn't certain that they will bring you into it. Certainly for me absolute silence and refusal to discuss the question would be far the easiest. The minute I begin to tell lies and half-lies I know I will feel so weak and defenceless against the accusations which are to be showered on me.
>
> Elizabeth implored me to try and get married in any circumstances; she said that the animosity of parents in such a case is so great and terrible to combat. I must say that up till now I haven't thought that telling them would worry me very much, but now I begin to realize it's going to create the most dreadful upheaval.

Rather surprisingly, Nemon kept all Patricia's letters to him while she kept none of his to her, so it is not easy to know what course of action he was advocating. From her next letter it appears that she was not very happy with his advice.

> My dearest Nemon
>
> I am so sorry to bore you with all this, but it's got to be faced quite soon. I have been thinking of their different reactions to the different things which I could say. If I refuse to say who or tell them someone killed or gone abroad, my mother will never rest until she finds out more; she is like that, she will think she is doing it for my real benefit . . . If I tell the truth and say we neither of us consider it advisable to legalize the situation in view of the political circumstances and put the refusal down almost more to me than to you, it might possibly be better. But that way I also see difficulties for you; they will want to know why you don't want to be as

helpful as you would be in the circumstances, why you wouldn't consider living with me if I had a small house, for instance. I suppose I could say this, that since I have found myself in this new situation I suddenly never want to see you again. Yes, I really believe it would be the only way to make things easy for you; although I would hate to tell this lie. Still I suppose I could bring myself to do it if you really seriously feel that anything else is going to cramp your life and your work. Of course I wouldn't even need to mention you. I could say I had completely turned against the man and beg them not to mention him in any way. This is the sort of thing my mother would be quite sympathetic about, I believe, and would probably do as I wished. What a tiresome farce all this is. Still I must settle things soon from every point of view.

Thinking it all over and over again this is what I would like to be able to say. To tell my parents that we undertook this because we thought it would have a *good* result, that you take a *serious* interest in my present situation and are willing to help me in any way you can, but that in view of the situation there is little you can do, that anything legal we both consider inadvisable and that the best solution is for me to have a little house and garden where you can come and help me from time to time. I suppose you will feel that I am trying to drag you into domestic life, but it seems to me that it wouldn't hurt you to let my parents think that you intended to be more helpful than you actually do intend, and it would make everything so much easier for me. If you actually were to be helpful in my life for some months or even a year, I sometimes wonder if it would be so disastrous to your life work as you think.

Also there is this war, and I see no decisive finish. Do you? I can imagine it followed by upsets and revolutions all over the world lasting for years so that it might possibly be to your advantage to have dug yourself in somewhere in good time while my family still have a little capital with which something could be done for us.

You will think about my various suggestions, won't you? I want things to be as easy for you as possible, but also I can't help wanting things not to be too terribly difficult for myself as well. If I really felt that my unselfishness was going to be a great benefit to you I should feel happier about it.

No letters remain to indicate what happened when Patricia told her parents. But they were horrified to have confirmed that all their hopes for their only child had been dashed. What exactly she told them is something I have no way of knowing.

Nemon needed to take his mind off these domestic worries and preoccupations, but his portrait-sculpture career continued only to putter along, without any spectacular breakthrough. It might have been from a sense of worry – desperation

even – that in the summer of 1940 he came up with a grandiose idea for a 'historical frieze'. He crafted a document full of high-flown prose and lofty ambition to design a 'National shrine of the glory of the British people':

> The doors open not only into a sacred place but at the same time into the most glorious assembly of the testimonials of its history. I want to display on the wings of these bronze doors the Creation of the Empire, from its earliest beginnings onwards, its famous events and venturous enterprises and great spiritual achievements. But this should not be a mere catalogue but subject to one great leading idea: the conscious and even unconscious striving for the realization of humanity through all stages of splendid successes or grim ordeals, in greatness through tolerance, in firmness against evil, in steadfastness through stormy times and humility in glorious ones. A world is thus unfolding itself to the imagination, suggesting creative imagination, indeed!

And on and on – an even more florid version of his 1920s *Temple of Universal Ethics*. How could such purple prose gush forth from a man whose English was improving but still halting? The answer is fairly obvious, since the corrections on the typescript are clearly in Patricia's hand. More extraordinary is the optimism of the project in the middle of the war. Nemon defends his timing of a grand patriotic frieze by saying that 'now that the turning point has definitely and decidedly come, I thought the moment propitious enough to plan into the future again'. The reality was that everything in his own and in his adopted country's life at this time was fraught with danger – and the Battle of Britain far from won.

Nemon's sketch of lovers, 1930s

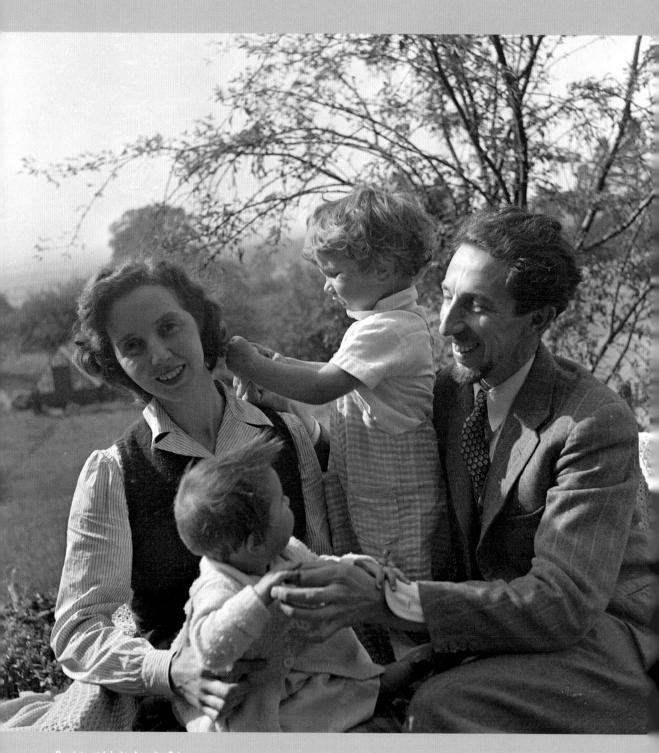

Patricia with baby Aurelia, Falcon
and Nemon at West View, Boars
Hill, Oxford, in 1943

Between Oxford and Norfolk 8

Boars Hill, three miles south-west of Oxford, has had a long association with poets – Matthew Arnold, Robert Graves, Robert Bridges, John Masefield, Edmund Blunden and many others – and was the home of the translator of classical Greek drama Professor Gilbert Murray of whom Nemon made a portrait bust. For my father it became both a retreat and a base from which to regroup in order to take on the British establishment, just as he had broken into Belgian high society to get his commissions.

European refugees abounded in and around Oxford during the war. Many were Jews involved in the arts and publishing. One close Boars Hill friend, Albi Rosenthal, became famous in the world of rare books and manuscripts. The composer Ronald Senator described Nemon as 'the typical twentieth-century trans-national Wandering Jew'. Oxford was a suitable choice of home. At the same time as moving to Oxford his English showed distinct signs of improvement. Patricia always corresponded in (remarkably fluent and accurate) French to her Croatian-born lover until, from January 1940 on, she wrote to him more frequently in English.

Nemon began renting a room in Holywell Street in Oxford, as well as taking over Paul Maze's Kinnerton Street studio in London. Oxford was considered a safe place to be during the war, and so, to be near Nemon, Patricia rented a house in Sandfield Road, north Oxford, and awaited the birth of her baby. On 27 March 1941 she gave birth to a boy in Oxford's Radcliffe Infirmary – my brother Falcon. Nemon must have been a caring father, even if not a very diligent one, as photographs show him holding the baby with great affection. He told his mother about the boy, and she sent an excited telegram from Yugoslavia saying how pleased she was to be a grandmother. The baby's other grandmother, Constance Villiers-Stuart, sent her maid to Oxford to look at the baby and see if he was 'Black or Jewish'.

Nemon wrote to Lady Beerbohm to tell her the news in a letter which is now in the Merton College archives. 'I have done a lot of sculpture in clay and one in real living material which looks like a baby, and it seems to be actually my best piece of work. When the time came to give a name to this piece of work I chose the name of a bird, Falcon, and I hope he will live up to his name.'

Nemon with baby Falcon in Oxford in 1941

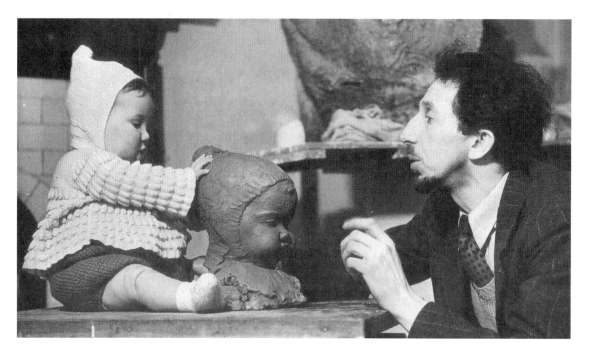

Falcon posing for his first bust aged eight months

Both before and after Falcon's birth the Norfolk grandparents kept up their campaign to separate Patricia from Nemon. In the summer of 1941 she wrote to him to say that her parents were making a big fuss of the baby, delighted he was safely with them in Beachamwell and seeing him as becoming 'a country gentleman after a scholarship to Eton'. The following January she wrote that 'Mother wants me to go to Oxford, collect my things and return here for good.' And the following month: 'Of course my parents want to separate you from the Didi' (as Falcon was dubbed). The financial pressure was constant. 'Norfolk', she wrote later, 'is a perpetual strain and misery.'

My father continued to work in his studio in Kinnerton Street, visiting Patricia and his son in Oxford from time to time. When she fell ill she stayed in Norfolk with a nurse to look after her and Falcon. Her father, who was much more sympathetic, did make some attempt to help financially, but his timber business was failing, and, as he had no money of his own, it was all very difficult. Besides, it was impossible to hide the help he wanted to give from the eagle eyes of the disapproving Constance. She never relented. Even when I, their second child, was born in 1943 Nemon and Patricia lived a life that was for ever scarred by poverty imposed by my implacable grandmother, who barred Nemon from Beachamwell Hall.

My first name was not chosen in honour of the Emperor Augustus's mother Aurelia but after the name printed on the side of a luxury Pullman Railway carriage that Patricia had almost certainly seen while she was waiting for Nemon at a London railway station. In that respect, at least, I was a true child of my

father – named after a horse that drew an Osijek tram and with me named after a railway coach.

Hornby model of the Pullman coach 'Aurelia'

Meanwhile in the summer of 1942 he and Patricia – having moved from one rented accommodation to another – had settled in Boars Hill. They rented rooms at West View, the home of Emma Matthews, who described her new tenants in a letter to her son Basil (as her daughter recalled in a memoir of her mother): 'My tenants are installed and look as if they will stay. He is a Jugoslav, a friendly sort, a sculptor by profession with a studio in London. His wife is English.' Clearly they felt it better if they pretended to be married.

Nemon loved his children and was always an affectionate father, but he was also a reluctant one; so reluctant that in the summer of 1941 he had applied again for a visa to travel – indeed, to emigrate – to the USA (where Jessie Stonor was living). Whether his plan was to invite his family to join him later or whether he was planning to abandon us we will never know. Several months later, on 19 February 1942, Thomas Cook and Son Ltd wrote asking 'whether you have received any word that the visa has been approved in your favour, since at time of writing a few opportunities are occurring of arranging Atlantic passages'. Of course no such visa was granted, and, as far as can be gleaned, no wind of his application ever reached the attention of the mother of his infant son.

Jessie Stonor had been in New York since Valentine's Day 1941 and was pining for him (and he clearly for her). This is certainly a more likely explanation for the visa application. She wrote long, agonized, passionate letters in French to the man who, she said, 'possessed three quarters of my heart' and 'would always

Nemon and Patricia
with Falcon and Aurelia
on Boars Hill in 1944

be in my soul and in my heart'. She was also sending parcels to her lover's family in Yugoslavia via the Red Cross, but, receiving no reply, feared the worst. (She was right to be concerned – they were killed in the summer of 1942.) She even sent money via Cook's money orders to Nemon himself, hoping, she wrote in December 1942, to increase their size from £3 to £4 by early the next year.

Throughout his life Nemon needed the money. He always had work but never got rich from it. One sitter, Captain Leonard Green, wrote in 1943 to thank him for the bust he had done with the words 'To my dear sculptor who merits cash but receives only glory'. Indeed, the middle years of the war were busy times. In early 1942 he made a bust of Margaret Maitland, the terminally ill wife of an Oxford

Sculpture of Margaret
Maitland playing the
piano with her eyes
closed, Oxford, 1941

friend F.E. Maitland, who wrote tenderly to the sculptor that he saw in the portrait 'an element of tragedy, but it is rather quiet and peaceful resignation . . . Sometimes I look at it and it seems to me that providence must have sent you just at that time, for it is most beautiful and full of her characteristic graciousness.'

It was around the same time that he made his bust of the classical scholar Gilbert Murray.

In April 1943 Nemon sculpted the Oxford Cathedral organist and conductor of the Bach Choir, Dr Armstrong (father of the future Cabinet Secretary Lord Armstrong of Ilminster). Our landlady, Emma Mathews, thought the bust 'lovely . . . the artist has caught a lovely expression, he is looking upward as if conducting a choir, and the singers are at their best and Dr Thomas Armstrong is among the

Falcon aged two, as
sculpted by his father

The conductor
Dr Thomas Armstrong,
Oxford, 1943

PHOTOGRAPH BY
S. DARLINGTON

angels'. George Aynsley, possibly a banker, commissioned a bust of his wife, which was much admired by the financier and property magnate Charles Clore. One commission led to another.

At the same time Nemon was mining another seam – his fellow Yugoslavs. As a Yugoslav citizen, and therefore – for all the Villiers-Stuarts' efforts – not an 'enemy alien', he relied upon the protection of the Yugoslav Embassy in London. When I wonder occasionally what 'my daddy did in the war' I find it easy to forget that he was not yet an Englishman. Of course, he would also have been wary of coming too close to the attention of any authority, which, in retrospect, was wise, given the attitude of the Aliens Office. At any rate, at the end of 1941 he had managed to get himself declared medically unfit for military service (on account of myocarditis, inflammation of the heart muscle, a genuine medical condition in his case). However, the Yugoslav Ministry in London wanted something in return from their fellow citizen. It is a moot point exactly what my father actually did by way of propaganda for the Yugoslavs. In May 1942 he was asked not to repay but to hold on to a small cheque, described in a letter from a certain Dragutin Subotić in the Education Department of the Royal Yugoslav Legation, as 'modest

Queen Marie of Yugoslavia examining the bust of her son King Peter II of Yugoslavia

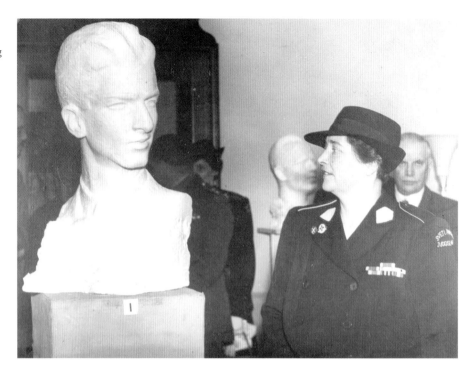

assistance from a modest fund whose origins were in the last war. If you do find permanent work and a regular income you could, although this isn't necessary, return this sum . . . I must accordingly return your cheque, and also enclose 2d to cover the postage.' In August 1943 his work 'for propaganda purposes' in connection with the Information Department of the Royal Yugoslav Government was formally recognized by the British Ministry of Labour and National Service, while a second letter soon after noted that 'Mr O. Nemon' would not be among the 'many officials of the Yugoslav Government leaving the British Isles in the near future for Cairo' but could remain in London, together with 'those able to speak English, for liaison and propaganda work between the British and Yugoslavs'. All those English lessons with Max Beerbohm were paying good dividends.

The London-based Yugoslav officials also supported their fellow citizen as an artist. Queen Marie of Yugoslavia opened an exhibition at the Yugoslav House off Exhibition Road in South Kensington in the summer of 1943. The space was shared between Nemon and a painter called P. Milosavlievitch. My father exhibited nineteen works, including his busts of King Peter II and Queen Marie, Sigmund Freud, as well as two children, Lord Charles Spencer-Churchill and his own son Falcon.

In January 1944 an exhibition of Yugoslav art opened in London's Burlington House. The sculpture room was dominated by eighteen works by Ivan Meštrović. Nemon exhibited just a handful of his own works, probably a selection from those shown at the Yugoslav House.

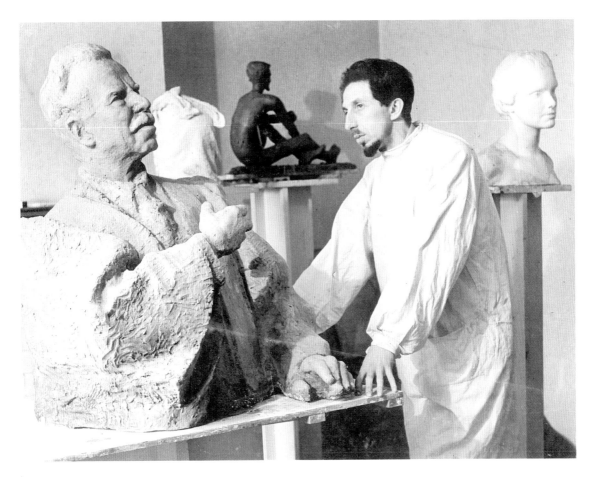

Nemon with his sculpture of Professor Herman Fiedler, Oxford, 1941

Nor were his Belgian connections neglected in the war years, although there was nearly a spectacular bust-up. The Belgian Institute planned an exhibition of Nemon's sculptures for the end of 1943 at its offices in Belgrave Square. Its curator, the art historian Léo van Puyvelde who was working at Windsor Castle, then summarily withdrew the invitation, apparently at the behest of the Institute's president. When Nemon's former lover Simonne learnt of this she blew her top, crying foul on grounds of anti-Semitism. She insisted that he should hire the most aggressive lawyers, and she brought into the dispute the heavyweight Belgian politician Paul-Henri Spaak who was at the time her lover and who would become her husband. It is not clear if this had a direct effect, but soon afterwards van Puyvelde wrote a humble-pie letter saying the Institute had been wrong. The exhibition took place just before Christmas.

Very soon afterwards Nemon's and Patricia's new life together in Oxford nearly ended prematurely and disastrously. The Beerbohms had introduced him to Professor Hermann Fiedler, who taught German and who was a Fellow of Keble College. Nemon's bust of him is now in the Taylorian Institute, Oxford.

Fiedler often held musical evenings at his house in Norham Road, and it was

at one of these that Nemon met a talented German pianist. They got on well and planned to meet more frequently but somehow never did. Nemon described what happened next in his memoir. It was early July 1944.

Suddenly my wife went down with pneumonia and pleurisy and lay critically ill in the Acland Nursing Home. I was with her one evening when the doctor took me aside and told me that she had no chance of recovery.

I left the nursing home in a daze. There was no treatment – no hope. My unhappy reflections were suddenly interrupted by a greeting from my pianist friend on the opposite side of the road. I replied briefly but did not stop; instead I went straight back to the friends with whom I was staying on Boars Hill.

They said at once, 'But there's penicillin now – it's the discovery of the century. We have some friends who are connected with the man who's working on it here.'

Even so, I thought, what could be done? The wonder drug was still at the laboratory stage and had not been fully tested. But it was important to pursue every possibility, so I asked them, 'What's this man like?'

'He's short, with bushy hair. Very musically minded – an accomplished pianist.'

Could it be . . . ? I wondered. I said aloud, 'What's his name?'

'He's called Chain.'

I promptly got his address from them and went there as fast as the taxi could take me.

He said, 'Penicillin's my child, and I'm not allowed to see it or touch it. But what I'll do is this – I'll steal it!'

Nemon's and Patricia's marriage certificate; Professor Sir Ernst Chain was a witness.

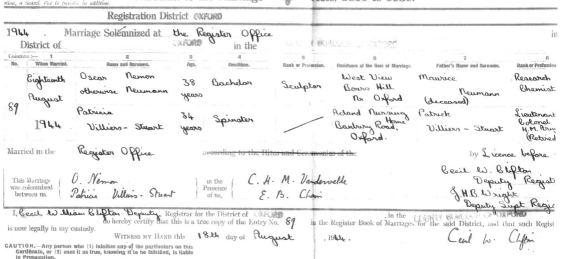

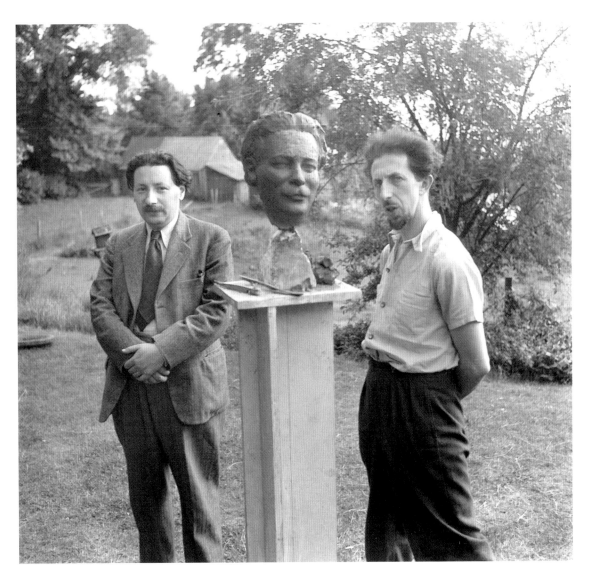

He brought the penicillin in its test-tube straight from the laboratory [in the Oxford School of Pathology]. It had never been used on a patient before. My wife was the first case. The treatment was carried out in the greatest secrecy, and it saved her life.

Professor Ernst Chain posing for Nemon in the garden at West View on Boars Hill

PHOTOGRAPH BY FRANCIS GOODMAN © NATIONAL PORTRAIT GALLERY

There is a degree of exaggeration here. My mother was not quite the first person to have been treated with penicillin, for all that it was in a very early stage of development. Nor did Chain literally steal the drug – security was not on today's scale – and he did have permitted access to the laboratory. None the less, it was a dramatic, life-saving intervention.

The near-death experience brought home to Patricia that if she died unmarried her parents would surely take her two children, Falcon and me, and never let

their father see us again. Even if Nemon had succeeded in keeping custody of us, at least, now, with her survival, he would avoid the fate of being a wartime alien widower with two small children and no prospect of earning what he needed to support them and himself, except through his efforts as a sculptor. So on 18 August 1944 my father and mother got married. At the time she still had drainage tubes sticking out of her ribs. One witness was Lalla Vandervelde, ex-wife of the Belgian politician. The other was Chain, also Nemon's best man.

As for Chain, he received the Nobel Prize the following year for his part in the great penicillin breakthrough. His contribution was, with fellow Nobel Laureate Howard Florey, to take (the third Laureate) Alexander Fleming's earlier discoveries forward by discovering its therapeutic possibilities and by describing its chemical composition. Chain was knighted in 1969, and Nemon's bust of him is now in London's Imperial College.

There was a much-treasured gold chain that Nemon gave his new wife for her birthday shortly after her life-threatening illness. She said she understood the symbolism as soon as she saw it. It seemed to Patricia not only a chain to bind her to Nemon but also a chain to drag her back to life. Indeed it was after a telephone call from Beachamwell at this time that she bared her soul for her husband in a letter to him. 'Oh, Nemi darling, I was so thrilled to hear your voice. It seemed hardly true after this long time. If I wasn't already in love with you I would fall in love with your voice.' As, indeed, did so many other women.

In the event, neither death nor deportation – nor even emigration – separated the disparate but now formally wedded couple. Nor did the convenience of marriage change their lifestyle. Patricia was not one of nature's most obvious mothers. She was not a good domestic organizer nor much of a cook. Indeed, in 1948 she said she would rather have a typewriter for herself and a television for the children than a 'frig' (refrigerator) and, as far back as 1942, wanting to get nearer to Nemon, lamented that 'perhaps one day there will be television telephones'.

On one level she adored her two children and her husband; on others she was fascinated almost to the point of obsession with her intellectual and poetic pursuits. Her long letters to her often absent husband – her 'darling Nemi' – were full of highly personal interpretations of the meaning of life, of man and woman, of the innocence of children, of Egyptian numerology, investigations of the occult, medieval mystics, the meaning of dreams, sanity and madness, the human soul, the atomic bomb, yogic breathing techniques, the balancing properties of obscene language, Nemon's headaches (perhaps owing to 'repressed emotions'), 'telepathizing' colour, the true aim of Nemon's Temple, her 'sadness and irritation at her own state of conflict', drafts of her poems . . . as well as multiple complaints about the hold her parents had over her with regard to money, rationing and the cost of a second-hand car. In one letter in the summer of 1947 she mentioned that

six-year-old Falcon had been questioning the wisdom of sculpture when it made so little money.

My grandparents continued to keep their distance from the relationship of which they so disapproved. My mother, however, was welcome at their Norfolk home, albeit closely scrutinized. I can recall that we children used to be put on a train to stay at Beachamwell. My father approved, as he thought grandparents were important, and these were the only ones we had. We were met at Downham Market station by Palmer the chauffeur, and the front door was opened by Lacey the butler. Falcon was called Master Falcon and I Miss Aurelia (later there was Miss Electra, too) by the indoor and outdoor staff and by the laundry woman Mrs Winner who lived in a house in the park. I loved going to see her with her enormous earthenware cauldron in which she stirred and prodded the clothes she was cleaning with a long wooden stick. During one summer holiday Falcon noted that Grandpa and Granny had everything made of silver, even the eggcups

Falcon and Aurelia dressed up to meet Queen Mary when she visited their grandmother in Norfolk in 1947

– everywhere you looked it was nothing but silver. Patricia said it was down to the butler, and she herself had never seen it all out on display since she could remember – adding dryly what a comedy life was.

One late night in 1947 my mother wrote to Nemon from Beachamwell Hall about what she called 'the unthinkable'. She recounted that these suicidal thoughts were perhaps due to their 'having a financial talk, my parents and I, and my mother showed herself in such a hard, unpleasant light that even my father was quite shocked. Later that evening she came into the bedroom and said I mustn't think that she did not want to do anything.' Patricia thought that her mother was feeling guilty and to make things up to her in some way agreed to buy her a car. Next day she raised the issue of the car with Constance, partly because her mother had just heard that her life's work was to be crowned in such an auspicious way she might be in a more

generous mood: Queen Mary plus some of her attendants, were coming to tea, as Sandringham, the royal home in Norfolk, was not far away. Patricia's instinct was right. 'At last, and at least, we have a car!' she wrote triumphantly, adding, 'It is an old two-door Morris.'

For the Queen's visit I was dressed in one of my mother's childhood lace dresses, and I was taught to curtsy, while Falcon had an outfit made of cream silk.

Queen Mary had a reputation for removing her hosts' precious china on visits to their homes, so my grandmother made certain that her most cherished Meissen china figurines were hidden from view.

The theme of man and woman was a constant preoccupation of Patricia's, to the point that even she occasionally worried that she was being 'tiresome and overdoing it'. She obviously found it satisfying to pin down the moral of whatever could turn into long discourses – for example, that 'There are three unities to be sought: Unity with Self, Unity with Partner and Unity with Children.' There were flashes of wry humour, too, as when she signed off one of her letters to her husband in New York, 'I wish we could envisage that the Return of our One Jew was the signal for the building of our Own Home!' Above all, she stressed the value of his love to her. 'Darling Nemi, it's so soothing if you love me, then I don't feel that loving you is such an agonizing torture.'

Throughout their life together my mother wrote hundreds, even thousands, of letters to my father. Her endearments included 'Anchor of My Life', 'My dearest darling Chosen One', 'Darling Twin of My Soul', 'Love Experiment and Experience' and even, in an especially benign – or perhaps ironic – moment, 'Dear Fellow Home Builder'. But in all the torrent of words – 'I can hardly catch them as they come to shape them properly' – there are very few enquiries into Nemon's work, his commissions or his prospects. She did, however, occasionally encourage him with philosophical explanations . . . such as her comment in 1943 that his work 'would be a mirror in which people would recognize themselves with a beneficial clarity'.

The business of citizenship became an increasing preoccupation for both of them in the years following the war. Marrying a Yugoslav citizen in 1944 obviously legitimized the children, but Patricia risked losing her own British nationality.

This she had no intention of doing. She wanted their son and daughter to be known as 'Nemon-Stuart'. Nemon, too, wanted to have a British family. He was, of course, conscious of his Jewish heritage, although he was not religious in the sense of belonging to a synagogue. Our upbringing was devoid of the traditions followed by more conscientious and orthodox members of that great faith. But being Jewish was not just part of his fate; it also carried risks in a climate of anti-Semitism – still rife in post-war Britain, despite the horrors of the Holocaust,

and my mother's parents were far from immune to that fashionable disease. In England Nemon seldom talked about his Jewishness. Even his reaction to the death of his close family in the Holocaust was largely internalized.

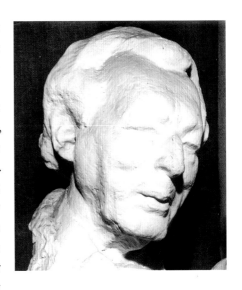

The facts themselves are sketchy. During the early part of the war Eugenie and Deze were living in Aranđelovac, Serbia, on some land that he had been given by Uncle Bernhard Klein, the husband of Eugenie's sister, Margita. Bernhard and Margita were both to die in Auschwitz. It seems that Eugenie and Deze were denounced as Jews by their neighbours. They were captured, taken to Banjica concentration camp in Serbia where they were shot on 3 November 1942. Banjica was a camp renowned for its extreme brutality. If I find it horrific to envisage my grandmother's and uncle's terrible fate, what must it have been like for my father who loved his mother dearly?

Dr Oscar Levy, the Nietzsche scholar who was in Oxford during the Second World War

Only his sister Bella escaped the Holocaust in Yugoslavia – by the skin of her teeth. I learnt from a man whose uncle was involved that a Serbian doctor called Ante Vuletić devised a programme to combat syphilis and persuaded the authorities that he needed medical staff to help him, many of them Jews. Bella was enrolled as a nurse and went to Bosnia in 1941. The staff lived in primitive conditions in a village with no water or electricity and little food. But they were saved and supported and even fed by grateful local people. When in 1943 war between Tito's partisans and the fascist Ustashe approached, most of the medical staff joined the partisans. Their number does not seem to have included Bella, although she did manage to survive. Dr Vuletić later received the Yad Vashem medal of 'Righteous Among Nations'.

Ronald Senator was close to Nemon when my father learnt about the fate suffered by his mother, brother and grandmother. It is hard to date exactly when this dire news reached him, because he seems never to have referred to it in any letter he wrote, certainly in none that has survived. Senator recalled that he was 'profoundly affected, even if he sometimes concealed his pain with a mask, saying with a cynical smile and a backward tilt of his fine head how minuscule was Planet Earth in the infinite vastness of the cosmos and how much fuss we made about it'.

Senator surmised that 'with the guilt of the survivor, Oscar recoiled from creating experimental works of personal feeling, in favour of his now famous sculptures of the leading figures of his time. Nevertheless, his memorial to the victims of the Holocaust in his native Osijek is also a public expression of his own grief.'

Anti-Semitism lurks in the murky background of the attempts to denigrate

REGISTRATION CERTIFICATE No. *461060.*

ISSUED AT *Abingdon, Beaks*

ON *1st December 1944*

NAME (Surname first in Roman Capitals)

NEUMANN, Patricia Frances, Mary, Zielden

ALIAS *NEMON*

Left Thumb Print (if unable to sign name in English Characters)

Signature of Holder *Patricia Nemon*

1

Nationality *YUGO - SLAV.*

Born on *28.9.10* in *London.*

Previous Nationality (if any) *British.*

Profession or Occupation { —

Single or Married *married.*

Address of Residence *"West View" Boars Hill, Nr. Abingdon Beaks.*

Arrival in United Kingdom on —

Address of last Residence outside U.K. —

Government Service —

Passport or other papers as to Nationality and Identity.

Patricia became an 'alien' after her marriage to Nemon in 1944.

and deport Nemon in the years leading up to, and even just after the start of, the Second World War. As war progressed the issue of his official status in the UK continued to plague him and his family. In December 1943 a member of the Belgian Justice Ministry wrote to the Aliens Department of the Home Office enquiring 're. status on marriage of Patricia F.M.F. Villiers-Stuart to Mr Oscar Neumann a.k.a. Nemon. Yugoslav'. In his reply on 4 January 1944 directed to 'Monsieur M. Heilporn' of 8 Eaton Place, a Home Office official wrote that he was 'directed by the Secretary of State to say that while he has no authority conclusively to determine the matter, which is one of law, he is advised that there is no means by which a British woman may on marriage to a Yugo-Slavian retain her nationality'.

The threat to Patricia was very real, considering that seven months later, when she did marry Nemon, she did not specifically and formally request permission to retain her British nationality (although given the hurried and perilous circumstances of the marriage the omission is hardly surprising). In fact, she tried to rectify matters by asking the Home Office, just four days after the wedding, if she could remain British. But it was not to happen so quickly.

Two years later, in October 1946, she sent a letter to the Home Office asking who had been snooping on the family, making enquiries about the children's family name. She queried the identity of an anonymous man who claimed to be a solicitor and who wanted a meeting with Nemon 'on neutral ground' but who could be identified only by his pinstripe trousers. Nemon refused to attend. In August 1947 Patricia wrote again, applying for a Certificate of Identity so that she could travel abroad, but five months later she changed tack, saying, 'now my husband's naturalization is so advanced that the policeman who came to

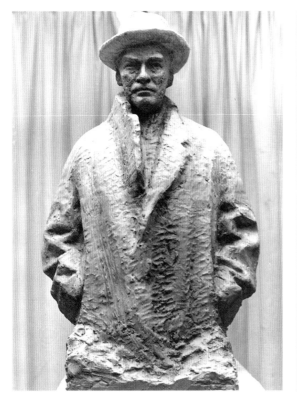

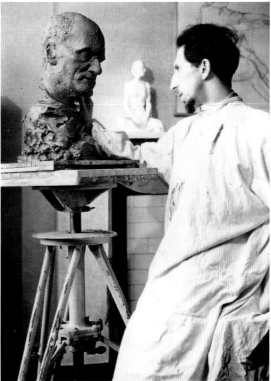

interview him suggested to me that I should also apply for naturalization and in this way regain my British nationality'. Nemon, however, was still having a hard time on each occasion that he travelled abroad, because he constantly had to apply for an extension to the time – usually six months – that he was permitted to remain in the UK.

Meanwhile the Nationality Division of the Home Office continued to wrestle with the problem of whether to grant N. 2072 ('Mr O. Neumann a.k.a. Nemon') a Certificate of Naturalization. The Chief Constable of Oxford, the Berkshire Constabulary and the Metropolitan Police were enjoined to make further enquiries. The dossier on his family, his travels and addresses, political affiliations, status as a sculptor, his finances, knowledge of English and so on and on, grew fatter and fatter through the early months of 1948. Two senior figures in the Ashmolean Museum in Oxford – Karl Parker, described as 'Keeper' and Albert Rutherston, Ruskin Master of Drawing – provided references, as did Dr Gilbert Murray and finally Emma Matthews, described as a 'semi-invalid householder' living at West View, Boars Hill, which was Nemon's and Patricia's address.

The most difficult part of the enquiry concerned the earlier MI5 reports about Nemon's suitability to remain in Britain, which culminated in the decision to deport him. However, in May 1948 Alien N. 2072 was finally cleared of suspicion, although it was noted that MI5 had never explained why he was considered to be

Above left
Sir Karl Parker, Keeper of the Ashmolean Museum, Oxford, 1945–62; the sculpture can be seen in the Print Room of the museum.

Above
Nemon working on his bust of Professor Gilbert Murray who lived on Boars Hill in the 1940s

Falcon, Electra and
Aurelia sitting outside
Pleasant Land in 1954

such a dangerous character, although he had never been rounded up or deported. The new enquiry simply referred to this anomaly as 'curious' and noted that, although 'MI5 had information that he was engaged in espionage, this was never substantiated'. The report from Mr S. Leppard, dated 22 June 1948, ends on a positive note. 'He is evidently a person more concerned with his art than anything else, and, as art is usually considered to be one of the more valuable contributions to civilization, his talents should be regarded as an asset to this country, and in this light I would suggest a favourable decision.'

Recognition at last! Curiously, however, the report ends by saying that 'his wife does not appear to have lost her British nationality as the marriage did not take place until 1944'. Perhaps Patricia's entire struggle had been unnecessary after all. In any case, our entire family had become British.

Until 1948 we lived in a rented part of West View on Boars Hill. Then the possibility arose of buying a piece of land near by with the aid of a little money Patricia extracted from her father. They planned to build a simple house on it. She said she wanted to call it 'Shadows – not far from Shalom or Shadow of Shalom'. On 23 September 1948 Nemon received a rare letter from his father-in-law Patrick, addressed to 'Dear Mr Nemon' and saying that he was 'glad to hear that the house is progressing satisfactorily and that it will be a less flimsy structure than I at first feared'. He went on to say how worried he was about his daughter's mental and physical health and recommended that Nemon take the family away for a good restorative holiday. Shortly after this Patrick died, leaving the dialogue between the Nemon-Stuarts and the Villiers-Stuarts in Constance's unforgiving hands.

A few days after her father's death Patricia wrote to Nemon from Beachamwell Hall. 'I have so clearly the feeling that my father's spirit hasn't stayed here for a minute more that it needed to and has returned to Ireland, the feeling that he could never be a ghost here because he lived here as half a ghost in life.' She found out that he had almost no money of his own to give to her. After a long conversation

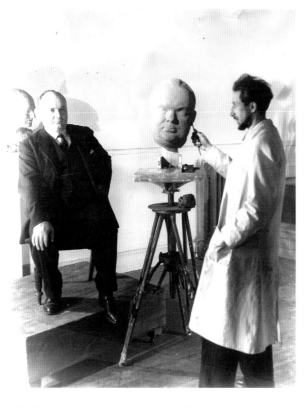

Paul-Henri Spaak
sitting for Nemon
in 1946

with her mother Patricia writes that she sees her 'in her true wickedness'. By the
following summer her view had not changed, writing to Nemon about her mother's
'bitterness and aggressiveness to all members of the Villiers-Stuart family, but it is
well sugar coated . . . Mother becomes, as it were, a charged battery of powerful
concentrated mental evil.' Some months later her tone softened a bit in response to
her mother becoming 'more amenable' over paying for some repairs to the outside
of the Boars Hill house.

Nemon was still living partly in Boars Hill and partly in London at his studio
in Kinnerton Street. Later, in 1954, he took a studio in Tite Street in Chelsea, and
a couple of years after that he moved to Nugent Place in St John's Wood. But in
the late 1940s he was often abroad. Sometimes he would visit his sister Bella in
Brussels – where he also sculpted Paul-Henri Spaak.

America became quite a second home. He was in New York in the autumn of
1947, staying with Paul Federn and remaining there until early 1948; and again
in June 1949 he travelled on the *Queen Mary* to New York and stayed with
his uncle and Aunt Jula, who had long since fled Vienna. Patricia flirted with
the idea of following him, but there was never enough money to make that a
realistic prospect. She was also, I suspect, more comfortable writing her husband
long letters full of thoughts and speculations and philosophical ideas than facing
the reality of uprooting herself and her children. She once even signed a letter

'Penelope' – recalling the fidelity of the wife of Odysseus, who was absent for twenty years before returning disguised as a beggar.

As for sculpture, there were a few commissions, but Nemon was finding it hard to get them. The USA seemed a more likely place to get regular work. On 23 August 1948 when he was back in Britain he wrote to Bella:

> My situation is so serious on account of so many difficult problems that many times I get stupefied by my destiny. Plans for my travel to America are getting nowhere because Patricia's mental state has got worse. I find myself in a conflict situation not knowing whether to stay here and dedicate myself to the children or to leave for America in order to dedicate myself to my work, which would mean placing these poor children into a boarding-school.
>
> In spite of my horrendous headaches I am still perfectly capable of reasoning which makes the whole situation even more painful to me.
>
> The house building is progressing. The children and Patricia are at her parents' in Beachamwell because they could not stay here any longer. There is a good chance of the house being finished by the end of September. Patricia and the children have now a fixed income until the end of their lives which enables them, with or without money from my side, to live well. This means a lot to me, although it should have happened a long time ago as it could have saved us all the bad things that have taken place.

He added, and then crossed out, 'and not now when it is almost too late'. And, of course, he was exaggerating wildly the amount of money his wife and children would have to live on from her parents.

It was not always easy when Nemon and Patricia were together in Boars Hill. My sister Electra, who arrived in March 1950, remembers that her mother would get cross that he was always in his studio, his fingers and hands covered in messy clay, while he hated the sound of Patricia tapping away on her typewriter. But they had good times, too, especially with us three children. Patricia once described the children to their father as 'the junior hierophants of the Nemon Temple of Love'.

Soon after his new daughter's birth, Nemon took off again for the USA and then to Morocco. Patricia was still at war with the 'concentrated mental evil' of her mother.

It was time for a breakthrough in Nemon's life. And it happened.

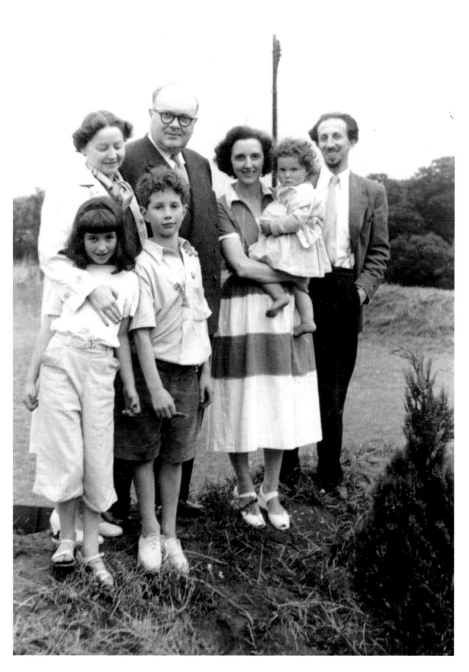

Paul-Henri Spaak and Simonne Dear visiting the family at Pleasant Land in 1952. From left, Simonne with her arm around Aurelia, Paul-Henri, Patricia holding Electra, and Nemon; Falcon is in front.

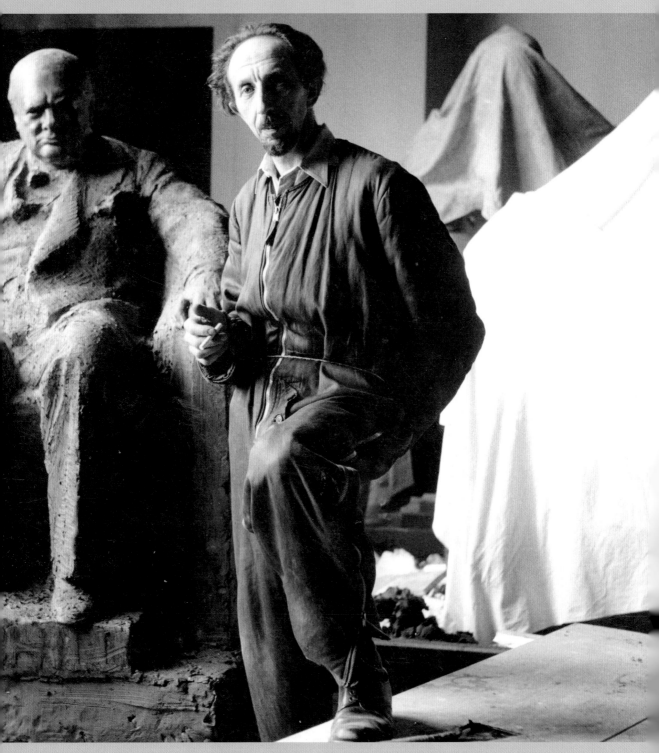

Nemon in his studio with his clay
statue of Sir Winston Churchill which
was about to be cast in bronze for the
Guildhall, London, in 1955

Churchill 9

I T SEEMS ALMOST too good to be true that Nemon and the Churchill family plus entourage came to stay at the same luxury hotel in Morocco at exactly the same time . . . with such important consequences for Nemon's career. There was an element of coincidence. There were also cunning plans . . . but whose plans? And how many of them worked?

Nemon's version of why and how he went to Marrakesh is not a matter of dispute. A friend of his, the French psychoanalyst René Laforgue, invited him to stay in Casablanca to avoid the worst of the British winter and its harmful effects on his health (he was seldom free from headaches). For their Christmas holiday at the end of 1950 Laforgue and his wife had planned to move to the Mamounia Hotel in Marrakesh, then as now a very smart establishment. But for anyone else there was no room at the inn. The Churchill party had booked all available rooms (paid for by *Life*, the American publisher of Churchill's Second World War memoirs) to give the Great Man, then Leader of the Conservative Opposition, the time and space to finish the fifth volume in peace and quiet. The coincidence of Churchill's booking in at the same hotel, however, made Laforgue even keener to press his invitation, sensing an unmissable opportunity for his friend. But Nemon hesitated. Even if he could somehow sneak into the hotel he felt that Churchill, whom he had hero-worshipped from afar for many years, would not take to the idea of sitting for his portrait when he was intent on resting and relaxing and – although my father Nemon didn't know this – writing his memoirs. Nemon said in his own memoir that Churchill 'would certainly not relish being hounded by a sculptor'. But in the end my father decided to accept his friend's invitation.

There is more than one account, however, of the circumstances that led to the portentous first meeting between Nemon and the well-guarded and then reclusive Mr Churchill. Nemon's own goes as follows:

> I went down to the restaurant for a meal and found that Laforgue had managed to reserve a table not far from the Churchills . . . I would be embarrassed to [make sketches] in public . . . but I would make some mental notes . . . After lunch, when I was alone in my room, I started making a sculpture of the head of Churchill . . .

Sketches Nemon
made of Churchill
at La Mamounia
Hotel, Marrakesh,
in January 1951

Afterwards, at mealtimes, my prolonged glances towards Churchill must have given an impression of rather rude attention. Occasionally I became aware of Churchill's studied return of my gaze. I became worried that such activity might be noticed by his Scotland Yard bodyguard, so I hastened to explain myself to this personage. He assured me that my anxiety was quite unnecessary. 'Mr Churchill is used to being looked at,' he replied, 'and he never notices anyone outside the circle of his personal guests. Look at him as long as you like – everyone else does.'

Despite that assurance, Nemon was aware of the possibility of Churchill's displeasure – even 'the possibility of my head making contact with a well-aimed dinner plate'.

He was, he recalled, eventually rescued by a mutual friend. He had met Sylvia Henley, a cousin of Churchill's, during the Blitz. Indeed, she had come to his rescue when he was being cold-shouldered as an impecunious artist by the stuffier members of the Allies Club in London. He could see she was puzzled at encountering Nemon in the poshest hotel in Marrakesh. After a few days she rang his room and asked why he was avoiding her. After hearing the explanation for his diffidence she begged him to show her the small sculpture he had just done of Churchill's head. Full of enthusiasm, Sylvia took it away to show to Churchill's wife. A few hours later Nemon received a note, dated 5 January 1951, from Mrs Churchill.

My dear Monsieur Némon

I should much like to possess the little bust you have made of my husband in terra cotta. Would you be kind and let me know your fee?

Would you allow me to say that I like it so much just as it is, and I think there is an element of risk in altering it. I have seen so many portraits and busts spoilt by attempting to get an exact likeness. Your bust represents to me my husband as I see him and as I think of him, and I would like to have it just as it is. It will be a great joy for me to possess it.

Yours sincerely

Clementine Churchill

This was exactly the kind of praise that Nemon appreciated . . . whomever it came from. He promised not to make any changes and, seizing the moment, said he hoped he might be given the opportunity to do other studies of her husband – 'possibly while he was busy painting'. She agreed.

Nemon remembered their joint expeditions with affection and amusement. He recalled that among Churchill's 'regular attendants' while he was painting was a little one-eyed goat; one day it disappeared, and Churchill's bodyguard was

January 15.1951

My dear Monsieur Nemon,
I had no time before leaving for Tinerhir to reply to your letter. It is indeed generous of you to wish to give me that beautiful little bust

of my Husband. I shall always treasure it. Thank-you very very much.
Yours sincerely
Clementine S. Churchill

Clementine Churchill's letter of thanks for the little bust of her husband

REPRODUCED WITH PERMISSION OF THE MASTER AND FELLOWS OF CHURCHILL COLLEGE, CAMBRIDGE

dispatched to find it – but would only pretend to search for it 'for fear of being presented with a hundred one-eyed goats if the generous-hearted Berbers came to hear of the loss'. Although Churchill disparaged his own attempts at painting and referred to them often as 'my daubs' – 'a child of seven could have done as well', he told Nemon – the sculptor took all this as excessive modesty, noting that 'wherever he travelled, he invariably consulted local painters about the particular qualities of the light where he may be painting'. Later, when they got to know each other better, Nemon allowed Churchill to sculpt his head – the only sculpture that Churchill ever attempted or realized. It is now in the studio in Chartwell.

Dimitri Dimancescu, a Romanian diplomat whose memoirs are presently being edited by his son Dan, has an altogether different version of the events that got the relationship off the ground. It is fair to say that in Nemon's memoirs his recollections are not always factually accurate – for instance, he writes that Churchill was preoccupied with the building of the Berlin Wall during this period in Morocco, although that event occurred ten years later. But even on a personal level Dimancescu's memory is quite different from Nemon's.

The distinguished Romanian soldier-diplomat, who was given a Military Cross for his work in blowing up the Ploeşti oil fields to deprive the advancing Germans in the First World War, was living with his wife in Marrakesh. They had met Churchill's daughter Diana in London, and she was one of the large party at the Mamounia Hotel. The others, he recalls, were Mrs Churchill, Lord Cherwell, Sir Henry Pownall, Colonel and Mrs F.W. Deakin, Denis Kelly, two personal secretaries, Miss Sturdee and Miss Gemmel, the crew of the plane and 'the always-present watchdog provided by Scotland Yard'. Miss Sturdee was the gatekeeper and key to anyone's access to her much sought-after boss. She was

the 'Chinese Wall . . . phone calls were cut short at the hotel's switchboard, and those who managed by trickery to reach Miss Sturdee were met with a gentle but stern "I am sorry."' It seems that the social élite of Marrakesh were deeply disappointed by their failure to break down the barriers to social intimacy with their most distinguished visitor. Dimancescu was all the more astonished therefore to observe the success of a 'Yugoslav sculptor [who] had a narrow head like Mephistopheles with a small moustache and a short pointed beard'. He added, only partly accurately, 'Besides being a sculptor he was also a psychoanalyst and a friend of Sigmund Freud for whom he had created a life-size statue.'

The Romanian then claims Nemon 'had come to the city to sculpt the head of the daughter of Antenor Patiño, inheritor of the Bolivian "Tin King"' and that Señor Patiño was 'footing his bills'. Then 'by tipping the Head Waiter generously . . . he got a table facing the "Old Man" . . . Instead of eating he kept sketching, all the while annoying the restaurant's most distinguished guest with his stares.' This at least chimes with what Nemon remembered. But Dimancescu went much further. He claimed he 'learnt from Miss Sturdee . . . that the management of the Mamounia has been asked to have Nemon seated at some other table'.

> Then one day he appeared at our house, and I had to receive him. Nemon, whom I had never met, had not bothered to announce himself. He brought with him photos of his work which I immediately admired for its artistic qualities. My wife and I invited him for dinner, and till late at night we talked art and psychoanalysis. He was a master of both subjects, and I enjoyed listening to him. I was quickly convinced that he should do a statue of Churchill.

There followed a plan, claims Dimancescu, involving the powerful but volatile Pasha El Glaoui, known as the 'Lord of the Atlas', who agreed to fund this monumental statue, replacing a water fountain near the city's casino with a large bronze statue of Churchill with 'an unobstructed view of the Atlas mountains to the south'. But still 'I did not have the courage to ask Churchill to sit for Nemon. And Nemon-the-artist would not produce a statue without seeing his subject in three dimensions.' This is the point where a very different account is given of how Mrs Churchill came into the picture.

Dimancescu's wife Ze was apparently by now getting rather fed up with the ever-present Nemon who would appear at their house 'at any odd hours'.

> One evening, thinking of a way to get rid of him, I said, 'Look here. I have an idea. Why not try to make a clay model from a small bust I have of Churchill in my study.' He immediately wanted it. The bust had seen better days. It had fallen one day, and the head had broken away from the shoulders. With some fish glue

and soldering metal I had reattached them. Moving his fingers over the bust, he said, 'My hands are itching to work. I want to do something tonight.' Grumbling as he left that it was a much younger-looking Churchill, he took it back to the Mamounia.

He produced a clay model twelve inches high. And somehow, without any of my doing, he got it through the 'Chinese Wall' and into Mrs Churchill's hands.

Finally, this alternative version is back on track. Although the ambitious project for a much larger statue never got past the French authorities – they 'would not hear of having a monument to Churchill before having one of the great Maréchal Lyautey' (the first French Resident-General in Morocco from 1912 to 1925), Dimancescu recalls. It was also bad timing for its sponsor, the Pasha El Glaoui, who was starting a campaign to oust the Sultan of Morocco, Mohammed V, and who had just been banned from the royal palace for insolence.

But for Nemon the Moroccan affair was a total success. However it came about, the ice had been broken in Marrakesh. He not only had his introduction but also had attracted the personal approval, even friendship, of Winston Churchill. Back in England the relationship developed fast. A new royal commission was the first result. Before her coronation the young Queen had expressed a wish to have a marble bust of Churchill to put alongside his famous ancestor, the Duke of Marlborough, in the armoury of Windsor Castle. Churchill, once again Prime Minister, chose Nemon.

It was not a popular choice among those sculptors who felt their reputations

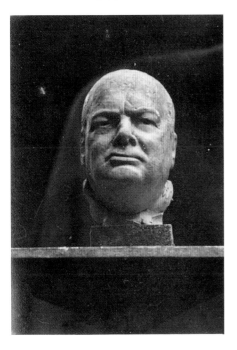
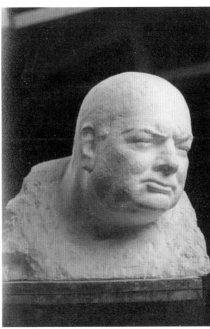

Nemon's marble bust of Winston Churchill commissioned by the Queen for Windsor Castle in the early 1950s

PHOTOGRAPHS BY FALCON STUART

Churchill's 1954
sketch of Nemon
drawn at Chequers
when Churchill was
Prime Minister

WITH KIND
PERMISSION OF
CHURCHILL HERITAGE

had been sufficiently established – two had been recently knighted – and who believed that membership of the Royal Academy put them way ahead of this upstart from Yugoslavia. 'I was informed later', wrote Nemon, 'by Sir "Jock" Colville, Churchill's private secretary, that Churchill resolutely stuck to his choice and disregarded the conventional thinking of the opposition.'

On 15 October 1952 Sir Owen Morshead, the Librarian at Windsor Castle, wrote to Nemon, 'The choice of yourself as a sculptor commends itself to the Prime Minister, who is prepared to give you a sitting in order that the final touches may be added to the model which you have already done from life.' In fact, a month later Churchill gave Nemon two separate sittings. On 20 November my father wrote to Sir Owen, 'The progress of my work depends on this most unpredictable sitter. On Sunday, for instance, I moved to Chequers where I had a very pleasant contact in a relaxed setting. He said to his lordly guests that the honour which has befallen him at the hand of the Queen has touched him more than if she had bestowed upon him the Order of the Garter! So you were right; he is deeply moved and is very proud to be immortalized in company with his great ancestor the first Duke of Marlborough.' (We children and my mother were immensely impressed that Churchill had sent his car to pick Nemon up.)

Nemon also did a portrait bust of Sir Owen himself which appears to be lost. I had hoped that Sir Owen's daughter, Lady May, would lead me to it, but she said she remembered being offered the bust but it was too large for her flat; she didn't know what became of it. Sir Owen's other daughter, Phoebe Woollcombe, told me that her father kept a diary, now in the Royal Archives at Windsor. It might have provided a clue, but unfortunately the diaries are not available for public perusal.

Nemon remained an unabashed admirer of Churchill all his life. Yet sculpting him was never an easy or relaxed task, however much Churchill had championed him against the opposition of the arts establishment.

One consequence of Nemon's closeness to Churchill immediately after his commission, when Nemon was still working on the bust, was his subject's desire to turn the tables. Churchill decided that he should get his own back and try his hand at sculpture by sculpting Nemon's head. 'And so our duel began,' Nemon recalled.

We had not been at work long when he became excited about the difficulties in which he found himself. His cigar began to come to pieces in his mouth and soon he was roaring like a lion over his prey. (It was after two o'clock in the morning, and Churchill had consumed his usual quantity of alcohol.) He shouted at me, 'How on earth can I work when you keep moving?' In the interest of continuing peace between us I kept still after that and, by doing so, lost an opportunity of making a real study of him.

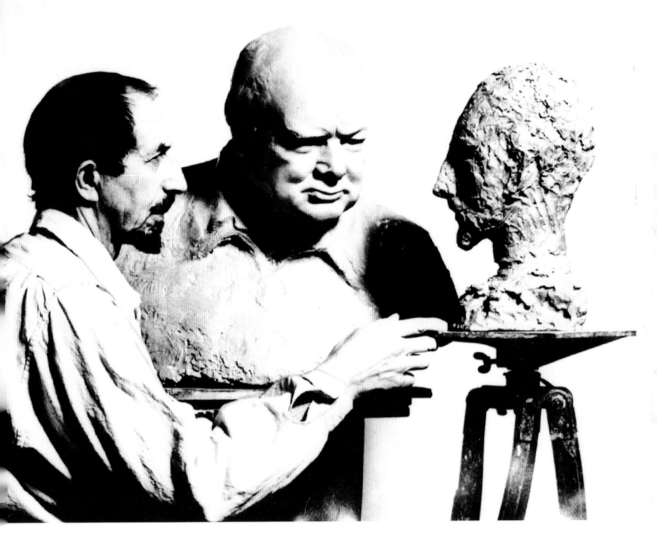

But Churchill persisted and managed to finish the only sculpture he was ever to achieve. Nemon had it cast in bronze and wrote to Churchill later, 'I beg you not to underrate the artistic value of this work, which would be considered by any expert as outstanding for a first attempt.' The first cast of the bust can be seen in Churchill's study at Chartwell and another one is in the Churchill War Rooms in London.

As for the head destined for Windsor Castle, it turned out to be the first of many busts and statues Nemon would do of the Prime Minister, but my father was far from sure at the start how things would work out. He recalled:

The portrait I made was the result of informal meetings at Chequers and at No. 10 Downing Street, where a room was put at my disposal. At No. 10 I worked on three heads at the same time, each showing a different aspect of Churchill. But I always dreaded the after-lunch sessions with my sitter as he was liable to be bellicose, challenging and deliberately provocative. Every time I lunched with him he always offered to sit for me after lunch, and I always dreaded it.

Nemon examining the bust Churchill made of him with his bust of Churchill looking on

Churchill rarely made appointments with me, but one day he did so, and he was obviously in a tense mood. My heart sank as he entered the room and strode over to the three shrouded heads. He pointed to the nearest and roared, 'Show it to me.'

I uncovered it – the most dramatic of the three. I could see his anger rising, and I waited for the outburst. It soon came. 'You think I look like a crafty, shifty war-monger, do you? Is that what you think?' I hurriedly said that I had not intended to give that impression but had tried to bring out his determination and purpose. He gave further vent to his wrath with some remarks about his 'bulldog' image, an attitude he struck for the morale of the nation, saying he was not just a ferocious watchdog but a man compounded of many qualities including about 50 per cent humour.

The bust of Winston Churchill that Lady Bonham Carter said was 'the most magnificent of them all'

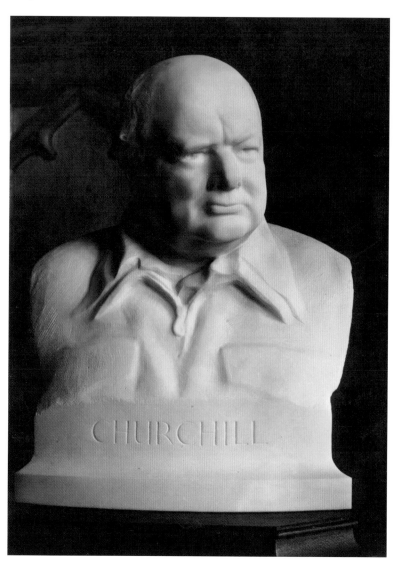

He demanded to be shown the second head. This satisfied him no better. He found the expression too 'intimate' for his taste and said that he wanted a portrait that would convey his features but make no statement; in short, a 'well-mannered and civilized portrait in the style of the Old Masters'.

Fortunately, the third bust was considered satisfactory – Churchill conceded it was 'civilized'. This was the one that was finished and stands today in the Queen's Guard Chamber at Windsor Castle. But Nemon's story of that frightening version of the judgement of Paris had an upbeat ending.

After Churchill stormed out I was sitting in an armchair in a thoroughly depressed state, wondering whether the best course would be for me to destroy all three models, when the door opened and he came back in. His temper had evaporated completely, and he apologized at once. He was extravagant in praise of my work. 'Why, man, you're a genius!' he said, and although the words were most heartening I found it hard to believe them.

Some years later, on 1 July 1956, Sir Owen Morshead wrote to Nemon, partly to inform him that he would be requesting the Privy Purse to send (finally) the remaining payment but also to give his verdict on the Windsor Castle bust.

Now, my dear Nemon, let me say in all sincerity that I like the bust. It is, to my eye, a penetrating and noble representation. It is too big; and this is wilful of you, because you know that I wanted it smaller. But the ingenious idea of placing it in the east window largely counteracts its being out of scale; and for my part I am content. What I wish chiefly to see is whether its present position will satisfy the Queen. If so, all is well.

The Queen was indeed content. Three weeks later Sir Owen reported her reaction. 'But I think it is excellent, don't you? And it looks well there, too; the only thing being that it shows the wrong side of his face.' Sir Owen quickly pointed out that, placed on the flank of the room, it was immediately seen by the public. 'She was quite contented,' he assured Nemon. 'It was evident that she really does regard it as a success and a desirable acquisition.' So relief all round.

This was far from the last bust Nemon did of Winston Churchill; indeed, the rest of the family queued up to have his magic fingers press their likenesses into shape.

It might be thought that Nemon himself would have become rich and famous as a result of all these commissions. My father, never pushy and always eager to please, accepted the honour, as he saw it, as being sufficient reward for being

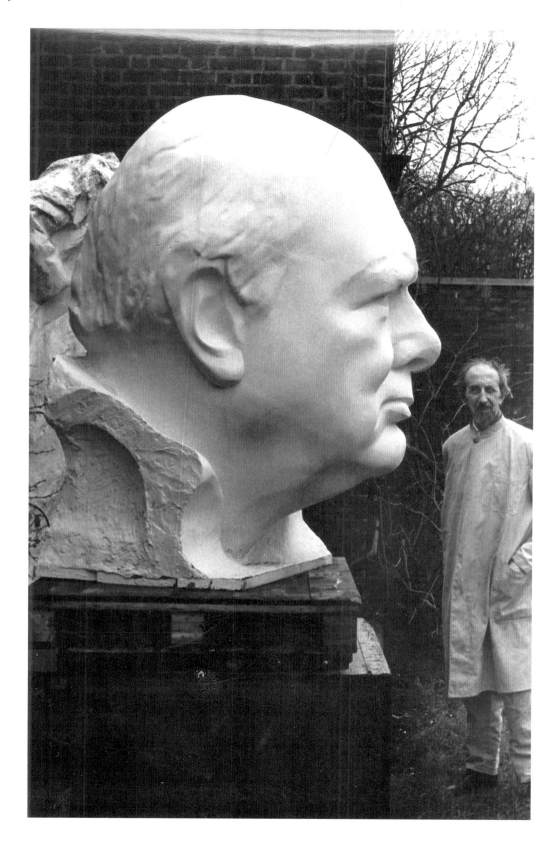

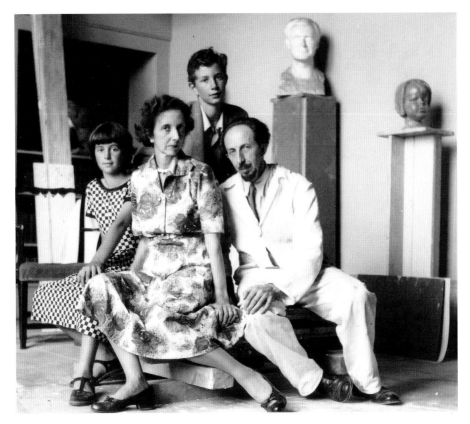

Left
Nemon, Patricia, Falcon and Aurelia in Nemon's studio, 1954; in the background are Nemon's busts of Churchill's son-in-law Duncan Sandys and Emma Soames, Churchill's two-year-old granddaughter.

Below
Randolph Churchill with his bust at his home in Stour, 1960s
PHOTOGRAPH BY FALCON STUART

given such prestigious work to do. A letter from Lady Churchill dated 11 February 1955 sheds some light on the situation, as she writes, 'It is most generous of you to say that the cost of the statue of my Husband, which I hope may be placed in the Museum at Chartwell, will be on the expenses of casting. Please accept my warm thanks.' Nemon always believed, despite the evidence, that one major work that he did virtually at his own expense would inspire others to pay him handsomely for his next commission, but it never quite happened like that.

Of course, he carried on regardless. The Duchess of Marlborough slipped him 18 guineas for doing the head of her young son, Charles Spencer-Churchill. Randolph Churchill, always short of a bob or two himself, nevertheless lined up his father's favourite sculptor for his own portrait.

Son-in-law Duncan Sandys was another sitter, and the bust now belongs to his daughter Laura.

Lady Soames and her daughter Emma, then aged two, were done in their turn, not to mention Jane, the daughter of Churchill's private secretary, Anthony Montague-Browne, and other political friends such as Lord Feversham, Sir Harry Brittain, Sir William Deakin and the Earl of Dalkeith as an undergraduate at Oxford, before he became the 9th Duke of Buccleuch.

The involvement of the young Queen Elizabeth in the choice of Nemon to

Below
The Earl of Dalkeith, aged twenty-one, Oxford, 1944; he later became the 9th Duke of Buccleuch

Opposite
Nemon with one of his busts of Churchill
PHOTOGRAPH BY FALCON STUART

sculpt the Windsor Castle bust of Churchill had many long-term consequences. One negative one was the suspicion that grew in establishment art circles, not least the Royal Academy, that a foreign infiltrator had come to London and was getting commissions that they should rightly have been awarded. But, on the plus side, the Queen's choice of Nemon not only marked the start of a long and productive relationship between him and the Royal Family but cemented what would turn out to be a very friendly and close relationship between the once and future Prime Minister and the charismatic Jewish sculptor.

The Jewish element was important, because Nemon recognized early on that Churchill had a real sympathy for, and awareness of, the historic plight of the Jewish people. In their many conversations together, while the sculpting was occurring or over dinner or during walks in the Chartwell gardens, the subject of the Jews came up frequently. Churchill, Nemon recalled in his memoir, particularly respected the fact that they were the first to abolish slavery through the invention of the Sabbath when nobody's labour could be exploited. He would regale his sculptor friend with stories of his support as far back as 1906, when leaders from the Russian Jewish community came to him as the Liberal Under-Secretary of State for the Colonies, pleading for the right to settle somewhere in the British Empire. In Nemon's recollection, Churchill's reply was, 'Of course we could find you somewhere, but you have been praying for 2,000 years for Jerusalem to be restored to you. Your prayers were not that you should be given Uganda. Go on seeking Jerusalem', which, of course, with Balfour's help, they eventually did.

Nemon wrote:

> Winston Churchill had a deep-rooted belief that God treats nations as they deal
> with the Jews. From his study of world history he had come to this belief, and he
> held it as a firm conviction. (He regarded Disraeli's role as maker of the Empire as
> a proof of this, and he had a great personal admiration for his predecessor.)

One day my father was at a lunch at Chequers along with Field-Marshal Sir
William Slim. As the conversation became more political Nemon began to feel
uncomfortable and asked to be excused. Churchill said, 'If you are a friend, stay!
And, Field-Marshal, I am sending you to Egypt, and I want to make one point
clear. I am a Zionist, and I want you to act accordingly.' This amazed my father,
that Churchill should show such courage when, as Nemon wrote, 'there was
a universal atmosphere of anti-Semitism'. He quoted Churchill as saying, 'We
owe an incalculable amount to the Jews. The great inventions of the twentieth
century have been made by Christians and Jews, as though God had revealed
His secrets especially to them' – citing Weissman's invention of TNT in the First
World War and Einstein's contribution to atomic science 'with which we were able
to put the seal on the end of the Second'. But, 'with his own peculiar ambivalence',
Churchill told Nemon that he reproached the Jews for bringing Communism
into the world as an 'unnatural offspring of intolerable urban life. I cannot bring
myself to forgive the Jews for producing Karl Marx.'

Churchill, Nemon remembered, was also puzzled by what he saw as an
anomaly in Christian thinking:

> He thought it an extraordinary feature of Christian civilization, based on the twin
> beliefs in the primacy of love and the practice of forgiveness, and yet allowing
> the systematic segregation of Jewish citizens into ghettoes for centuries. Quite
> apart from the religious considerations and particular tenets of faith, any social
> philosophy that could tolerate the planned degradation of large numbers of a
> community would be totally abhorrent to Churchill, who was an unashamed
> protector of individual freedom and dignity all his life.

Nemon was witness to many of Churchill's dinner-time conversations . . .
some of which would turn into rants. He recalled in his memoir one occasion
when Diana, Churchill's daughter, asked him if he intended to keep the traditional
vigil that followed the conferment of the Order of the Garter. He said he had sent
the Queen a medical certificate to exempt him. Diana declared that this was a
gross breach of tradition, a disregard of religion and, above all, a denial of divine
sovereignty. This was a red rag to a bull, well pumped up with food and wine. She

declared that when the day arrived St Peter would certainly dispatch him to Hell and would point in accusation to Dresden and Hiroshima.

> At that point Churchill loosened his jacket and said, 'I should stand my ground against St Peter. Yes, I'd fight him. I defended my country and my children against a madman . . . yes, a madman! A creation of the Almighty, too! In my position, I have known full well the intrigues and the quarrels within the churches. It was I who nominated all those bishops, those archbishops, those Dr Garbages (Garbutt) and those grave rabbis as well. I've been the arbiter in their disputes and you expect that I, knowing as I do their behaviour, can have respect for the God they pray to?' He carried on like this for about an hour, declaring he felt no guilt for what he had done. 'I was determined not to let that monster invade my country – even by means banned by the Treaty of Versailles. For that, if needs be, I'd willingly go to hell!'

This was the fighting spirit that appealed to Nemon, whose closest family had been the victims of Hitler's Holocaust. But he liked Churchill's softer side, too . . . when, for instance, he hesitated over carving a large roast chicken that had been set in front of him. When Lady Churchill urged him to get on with it, he replied, his eyes still fixed on the dish, his voice fraught with emotion, 'I'm just wondering if this is Ethel.' Nemon recalled that Churchill cared about all his pets and would never sit down at table without having first ceremoniously fed his dog Rufus. In the garden at Chartwell a robin would come and perch on Churchill's head. Another tale from Churchill's rich dinner-table repertoire was about an ageing horse in his racing stable, Colonist 11. Before the race he talked to it in its stall, telling it that if it won he would buy it a nice field of its own in which to retire. The animal ran a poor race, and Churchill was convinced that this was because Colonist 11 had its mind on the lovely, rosy future it had just glimpsed and not on the race itself.

Perhaps the most difficult of Nemon's statues of Winston Churchill to execute was the one for London's Guildhall. On 9 December 1953 a Special (Guildhall Reconstruction) Sub-Committee of the City's Court of Common Council 'resolved that it be recommended to the Grand Committee that Mr Jacob Epstein be asked whether he would be prepared to undertake the execution of a bronze head and shoulders bust of Sir Winston Churchill'. Nothing came of this, but a month later Nemon had moved into the frame, with the same price tag of a thousand guineas, which my father accepted, saying it 'would cover his expenses so far as he was able to judge'. In November 1954 he came back with a model for a large seated figure, this time costing £3,000, a sum that was submitted by the Grand Committee to the Coal and Corn and Finance Committee, a strangely named body which was nevertheless responsible for finding the cash. They thought about opening a

Nemon in his studio with his clay statue of Sir Winston Churchill, which was about to be cast in bronze for the Guildhall, London, in 1955

subscription by Members of the Corporation but 'negatived' the idea. It seems that Nemon realized that other sculptors had also been consulted and were ready to accept the original fee. In any case, when Churchill was consulted, he said at first he did not know any sculptors but, pressed to actually look at the list presented to him, stopped at Nemon's name. 'They brought me the great news (to my dismay)', my father recalled, 'and tried to convince me that there would be many benefits from obtaining such a commission. Alas, from experience I knew that there are no such advantages when one is asked to make a memorial of someone.' Churchill, it appears, actually would have preferred a full-length statue (this was the time of Graham Sutherland's controversial portrait, and Churchill had more confidence

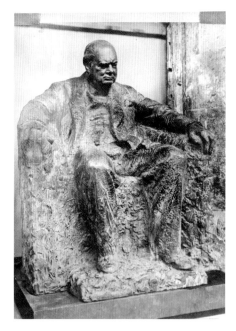

Nemon's statue of Churchill in the Guildhall, London; the statue was unveiled by Winston Churchill in 1955.

that Nemon would come up with something of which he would approve).

It was not an easy commission to fulfil. Churchill was depressed, but finally – when the statue was almost finished – came to the studio for a sitting. He seemed satisfied, but Nemon remembered:

When Churchill heard about the derisory fee he summoned the Lord Mayor to No. 10 and said, 'I hear you have commissioned my sculpture and you are making the artist pay for it. If you need money, I will lend it to you.' It brought no response. When I mentioned it to wealthy people in the City myself, I was just as unsuccessful. It was hard to believe they had no sense of history. Perhaps they were only too eager to forget about the war so that they could get on with their business of making money once more.

It was the old question of prestigious commissions without financial reward. A further problem was Churchill's unavailability for sittings. With just three weeks to go before the unveiling on 21 June 1955 Nemon began to grow desperate. The only thing to do, he realized, was to find a model with the same massive build and get on with the job. So he went round to the pub nearest his Chelsea studio and happened to see a familiar face, the daughter of the Russian ambassador. She said she could produce a dozen acquaintances of comparable dimensions with the greatest of ease and promised to send someone along. A day later a man turned up who was physically suitable and seemed very civilized, expressing great admiration for Churchill.

When he knew the pose I wanted in order to shape the figure and the drapery of the clothing, he said he had an armchair that would be just right. So he arranged for it to be delivered to my studio, and he came for sittings frequently – in fact more frequently than was strictly necessary. Despite his interesting conversation – he appeared to be a journalist who knew a great deal about many prominent people – he eventually became an embarrassment.

The embarrassment turned out to be real enough, but not for any reason my father could have suspected. The first intimation of trouble came when a *Daily Express* reporter rang up the day before the unveiling. He would not be fobbed off by being referred to the City of London, Nemon's clients, saying it was a more personal matter. Did Nemon use a man called Hamilton as a model?

I had to say yes. Did I know he was a notorious fascist? I did not. Was I aware he had been gaoled twice by Churchill in the two world wars? Of course I never dreamt that such a person would be introduced to me – least of all through the Russian Embassy. Naturally I was appalled. I did all I could in high places to put pressure on Beaverbrook not to publish Hamilton's story, which would certainly cast a cloud over the unveiling. But, as many knew to their cost, whenever there was a conflict between good behaviour and good journalism, with Beaverbrook journalism invariably won.

The only concession the press baron made was to delay publishing the story until the day after the unveiling ceremony. This passed off well, with Churchill expansive in his praise of Nemon during his speech in front of the world's media. 'I greatly admire the art of Mr Oscar Nemon whose prowess in the ancient realm of sculpture has won such remarkable modern appreciation,' he declared. 'I also admire this particular example, which you, my Lord Mayor, have just unveiled, because it seems to be such a very good likeness.' But the Hamilton affair left a nasty aftertaste.

When I was having lunch with Churchill several weeks later, he asked me how it came about and I told him – without being able to calm his anger. 'If I'd known this would happen I'd have sat for you at midnight' was his answer. But it was too late, as the rogue Hamilton had pocketed his money. My stand-in problems were not always so troublesome. After the unveiling of a Churchill statue in Mexico I apologized to his daughter Mary for the fact that it was the third statue she had now encountered with the head of her father and the body of her husband Christopher who had posed for it. 'That's all right,' came her reply. 'Just as long as you keep it in the family.'

In fact, Nemon kept on revising the statue after its unveiling. He was dissatisfied with the hands – 'they are the expressionless hands of no one', he told the *Sunday Express*. Churchill also wanted one of his feet brought forward to increase the depth of the figure. The Town Clerk found all these modifications hard to handle, professing to find Nemon difficult to deal with. He cannot have been happy when an alternative model of the entire statue was produced . . . only for Churchill to say he preferred the original version 'with the exception of the hands'. It was as well that the 'bronze' statue unveiled in June 1955 was, in fact, a bronzed plaster because tinkering went on until the end of the decade. In January 1959 it was tilted forward slightly when it was erected in a new position in the Guildhall.

Some years later Nemon took a friend to see his statue *in situ*. He was shocked

to see that it had disappeared. He discovered that it had been sent off to a foundry to have another cast made – for sale in South America. The City of London, it turned out, had included in Nemon's contract a clause whereby the artist signed away his copyright. Only after a long battle did they admit this was somewhat unfair and finally gave Nemon a small slice of the profit.

Churchill was always attracted to the USA, not just because he was half-American himself – and indeed was made an honorary citizen of that country. One weekend in the autumn of 1956, when the result of the US election was about to be announced, Nemon was staying at Chequers and came into the front hall late on Sunday morning to find Churchill staring at his fish tank. He pointed to a procession of half-a-dozen spotted tawny fish he named as 'leopards' and proceeded to identify each of them. A lean and haggard one with a pronounced nose swam by. 'That's Monty,' Churchill said. Pointing to a round fish with a puckish face, 'That's Max [Beaverbrook].' A massive black fish pushed its way to the front. 'Mussolini.' A rather unpleasant fish with a tuft of hair sticking up on his head thrust itself forward. 'Ah – there's Hitler.' A neatly spotted speckled one swam into view. 'There's Anthony [Eden] – and that one there is a widower.' Nemon asked how on earth he knew that. 'We buried his wife yesterday,' said Churchill.

> Then Churchill's secretary came up and said, 'Sir, we have just received the news from Washington that Eisenhower has been re-elected president.' Churchill remained motionless in front of his aquarium. Then he turned to me and said, 'And now I shall also have a fish that can talk.' I said that I never knew such a fish existed. 'Believe me, it does,' replied Churchill, 'and this one speaks with an American accent.' There was something of an echo of these reflective sessions in front of his pet fish when he returned in his last years from Cabinet meetings and would sit at the table gazing into space and mumble, half aloud, 'Those hungry eyes. Those hungry eyes! I really should resign. One cannot expect Anthony to live for ever.'

One further demonstration of how close Nemon became to the Churchill family was his friendly and supportive relationship with the eldest daughter Diana, who suffered from periods of fragile mental health. Her sister Sarah Churchill wrote in her memoir *Keep On Dancing* that 'Oscar Nemon, the Jugoslav sculptor, was to do what I think were the finest sculptures of my father . . . and was an enormous support to Diana. His help cannot be over-praised.'

When Diana died suddenly in 1963 I was with my father in Boston for the unveiling of his bust of Freud at the Boston Psychoanalytical Society. Nemon was very upset at the news and immediately flew back to England. Diana's mother,

Clementine Churchill, wrote to him after her daughter's death thanking him for being 'a great source of pleasure and comfort to Diana'.

Nemon made many more representations of Winston Churchill. The most famous must be the one in the Members' Lobby of the House of Commons – the one where Churchill is striding through the rubble of war-damaged London. As Nemon said, 'I was trying to express an idea of impatience and hurry, of a man wanting to see something done.'

Shortly after Churchill's death in 1965 an All-Party Committee was set up to find a suitable way to erect a memorial to Sir Winston Churchill, with the Labour MP Manny Shinwell as its chairman. The ten-year rule, which laid down a convention that no statue of a deceased statesman should be erected in the Palace of Westminster within ten years of their death, was promptly waived by the Speaker. The Committee decided to commission Nemon to make a bronze statue which would be placed on the vacant plinth by the Churchill Arch, opposite the statue of Lloyd George.

The arch has been left in its slightly dilapidated state because Churchill refused to accept the advice of the Minister of Information after the House of Commons was extensively damaged in a bombing raid that no publicity should be given to the disaster. The Prime Minister replied that, on the contrary, 'Publish it to the world, and leave that arch to remind those who come after how they kept the bridge in the brave days of old.'

This statue is famous for its shiny toe, which is touched for luck when the staff's attention is distracted. The first people who gave the toe a quick rub were

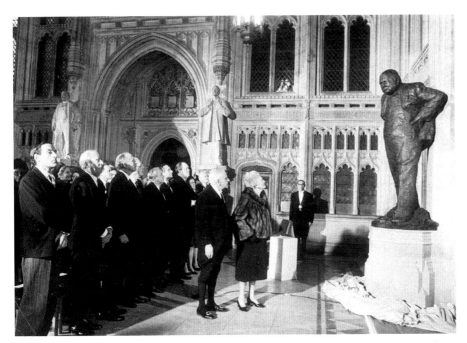

Lady Churchill unveiling Nemon's statue of Winston Churchill in the House of Commons in 1969; four Prime Ministers were in the audience: Edward Heath, Alec Douglas-Home, Harold Macmillan and Harold Wilson.
GETTY IMAGES

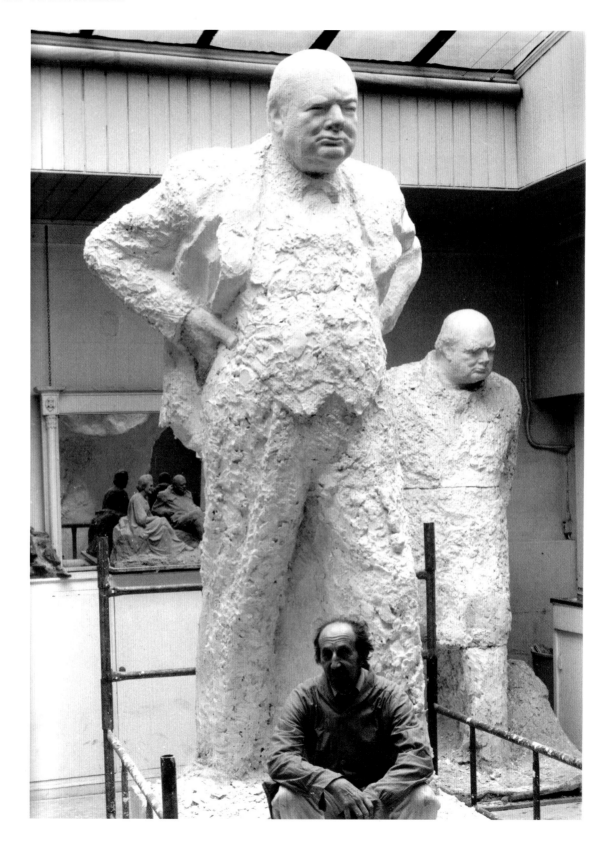

Lord Shinwell celebrating his ninety-eighth birthday; Nemon's bust of him can be seen in the Lower Waiting Hall in the House of Commons.

MPs on their way to make their maiden speech. This rubbed away the bronze patina, leaving a conspicuously bright golden toe – to the extent that its sculptor used to come in at weekends with a pot of bronze paint to touch it up.

Nemon also made a bust of Manny Shinwell, and this can be seen in Lower Waiting Hall of the House of Commons just off the Central Lobby.

Other famous statues of Churchill include the large portrait of him and his wife Clementine in the garden of their Chartwell home, and more are on public display in Mexico, Copenhagen and Brussels (on the rond-point Churchill in that city) to Westerham in Kent, Quebec and Kansas City.

Smaller busts of Churchill, of course, appear everywhere – the British Embassy in Paris, Conservative headquarters in London, the Forest Hills of Nazareth, Monte Carlo, the Capitol in Washington, DC, Churchill College, Cambridge, Blenheim Palace, Montefiore Gardens in Jerusalem and the National Portrait Gallery . . . not to mention reproductions on plinths, desks, tables and window-sills all over the world. It is widely recognized that the 'standard' and finest busts are those originally made by Nemon, however often they have been copied.

Certainly one of the most popular – and accessible – representations was the famous Churchill crown or five shillings from 1965. Remarkably, it was the first time that a coin of the realm contained the head of the monarch on one side and the head of the subject on the other – the Queen had to give her express approval for this innovation. But the choice of artist to do the job was not straightforward. First in the field was a man who was runner-up in the competition to do the first coinage portrait of the Queen at the start of her reign in 1953, Cecil Thomas.

Opposite
Nemon in his St James's Palace studio with two plaster casts of his statues of Churchill

The 1965 Churchill crown

Aggrieved at losing out to Mary Gillick around the time of the Coronation, he had made himself unpopular to the people at the Mint who were entrusted with making the choice. Another candidate was much younger and really only there to make up the numbers. Nemon may have been thought of as the 'wild card', but in the end he was the prime choice. Martin Charteris was drafted in to make sure my father finished the work on time – his reputation for late delivery had got around.

Nemon always loved doing reliefs, but he had never sculpted a coin before, and there were bound to be technical problems. For one thing, each cupro-nickel crown had to be struck by two extremely heavy presses (one of 250 tons and the other 360 tons). The Royal Mint itself described the Churchill Crown as 'one of the most difficult ever produced'. It meant that some details had to be cut out – such as Nemon's small initials to the left of the head, which were approved but then deemed impractical – and the relief was flatter than the artist had intended. Indeed, Nemon was not at all happy with the result. Four years later he was persuaded by a maverick American entrepreneur called Neil Cooper to rework the Churchill portrait on another version of the crown, adding 'D-DAY 1944' underneath and designing a Churchill coat of arms for the reverse.

Meanwhile, the original crown was a big success with the public. After just two months, by November 1965, about three million were circulating worldwide, particularly in North America. By March the next year more than three times the number of any previous crown issue had been struck. Nemon's Churchill Crown, despite its heavy weight, was damaging pockets all over the country (even if some taxi drivers were hesitant to accept it as real money). A writer in the *Daily Telegraph* said that 'the massive jingle of a couple of these coins in my pocket has a far more heartening effect than any tatty old ten-bob note . . . is it not a better memorial to Churchill to have his coin readily moving throughout the honest business of a free kingdom?'

There has been no greater admirer of Winston Churchill than my father. In his

The statue of Churchill in Westerham, Kent

Nemon with his statue of Sir Winston and Lady Churchill, which now stands in the garden at Chartwell House, Kent

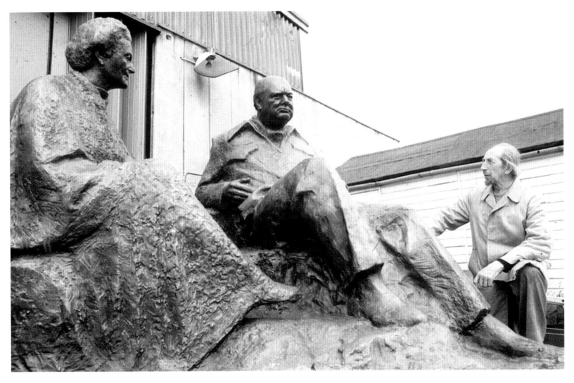

speech at Nemon's funeral his friend Albi Rosenthal said, 'For Nemon, Winston Churchill symbolized greatness of character as a bulwark against inhumanity – this was the mainspring of Nemon's message, as expressed in the numerous busts and statues of Churchill now in many lands' (tribute printed in Albi Rosenthal's book of essays, articles and other writings *Orbiter Scripta*).

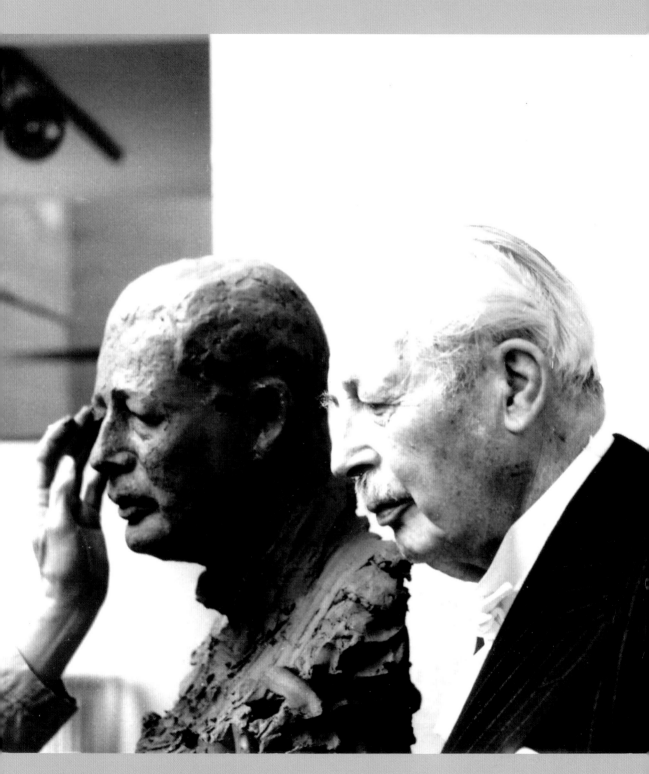

Harold Macmillan posing
for Nemon
PHOTOGRAPH BY
FALCON STUART

... And Other Celebrities 10

NEMON REGARDED MAX Beaverbrook as the 'one man Churchill was close to who might well have led him astray'. The press baron tried to tempt the sculptor into selling gossip shared by his celebrity clients – believing that most people could be bought, especially anyone in need of some ready cash, as was always the case for Nemon – but

> He used to get furious with me because I withheld information about people I knew and he knew I knew, and he also disliked my habit of shying away from publicity. He wrote himself in one of the paragraphs of his gossip column in the *Evening Standard*, 'And Mr Nemon will also be there but will be invisible.'

Despite this, Nemon sculpted a head of Lord Beaverbrook in the spring of 1962, when Beaverbrook was turning eighty-three and my father was simultaneously completing his bust of the Queen for Christ Church, Oxford. In their biography of the curmudgeonly Grand Old Man of Fleet Street, Anne Chisholm and Michael Davie record that in his will Beaverbrook left Lady Beaverbrook no money but a portrait by Graham Sutherland, a bronze head by Nemon and 'all gold and silver boxes and all musical boxes of which I die possessed'. Clearly the bust was appreciated in his lifetime. And after his death it 'formed the centrepiece of the last posthumous ceremony in the town square of Newcastle, Miramichi, New Brunswick: a larger-than-life head of a man with his coat collar turned up, frowning into space, mounted on top of a rough sandstone plinth . . . It was into the base of the plinth that, at the climax of the ceremony, Lady Beaverbrook placed an urn reported to contain Beaverbrook's ashes.'

My father's increasingly close connections to the political (if not the artistic) establishment started to pay off with other commissions. One such was of the founder and benefactor of St Antony's College, Oxford, Antonin Besse. This went down especially well with Madame Besse, who unveiled the bust of her late husband in the college library – so much so that Nemon did a bust of her, too. This in turn was followed by a commission to do a bust of the First Warden, Sir William (Bill) Deakin, who was about to retire. However, his wife Pussy Deakin

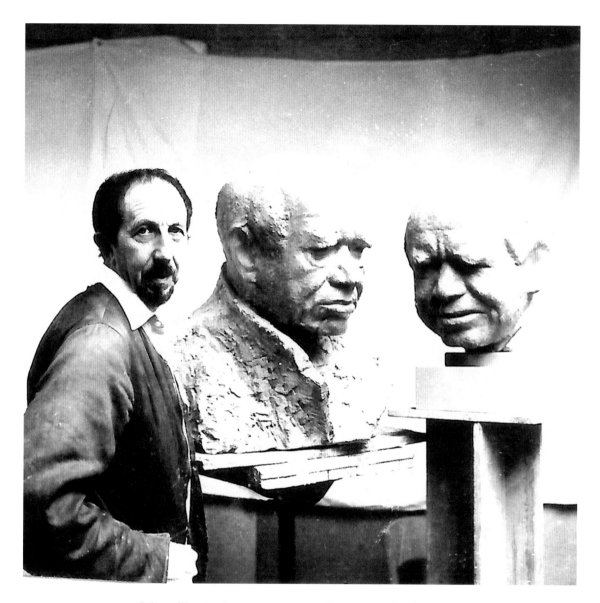

Nemon with his busts
of Churchill's friend the
newspaper proprietor
Max Beaverbrook
PHOTOGRAPH BY
FALCON STUART

did not like the first attempt, considering it too burly, so Nemon reduced its bulk.
This dragged on until the college lost patience, declaring that although 'to his
wife it might not seem a flattering piece of portrait sculpture, it is certainly Sir
William Deakin as the artist sees him'. Actually, the subject himself was not best
pleased either, saying that his portrayal 'looks as if I am suffering from advanced
tonsillitis'.

In 1955 the Ministry of Defence asked Nemon to make a sculpture of
Field-Marshal Montgomery of Alamein. Four years later it came to pass. The
blimpish Field-Marshal and the intellectual foreign and Jewish artist might be
thought to have little in common, but they shared one characteristic that each
noted and appreciated in the other: personal charisma. It was Montgomery's

initiative in building bridges with China that Nemon picked out in his memoirs, ignoring the more controversial aspects of Monty's politics, his support for Apartheid and his opposition to the reform of the law criminalizing homosexual behaviour. 'Personal contact', wrote Nemon in his memoir, 'could be an uncomfortable experience because you could never forget that you were in the presence of an unusual individual with strongly held convictions.'

The Field-Marshal was nothing if not abrupt. His first question to Nemon was, 'How long will it take you to finish this sculpture?'

When Nemon said he really didn't know, Montgomery barked, 'Who should know then?'

Nemon mumbled something about it depending on how difficult the subject was.

'All right, then,' said Monty. 'How many sittings did the Queen give you?'

'Ten,' Nemon replied nervously – although in truth he had only seven sittings with the Queen.

'How long each?' Monty demanded to know.

'An hour – approximately.'

'What a waste of time! Anyway I'll give you ten sittings, too.' Nemon's assistant at the time, Nigel Boonham, remembers that in fact the number was nearer four or five.

It was hard to get Monty to stay still. He would jump up and do some gardening at any moment. Nemon compared the sittings to tailor's fittings – intervals during his restless comings and goings. From time to time Monty would issue nuggets of wisdom to his visitor. 'No such thing as green fingers – silly idea.' Or 'There's no luck on a battlefield – only hard work and hard thinking.' Or, in reply to a request to frown, 'No, I never frown. Silly people frown.' To Nemon's forays into giving his own opinions, Monty would say, 'In the Balkans perhaps but not here. Not in England.'

Sir William Deakin, the Warden of St Antony's College, Oxford, 1950–68

PHOTOGRAPH BY DAVID PARKER

'I came to believe', Nemon wrote later, 'that Churchill was probably the only man in England daring enough to tease him to his face', but he was also generous, in retrospect, with his praise for the Field-Marshal's 'indomitable patriotism'. My father was inclined to give Monty the benefit of the doubt. 'His directness and amazing frankness led some people to accuse him of vanity, but it was often simply the impression left by his concern for truth, his lifelong habit of speaking his mind and his care for clarity which was admirable but without tact.'

It is even likely that Montgomery thought well of the statue that was done of him. In August 1960 he wrote a letter to Nemon asking what the situation was

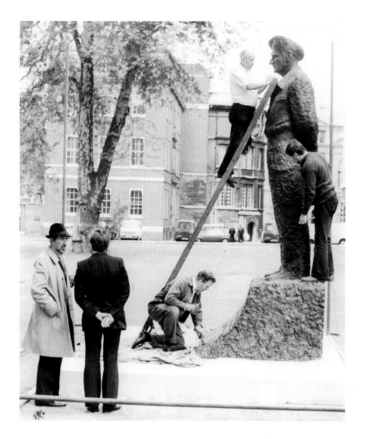

Statue of Field-Marshal Montgomery in Whitehall, London

regarding the bust he did last summer. 'You were going to give me a small one for my study.'

The large statue of Field-Marshal Montgomery in an 'at ease' pose and with trousers and base made roughly (from 'slushy rubble' according to Nigel Boonham) was finally erected in front of the Ministry of Defence just off Whitehall in 1980 on the anniversary of the D-Day landings. Its position has been moved slightly on several occasions, but the decision to site it opposite the Ministry of Defence was defended by Monty's brother, who said that the old soldier was proud to have entitled one chapter of his memoirs 'A Nuisance in Whitehall'.

Not all the unveilings and ceremonies went without incident. The Belgian politician Count Yves du Monceau told me how in 1967 he came to Nemon's studio in St James's Palace to commission a statue of Winston Churchill to erect in Brussels. While he was in the studio the Queen Mother joined them, and they discussed their different ideas of how the statue would look. A ceremony was planned for the unveiling by Princess Margaret on 13 October. Count Yves became increasingly worried when the statue had not arrived by early October. Every day he went to the newly named 'Churchill Square' hoping to see it *in situ*. With only a day to spare, to his great relief, he found some workmen installing the statue on its plinth. One of them called him over and tapped the statue, saying,

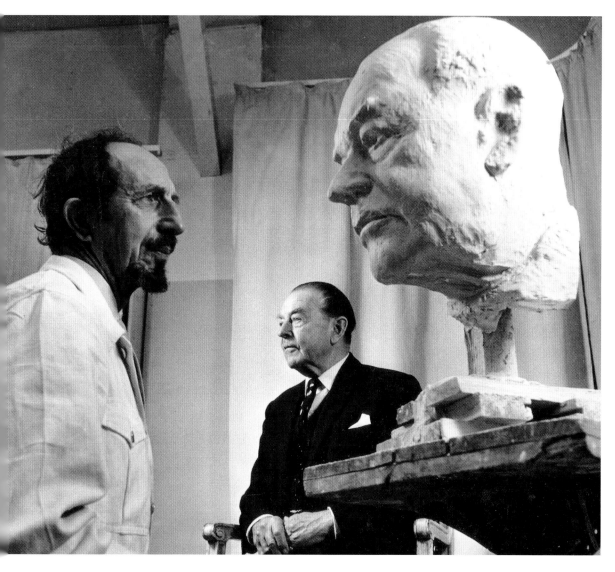

Lord Alexander of
Tunis posing for his
bust in 1978
PHOTOGRAPH BY
FALCON STUART

'This isn't bronze; it's plaster painted to look like bronze. The bronze one will be coming soon.' The ceremony went smoothly, and all would have been well if there hadn't been a heavy rainstorm which started to wash away the paint and made it look as if the statue were melting. Count Yves told me that he had to erect some sort of scaffolding and discreetly dry the paint with a hairdryer until the solid bronze version arrived.

Count Yves also commissioned a copy of the statue of Montgomery for Brussels. He was invited to the unveiling of the statue in London. After the ceremony he heard a woman say, 'Monty would not have liked to be seen wearing those trousers. He was a stickler for perfect creases.' So Nemon was asked to improve the creases before the statue was put up and unveiled in the Belgian capital on 7 September 1980.

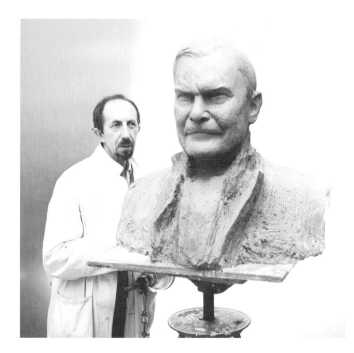

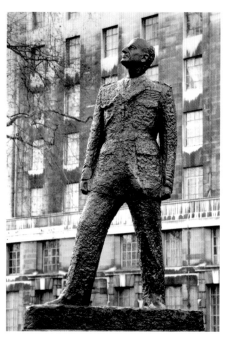

Two more field-marshals came to Nemon's studio for sittings: Earl Alexander of Tunis and Lieutenant-General, Lord Freyberg (the bust of the latter is now in New Zealand House in London).

Among Churchill's other close wartime colleagues was his Chief of Air Staff Charles 'Peter' Portal, later Viscount Portal of Hungerford. In 1942 Jacob Epstein had created a bust of him. Now, in November 1970, suffering from cancer and with only a few weeks to live, Portal agreed to a suggestion that a full-length statue be made. According to his biographer Denis Richards, he 'indicated that he was impressed by Nemon's work'. The sculptor duly appeared at Portal's home in West Sussex. The two got on well, and Nemon was able to get in a couple of sittings before Portal became too ill. A sum of £20,000 had been raised by public subscription, and the statue was unveiled on London's Victoria Embankment in May 1975 showing Portal bare-headed and gazing up at the sky, 'as he had once been photographed at Hatfield aerodrome in 1941 watching Geoffrey de Havilland test fly the Mosquito'. He is also looking straight up at the golden eagle on top of the RAF War Memorial sculpted by William Reid Dick. Some critics thought Portal's stance too defiant, too heroic; they may have been influenced by his central role in directing bombing operations during the war, although any man who kept hawks at Winchester College and Christ Church must have something heroic about him (he claimed that he owed his life to observing hawks – they taught him how to dodge German fighters in the First World War when he was over enemy lines in a tiny reconnaissance biplane).

As with his statue of Churchill, Nemon needed someone of roughly the same

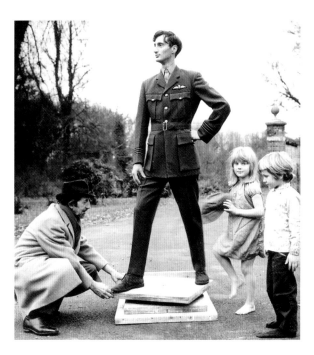

Nemon's son-in-law George Young posing for the sculptor in the uniform of Air Chief Marshal, Viscount Portal, with George's children Sophia and Gerry Young looking on, 1971
PHOTOGRAPH BY FALCON STUART

dimensions to don the appropriate uniform and model for him, so he could properly represent the folds. My husband George was happy to offer himself for this role.

By coincidence, I met the niece of Viscount Portal one day in Cambridge and came greatly to admire her. Jane Portal was one of Churchill's young secretaries and met my father frequently at Chartwell. When I met her she said at once, 'Oh, I loved Nemon.' She told me how she used to sit spellbound, with her notebook ready to take dictation, while Churchill was talking to Nemon. The politician, she said, 'profoundly admired and liked the company of your father . . . and he didn't like everyone!'

There is a further connection because Jane Portal also worked as secretary to Ernst Chain at Imperial College, where Nemon's bust of Chain was installed. She continued to admire my father and wrote to me later that 'the story of your dear father's life is both inspiring in its success as well as very moving. His journey was so brave and resolute but always with that concern and deep interest for the human soul in all its complexities. No wonder Winston felt such trust and freedom in his company.'

One of Churchill's greatest admirers was Lady Violet Bonham Carter, daughter of the former Prime Minister H.H. Asquith, who had hoped that Winston would marry her. Instead he proposed to Clementine. His rejection led to enormous disappointment but did not diminish Lady Violet's admiration for him. Nemon started sculpting her in 1959, and she gave him a great many sittings.

He clearly made a huge impact on her. She wrote, 'I must write to you a line

Nemon's bust of Lady
Violet Bonham Carter
PHOTOGRAPH BY
FALCON STUART

of gratitude because of my "sittings" and "standings" with you, and the talks which illuminated these have been bright candles in darkness and helped so much to keep me alive . . . You always opened windows for me, and I only feel guilty at accepting the waste of so much of your time.' And later on, 'It has been such a joy and refreshment to talk to you – it kept me alive.' After her husband died, she wrote again. 'During the agonizing years when my husband was dying, you were the one human being I loved to see.'

Nemon's letters to her, now in the Bodleian Library, began formally – 'Dear Lady Violet' – but the contents showed that the warmth of feeling was reciprocated. In one of his letters he said, 'Your letter gave me such a great pleasure to read. I felt as if I had been found by a good-hearted friend, having mislaid myself.'

On hearing that Nemon planned to give her a bust of Winston Churchill in 1960, Lady Violet wrote to Nemon, 'What joy your letter brought me – with the prospect of seeing you again and the promise of beloved Winston's head. I can hardly believe it – it seems too good to be true. It is like being given the moon – the object in the whole world I most desire (head not moon, I mean!).'

On her birthday in 1967 he sent her a gushing telegram. 'Many happy returns of the birthday for the tireless champion of optimism. May that scented spring flower Violet for ever renew hope and, with you, be synonymous with all that is noble and worth while.'

Lady Violet had been instrumental in securing for Nemon the contract to sculpt a bust of John Christie, the founder of Glyndebourne Opera. She wrote to him in December 1959, 'You are going to do John Christie's bust, and it is I who achieved it.' While the work progressed Christie explained that he really wanted a portrait – a painting rather than a sculpted bust. But he had a favourite dog called Sock, and during the sittings Nemon sculpted the pug on the back of the head, which Christie could look at while the artist worked on the front. This did the trick. Lady Violet wrote, 'John is delighted with it – the inspired Sock-chignon has reconciled him to sculpture.'

The Christie family were less enthusiastic about this artistic licence, describing the canine addition as 'macabre'. While the debate about Sock's future went on, Nemon was instructed to work on both options – being offered £200 to complete the work with Sock still intact and £500 without him. The antis won, and, by the time Lady Violet unveiled the bust in 1961 – remarking that it reminded her of Beethoven – Sock had been sacked. I joined my father for the unveiling, and in a letter to my father Lady Violet called me 'your delightful daughter'.

The last of Churchill's political colleagues to receive the Nemon treatment was Harold Macmillan – although his was not the last of his portrait busts of British Prime Ministers. My father and Macmillan seemed to enjoy each other's company. Nemon wrote in his memoir that he enjoyed the politician's 'shrewd

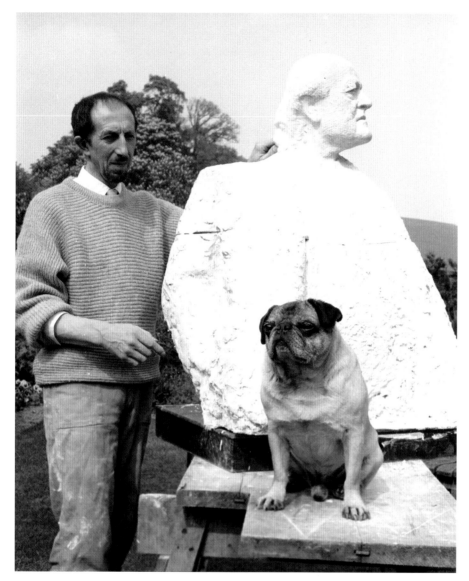

John Christie's pug dog Sock posing for his bust which Nemon put on the back of the head of his master

© GLYNDEBOURNE PRODUCTIONS LTD PHOTOGRAPH BY GUY GRAVITT, ARENAPAL

opinions and private judgements of leading politicians, in phrases that were often mocking, always penetrating but not softened by the charm he displayed on the public platform'. Once, while he was sitting for his portrait, an aide handed the Prime Minister a draft of a speech he was to make, only to be told, 'That's all right – but not enough humility.'

My father liked the fact that, although in many respects a conventional man, Macmillan had a taste for eccentric friends and colleagues . . . such as his private secretary John Wyndham. Nemon tells the story of how Wyndham arranged Macmillan's schedule so that he was in the artist's studio at midnight, just as Big Ben was

Patricia, Nemon and Aurelia, aged fourteen, London, 1957

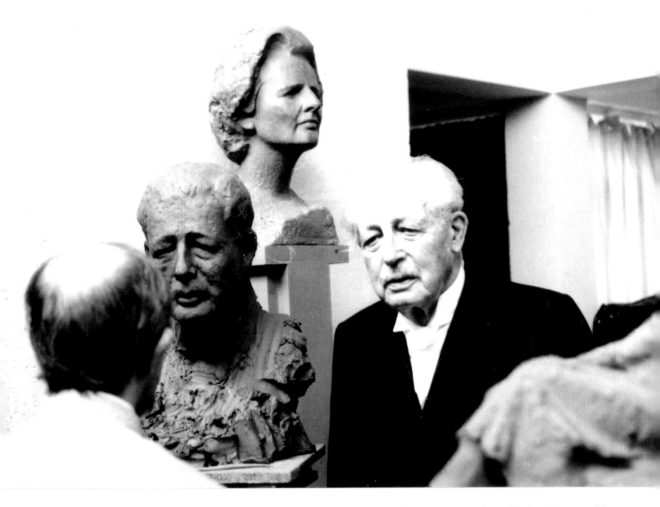

Harold Macmillan
posing for Nemon with
the bust of Margaret
Thatcher in the
background
PHOTOGRAPH BY
FALCON STUART

ringing in the New Year . . . only Macmillan was quite literally handicapped by the fact that his hands were just then encased in plaster while Nemon was taking casts of his hands.

Nemon's bust of Harold Macmillan can be seen with other busts of twentieth-century Prime Ministers in the Central Lobby of the House of Commons, and another bust of Macmillan was unveiled in the Oxford Union in 1959.

The last Prime Minister to be sculpted by Nemon was Margaret Thatcher. In 1975 Mrs Thatcher had just been elected leader of the Conservative Party but was not elected Prime Minister until 1979. Nemon commented, 'She is a beautiful lady to look at, but she must be so busy that it will no doubt be difficult for her at present to find times for sittings.' The commission took some time to complete, but the bust was finished and now stands in the Carlton Club in London.

The photographer Eve Arnold visited Nemon's grace-and-favour Friary Court Studio in St James's Palace in 1977 to take pictures of Mrs Thatcher – the idea

being she could use a bust of Winston Churchill in the background to show how the new Tory leader was following in the great man's footsteps. 'There stood vast uncast statues of Britain's saviour in the garden,' Eve Arnold wrote, 'a six-foot cube acting as a plinth on which there was a neckless Churchill, a nine-foot striding figure and numerous small maquettes, all realistic and in the heroic mould.' At last she got the pictures she wanted.

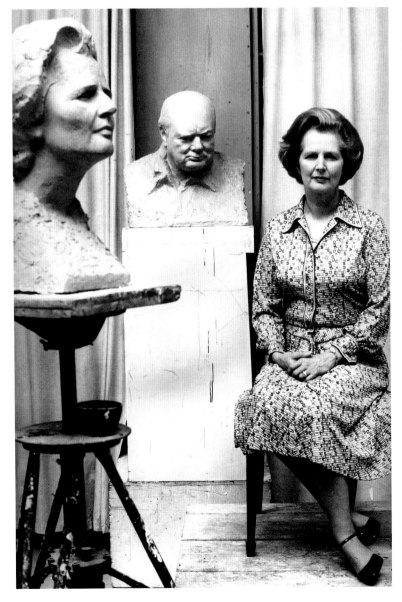

Margaret Thatcher posing for her likeness while sitting next to a bust of Churchill, 1978
EVE ARNOLD/
MAGNUM PHOTOS

Per Ardua ad Astra,
University Avenue,
Toronto

North America 11

LIKE MANY PEOPLE caught up in the turbulence of twentieth-century Europe, Nemon had a soft spot for the USA. For many Jews in the inter-war years, the choice of crossing either the English Channel or the Atlantic Ocean was a hard one and as often dictated by chance or whim as by necessity. With Nemon's closest girlfriend Jessie Stonor installed in New York from early 1941, and writing him fond and even passionate letters, he was tempted to follow her there, but he was thwarted not just by his commitments in Britain but by the difficulties and dangers of making the transatlantic crossing during the war. Thus it was a journey he was first to make only in the autumn of 1947. His stay was brief and unproductive.

For Nemon – and Patricia – the late 1940s were full of stress. He had to come to terms with the news of his family's horrifying fate at the hands of Yugoslav fascists. The commissions were thin on the ground. The plans to build the Boars Hill 'hut', as Patricia called it, were in preparation. She wrote to Nemon, who was in Brussels sculpting Paul-Henri Spaak, asking if he could possibly find some aluminium sheets and plasterboard in Belgium. At the same time she was preoccupied with her poetry and her reflections on death ('sounding a trumpet call to the future'), yogic breathing and solar rays, obscenity, Jewishness, Gnosticism, Einstein and Freud . . . 'In your absence', she wrote in February 1948, 'I am like steam under pressure, a kettle going weeeeeeee . . . Torrents of words want to pour out. I can hardly catch them as they come.' She told him she had 'tortuous jealousy dreams', doubtless referring to his infatuation with Jessie.

In April 1948 Jessie died of cancer. On that same day Patricia wrote from Norfolk to Nemon – 'my errant boy' – that she had always thought 'some vast form of self-realization would have to come to him before he would really begin his life's work'. Perhaps it would come in the form of love, she mused, or a child or even her own death – 'just take care it is not your own'. She added, 'Don't be so ambitious that you leave us.' A few months later she wrote, 'I so need you to develop me to keep me to a useful middle track. That's what made me so cryingly sad about you and poor Jess. I wanted you to recognize that your destiny lay in my development, even in spite of apparent disadvantages, but I know it was asking

impossibly too much of you. I knew that I was both too advanced for you and too hopelessly backward for you, as indeed may still be the case.'

It was at this time – just as they were starting to make the move from West View to the new 'hut' – that Patricia, seemingly with Nemon's connivance, plotted to get him up to Norfolk to have a first meeting with her parents. He was to write to them claiming that her mental health was so fragile that he needed to discuss with them the 'danger' she and the children would be in if and when he went to the USA. This bizarre idea seems to have been triggered by my grandmother Constance's plot to induce Nemon to go to the USA, to become an American citizen 'in order to make real money' and to stay there 'continuously for two years'. Patricia told Nemon that her mother was being 'quite amicable' about her son-in-law but added that she had made a 'nasty dig', wondering if he knew that as a British citizen he was responsible for his wife's debts, saying, 'Pity if they landed him in prison.'

None of this was designed to improve Nemon's headaches or his mood. Nor did any of the plots lead to a meeting of the warring parties. But the hut was finished, and in the autumn of 1948 we moved into our Pleasant Land, my parents' new Jerusalem, although almost immediately Nemon set off to Basel. The motive for this trip was almost certainly to arrange to make a sculpture of Jung, and Patricia was hoping that the commission he was angling for there would 'earn you a passage to America'. (She also rather optimistically thought his move across the Atlantic might be funded by the 'damages' he could win for 'being kept waiting so long', presumably for his naturalization papers.) But it was not long before he took himself off to New York anyway in search of commissions and fulfilment.

It was not a successful venture. Almost every day he received letters from Patricia several thousand words long. At the end of February 1949 she made a rare reference to him being so far away, hoping that he would stay in New York 'long enough to get it out of his system . . . However, not quite for the reason Aurelia envisages a long absence desirable.' At this point my mother quoted a conversation that I – now almost six years old – had with her:

Robert F. Wagner Jr, Mayor of New York 1954–65

Aurelia: I do so like babies. You must have one.

Patricia: But, you see, Papa's away.

Aurelia: Couldn't you get another man to help you. Couldn't you have several men stay here?

Patricia: I think it would make things rather mixed and complicated to have a baby with a different father.

Aurelia: Would Papa be cross?

Patricia: He might be a little.

Nemon's relief of baby
Electra, 1951

Aurelia: But he wouldn't need to know. He's so long away that the baby would be
quite big before he's back.

By May, however, my father was back in England, and very soon Patricia was
pregnant again – with their third child and second daughter, Electra (a name that
my young sister later felt to be uncomfortably redolent of matricide, although
Patricia was ready with the name Merlin had her child been a boy). My mother
wrote in a letter from Norfolk to Nemon in Pleasant Land, 'A man is apt to die for
the love of his cause, woman to be pregnant for the love of hers.' The birth of this
second daughter the following March did nothing to calm Nemon's restlessness.
In early April 1950 he set sail for New York again, leaving Patricia to register my
sister Electra's birth only just before the deadline.

Nemon's aunt, Jula Spitz (the twin sister of Milan,) and her husband Rudi had
reached the safety of New York just before war broke out. Nemon stayed with
them for some of the time he was in New York, not just briefly in 1947 but for the

first five months of 1949 and then from April to July 1950. Later he used to stay more often with Peter Glauber, a psychoanalyst friend, and his wife Helen. There are few clues as to what exactly Nemon was doing in New York during these four months in the middle of 1950. He had distractions, for sure, among whom was a beautiful young American psychotherapist called Patricia Donovan. But his health was not good – almost certainly more of his migraines – 'living in his prison of headaches', in my mother's words. One of her letters mentioned her sorrow that he has had 'such a painful experience with Dr Federn', but there is no further explanation as to the cause of this pain. He must have had some successes, too,

Joyce C. Hall of Hallmark Cards with his grandchild in Kansas in the 1960s
PHOTOGRAPH BY FALCON STUART

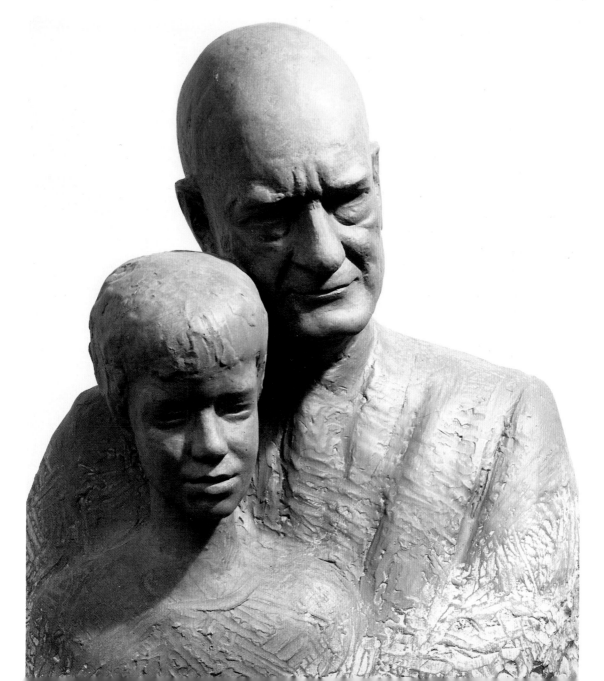

because she wrote in another letter, 'The dollars will also be welcome.' There was mention of a possible 'synagogue order', but I can find no evidence that it came to anything. This sojourn in the USA was not to prove the turning point in his career. That was to come during the trip to Morocco that Christmas when he met Winston Churchill. His next American trip after that was not until 1958, when he turned up in Kansas.

Nemon's friendship with Joyce Hall was enduring. It is likely that he and the sculptor were introduced by Winston Churchill, as Hall was a friend of the politician. Known as 'the Emperor of Good Wishes', Hall was the founder and ardent promoter of Hallmark Cards, Inc., a man convinced that if people sent more good wishes on beautiful cards they would have better relationships and spread peace throughout the world. Nemon first travelled to Kansas City in August 1958. This must have been a short exploratory trip, although Nemon's connection with Kansas and the Hall family – particularly Joyce and his son Don – would last until his own death over a quarter of a century later.

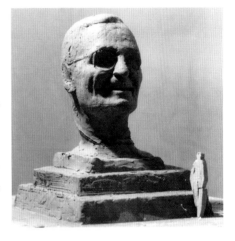

Nemon's clay version of a giant bust of US President Harry Truman
PHOTOGRAPH BY FALCON STUART

A bust of Joyce Hall was finished and paid for in 1961. Nemon's fee was reduced by a large number of advances, including a dentist's bill, hospital treatment for my brother Falcon, who had accompanied Nemon to Kansas, and three sizeable wads of cash. Other loans – including cash and Falcon's air fare – were queried rather sternly with an explanation demanded. Nemon declared he had been misunderstood, and presumably an amicable arrangement was reached with the Hall family.

Hall was a friend of two American presidents, Harry S. Truman and Dwight D. Eisenhower. He did Nemon a favour by introducing the sculptor to both. Truman lived on the eastern outskirts of Kansas City, so a meeting was easy to arrange. He received Nemon in his museum. Taking him down to the basement, he pointed to a long row of busts relegated to obscurity on a shelf and warned him that a similar fate might happen to his own work. This was not a good omen, and Nemon later made only a clay bust of Truman which was never finished or cast in bronze.

He had far greater success with Eisenhower, who had only just left the Oval Office in January 1961, and a bust was made during that summer at Gettysburg. They were able to chat about their mutual admiration for Churchill and formed a good relationship, even though Nemon's time with the former President was limited by the fact that it coincided with the Berlin crisis. Hall and his co-sponsors were also delighted with the finished bust, and the Spode Company made multiple copies, which Eisenhower approved of and endorsed. In January 1969, just two months before he died, he sent Nemon a letter from the Walter Reed Hospital in

Nemon's bust of President Eisenhower; the whereabouts of this bust is unknown.
PHOTOGRAPH BY FALCON STUART

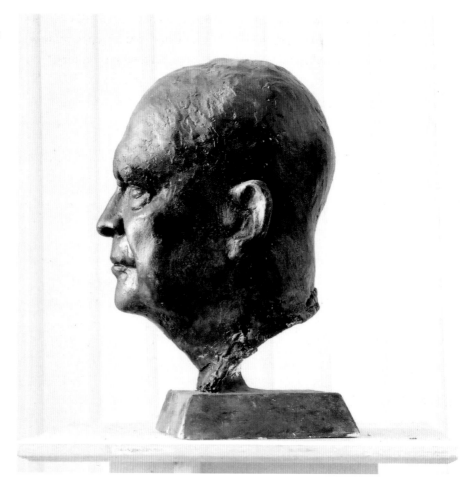

Gettysburg, admiring the likeness. 'I believe it is the best sculpture I have seen and am complimented that it was your skill and artistry that was selected . . . You were most patient with me the weeks you were in Gettysburg, and I am grateful for this – and the fine work you completed.'

Lady Violet Bonham Carter had been apprehensive about my father going to North America, fearing that he might be 'sucked in to the mammoth maw of the USA'. She worried about his health, that he might not be up to the strain in a continent that 'demands a kind of steak-fed strength and India-rubber buoyancy to survive in'. She worried, too, about Americans' 'exhaustive and exhausting conversation . . . Ike may be drowsy and cosy – but not so his entourage! *Do* take care of yourself – Gettysburg "*ne vaut pas*" your health and precious gifts. My love to you and *anxiety* about your venture.'

Nemon himself was reticent about taking advantage of her introductions. He wrote from Kansas City that 'it would be doing them a very bad turn, looking as I do so utterly un-American they may worry about finding a suitable disguise for me'. In another letter he said he found himself 'outrooted' and lonely.

This kind of self-deprecation and nervousness did not go down well in brash American society. For the most part it was laborious and often disappointing work chasing commissions and trying to sell copies of existing sculptures there. In the early 1960s, for example, Nemon tried unsuccessfully to interest the Baltimore Psychoanalytic Society and the Menninger Foundation in buying a copy of the large Freud statue. His Churchill statues and busts were another potential source of revenue, but, again, it was hard to get people to pay for them. In June 1963 Nemon wrote to Lady Violet that 'alas, the English Speaking Union has firmly made up their mind that the statue to Sir Winston must be an all-American effort. My activities are for the moment not very spectacular.' Even Douglas Fairbanks tried to get involved in New York, but nothing seems to have happened as a result. But the sculptor did get commissioned to do a bust of New York's Mayor Robert F. Wagner Jr in the summer of 1964. The problem here, he wrote, was getting time to see the Mayor, whose 'role is unique in this city of continuous practice of "hold-ups", strikes, demonstrations and drinks. I hardly can see him except in the daily papers.' I can find no evidence of the survival of that bust. Seven years later, in November 1971, he had some success when he charmed Pamela Harriman, wife of Winston Churchill's son Randolph, by 'offering me "my head". It is very sweet of you,' she wrote. 'I did so enjoy our days at Haywire while you were doing it.'

A couple of rare examples of letters from my father have survived, giving a flavour of the kind of attempts he must have been making in the last decades of his career, especially in evoking interest across the Atlantic. On 24 June 1972 he wrote to a Mr Stone in Los Angeles from a friend's house where he was staying in Santa Monica; the style gives quite a good flavour of Nemon's voice and manner.

> I have the exceptional pleasure to be in your remarkable city, where I am doing the sculpture of Dr Franklin Murphy, an acquaintance of long standing.
>
> Also it has been my good fortune that you should live here, because in this way it leads me to you in relation to the sculptor and Freud.
>
> Forty years ago Freud sat for me and was not unimpressed by my full-length sculpture of him, and in this respect I have been advised to get in touch with you and ask for an opportunity of meeting you to discuss the matter of having a Freud statue for Los Angeles.
>
> Guided by the unique position you have in this matter, I shall be grateful if you could let me know, at the above address where I am a house guest, when we could meet.

In February the next year he had not given up, writing to a Dr Rangell in the same cause but with increasing desperation:

Since I had the privilege of knowing Freud personally, it is heart-breaking to see the indifference on behalf of those whom I have approached to help me realize my sculpture on a big scale. It only depends on a small sum of money in comparison with the huge sums of money spent on doubtful works of art. Of course, Dr Winnicott made a unique effort to have one of my statues of Freud here in London, where it was least indicated keeping in mind Vienna and the USA.

In my studio I have a sitting figure of Freud, which Freud so very much liked. It is 2 feet 5 inches high, and I am willing to reproduce it in bronze in a limited edition in order to keep its artistic value. I would then like to address myself to the institutes all over the world, or just to those in the USA, offering this work for the sum of about 7,000 dollars. This would enable me to realize a heroic statue which could be situated in a prominent place in the USA. This work could of course be given to institutes by an individual sponsor, tax free.

In the autumn of 1975 he was trying to arrange through the good offices of Dr Murphy a statue of Freud to be placed in the University of California Los Angeles sculpture garden (named after Murphy whose own bust Nemon had sculpted). He suggested that it might cost 60,000–70,000 dollars. Four years later he was negotiating with Dr Armand Hammer of Occidental International Oil, Inc. for a £150,000 gift 'required for the Hyde Park project' – presumably the mooted but never realized Churchill statue on a landscaped site there.

Over this same period Nemon was in touch with Henry 'Hal' Jackman, the rich and powerful son of the rich and powerful Canadian politician and entrepreneur

Nemon, Patricia, Aurelia, Electra and Falcon wearing the 'cowboy' clothes Nemon brought back from Texas in 1957

Harry Jackman, who founded during the Great Depression the Empire Life Insurance Company with headquarters in Toronto. Philanthropy was a family tradition – the Hal Jackman Foundation is still distributing millions of dollars to promote the arts. Harry himself had acquired a statue of Sir Winston Churchill, but Nemon thought he could go further. There is a draft of a letter dated 12 September 1975 in which he started with his customary flattery, although overplaying his hand when it came to his target's nationality.

Hitler said that the English are so mad that they do not know when they are defeated. This seems to apply very much to you, the stubborn, eccentric Englishman, who does not give in to adversity.

I feel very impressed that you are pursuing again this project [a large-scale Churchill figure], but I am afraid that the Colossus will be much too costly to realize in bronze; perhaps it could be achieved in another medium.

A standing statue, on which I could improve and adjust to the environment, could be effective and a proud reminder to English-speaking Canadians of one of their greatest men past and future . . .

The plinth or surround of the statue should really be financed by the City of Toronto, as was the architectural arrangement of the statue in Mexico City where no expense was spared to honour a great man of the century, to whom the Mexicans are not indebted, nor with whom they have any kinship.

My project of Churchill in a siren suit for Parliament Square, which I would like to see executed in Toronto and of which I am sending you a picture, would also be appropriate in the city among the English-speaking population.

This was the project that Nemon failed to win for himself, losing out to Ivor Roberts-Jones. But the Churchill project for Toronto did go ahead. At 2.30 in the afternoon of Sunday 23 October 1977 Mayor David Crombie presided over its unveiling in Nathan Phillips Square in the presence of Henry R. Jackman and Winston Spencer Churchill, the grandson who was doing a stint as a Member of Parliament.

The Toronto connection was re-established in 1981, two years after Harry Jackman had died and been succeeded by his son Hal. Nemon was commissioned to make a sculpture to be an Air Force Memorial on downtown Toronto's University Avenue – and the Jackman Foundation as well as Hal's brother, Dr Frederic Jackman, were involved with the funding. In July Nemon showed off his maquette to the family in London. The plan was to unveil the sculpture the following July on Canada Day. It was not entirely Nemon's fault that this proved to be over-optimistic – by two years.

In early December 1982 – already the first deadline had long passed – a completed thirty-foot plaster model of the memorial statue was encased in scaffolding in the garden at Pleasant Land. Then a fierce gale blew in and the scaffolding collapsed, bringing the statue (as well as one of Churchill located below) crashing to the ground. It was the prelude to a whole year of wrangling as to who or what was responsible. In the end the insurers paid Nemon £25,000 in compensation, covering the cost of materials lost, interest on the delayed commission fee and the cancellation of other contracts. One final letter from June 1984 survives from Nemon's long-suffering solicitors, reminding him that the insurers had refused to stump up all their professional fees and asking him to send them the balance. I can find no record of his reply.

Although it took Nemon five months to screw up the courage to tell his sponsor

in Toronto about the accident, he did get on with making a new statue. The cost to Hal Jackman was well over £50,000. A columnist on the *Toronto Star*, George Gamester, wrote on 12 January 1984, 'Look, on University Ave. Is it a giant clothespeg? The world's largest zipper? No, a new statue!' In fact, the real thing, in blackened bronze, forty feet tall (including plinth) and weighing two tons, was still in Nemon's Oxford garden and would be flown over by the Canadian Air Force in April. The illustration in the newspaper showed a picture of the plaster maquette of the tall slim bobbly plaster figure, arms upraised, with a bird suspended on thin wires above its head. The photograph was probably taken before the accident, because a small figure of Churchill is seated perilously underneath it – before being damaged by the plunging scaffolding.

In the end the Queen and Prince Philip were in Toronto to unveil the dedication plaque at the base of the towering statue on 29 September 1984 in the presence of assorted dignitaries and Canadian airmen as well as a large crowd of onlookers. But Nemon himself was not there. He was too ill. The Queen, who knew my father from her sittings for him, expressed her regret.

The party was only partly spoilt by first a column and then a leading article in the Toronto *Globe and Mail* in the weeks preceding the official unveiling. To begin with, Nemon's artistic abilities were attacked by one J.B. Mays, and then a leader appeared entitled 'Say No, For Art's Sake'. 'Street by street,' part of it read, 'Toronto fills up with inferior sculpture. The council accepted a monolithic monstrosity from the Jackman Foundation to sit on University Avenue' and went on to list other works of art it claimed were the result of yielding to pressures from sponsors rather than make 'artistic judgements'. The statue had many supporters but remains controversial. In 2006 Dale Duncan described it as 'the notorious *Per Ardua Ad Astra*, better known as "Gumby Goes to Heaven"'.

Kansas also reappeared on Nemon's agenda in 1981. Fulton, Missouri, being just down the road, it was a British Prime Minister rather than an American President who was now the focus of attention. Churchill's famous 1946 Iron Curtain speech was delivered at Westminster College in Fulton, and folk were not about to forget their hour of fame. Over to the west of the state, at the confluence of the Missouri and Kansas rivers, the people of Kansas City basked in its reflected glory, and among them were many fanatical devotees of Churchill. As the great man's favourite sculptor, according to Martin Gilbert in his book *Churchill and the Jews*, Nemon was welcome in many homes, including that of Miller Nichols, Chairman of J.C. Nichols Company, a real-estate giant with headquarters on the Country Club Plaza, the dazzling downtown square noted for its fountains and statues. Ironically, the J.C. Nichols Company had been notorious in its pre-war heyday for using restrictive covenants, by which African-Americans and Jews were barred from owning or occupying properties in the exclusive Country Club

President Obama walking past Nemon's statue of Churchill in the House of Commons, accompanied by the Speaker of the House of Commons and the Lord Speaker, 2011

© UK PARLIAMENT/ JESSICA TAYLOR

The Speaker of the House of Commons, John Bercow, looks on while President Obama touches Churchill's toe; perhaps he made a wish

© UK PARLIAMENT/ JESSICA TAYLOR

district that Nichols helped develop. But in October 1981 Miller Nichols, son of the founder and now chairman of its board, dangled the prospect in front of Nemon of a highly lucrative commission for a large Churchill bronze (to add to an over-size *Bronco Buster*, the famous statue by Frederic Remington of a cowboy riding a rearing stallion). He said he was interested only in the bronze of Churchill with his wife Lady Clementine, which would be placed on the Churchill Bridge. When the maquette arrived at his Kansas City home early the following year he was thrilled. He wrote that he would get his friend Ronald Reagan and Margaret Thatcher to come over and unveil it, adding that 'Mr Jim Hale, Editor of the *Kansas City Star* and a good friend of mine' would ensure it was given 'the right kind of exposure'. He was, however, consistently concerned about how much it might cost him.

In March 1982 he said he was content with Nemon's quotation of $140,000 ... a sum he was 'satisfied I can raise'. He wrote that he was keen for the statue to be part of the 'City in Celebration' programme in 1983. But they were still talking money later in the autumn, and Nemon said he would need twelve months to complete the work and have it delivered. Nichols also wanted it to be a companion piece to the one he believed would be erected beside St Paul's Cathedral in London. 'Obviously', he wrote ominously, 'it would be a great disappointment to us if the one in London is not done.' His other worry was that he – or Nemon – might die before the work was completed. 'In that event, do you have assistants that could take over and finish the project?' he wondered. Finally, he wanted Nemon to persuade Margaret Thatcher to write and endorse the plan for a joint dedication with Ronald Reagan and to express 'her feelings towards the project'.

Nemon replied quickly, pointing out that 'the universal custom in my profession is for payment for such a public monument to be made in three stages: at the start of work on the commission; at the time when the finished and approved model is delivered to the foundry for casting; and, finally, on its delivery to the site for erection – in three equal instalments'. On the matter of untimely death, he told Miller Nichols that 'apart from whatever effect my own powerful prayers will have, to your benefit, during the year ahead, you may have become aware that those who collaborate with me, such as Joyce Hall and Sir Harry Brittain, have a tendency to live for a century or more'. At the same time he hinted at the problems he was having raising the funds for the St Paul's statue. On the other hand, were he to die prematurely, there was a maquette in Blenheim Palace that could be inspected.

Luckily Miller Nichols was almost as big a fan of Nemon as he was of Winston Churchill, describing my father as 'Royal Sculptor of England'. To increase the publicity for the Churchill statue in Kansas City, a play called *Churchill* and starring Roy Dotrice was to be presented. Proceeds from the play would go towards the purchase of the statue, and it raised $20,000. Sponsors were sought

Nemon's bust of Winston Churchill being installed in the Capitol, Washington, DC, 30 October 2013. From left: Sir Nicholas Soames, Member of Parliament (Churchill's grandson, Speaker of the House), Harry Reid (Senate Majority Leader), Laurence Geller CBE (Chairman of the International Churchill Society), John Kerry (US Secretary of State), Mitch McConnell (Senate Minority Leader), Nancy Pelosi (House Minority Leader)
©THE SPEAKER'S OFFICE, THE CAPITOL, WASHINGTON

for both. Margaret Thatcher was induced to write a letter of support. On 26 November 1982 she did so, saying that 'I cannot imagine a more ideal location . . . I am sure you will be delighted with the sculpture.' (An attempt to lobby the British Prime Minister to put some Treasury funds towards the mooted companion statue at St Paul's came to nothing, so plans were shelved.

By October the next year a mould was being sent to the foundry and a second payment of $50,000 was being dispatched to the artist. In terms of Nemon's career, the money was welcome but came rather belatedly in terms of resolving his long-standing financial problems – as usual, the bulk of the money went towards his expenses, including the costs of casting and delivery.

Success in America – even if it did not involve new commissions – came too late for Nemon to enjoy it for long. He was too ill to travel either to Toronto or to Kansas City, where he would have been fêted with the kind of pomp and ceremony that his long career deserved.

After his death there were two important unveilings of his busts of Winston Churchill. In 2007 I flew to New York to attend a ceremony at the Franklin and Eleanor Roosevelt house in Hyde Park. Churchill's granddaughter Edwina Sandys, also a sculptor, unveiled the bust with me. It stands opposite a bust of Roosevelt, as if the two war leaders and friends were talking to each other.

Seven years later I was in Washington, again for an unveiling ceremony in the Capitol. This was very grand occasion attended among others by the Speaker Nancy Pelosi, the Secretary of State John Kerry and Churchill's grandson Nicholas Soames. The bust can be seen now in the Capitol's Freedom Court.

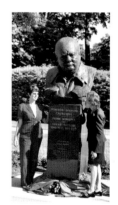

Aurelia with Winston Churchill's granddaughter, Edwina Sandys, unveiling Nemon's bust of Churchill in the Freedom Court at the home of Franklin D. Roosevelt, Hyde Park, New York, in 2007

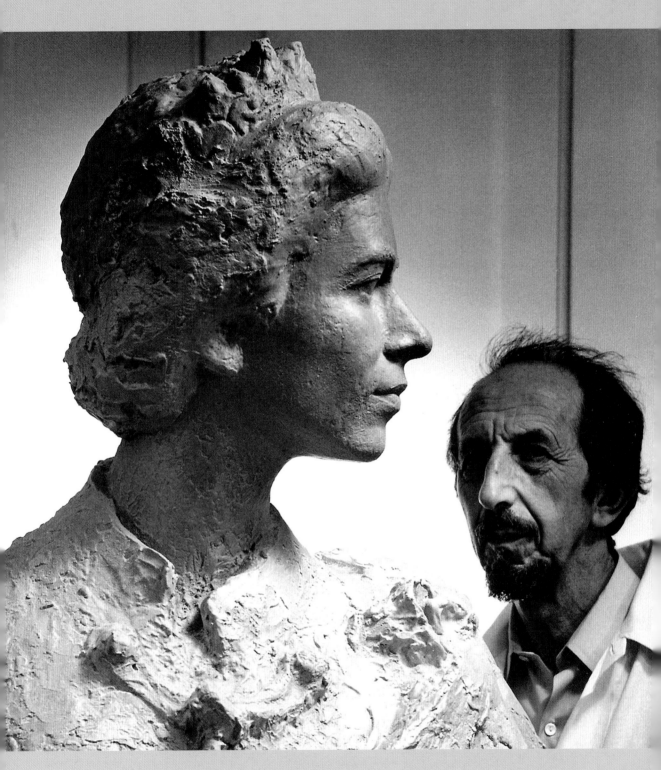

Nemon looking at the bust
of Queen Elizabeth II he
was sculpting for the QE2
cruise ship in 1969

Royal Families 12

MY FATHER'S FASCINATION and familiarity with European royalty
began in Belgium, when his exhibition in December 1934 featured
a head of King Albert I. Four months earlier Nemon had written to
Bella about his 'embarrassment':

> It's beyond all limits. This 'miracle', if you please, that has happened to me to
> model Albert I has infuriated like wild animals everyone who is jealous of fame.
> All those who are trying to ruin me are rich. It has to do with the fact that Princess
> Jean de Mérode, a personal friend of the King and Queen, has bought the bust,
> which will be placed in the Invalides. I fully understand that this is a kind of
> provocation, but the Princess is shielding herself behind the argument that, had a
> Belgian sculptor been able to create to that high standard an artistic portrait of the
> King, she would surely have commissioned a Belgian national.

This was merely the first time in Nemon's career that a prestigious and
high-profile commission to sculpt a major figure would provoke animosity in
high social and artistic circles – later on in his life, busts of the Queen of England
and Winston Churchill evoked comparable responses.

In February 1934 King Albert I died in a mountaineering accident at the age of
fifty-eight. His son Leopold III was married to Astrid, a member of the Swedish
Royal Family, but the following year she, too, died in an accident. In her case she

Nemon with his busts
of King Leopold III and
King Albert I of Belgium
in Brussels, 1930s

was driven by her husband into a tree
at the edge of Lake Lucerne. She was
only twenty-nine. Nemon was to make
busts of both Leopold and Astrid.

In King Albert's case an added area
of controversy was Nemon's treatment
of the royal mouth, which was open.
His widow, Queen Elisabeth, protested
to Nemon that she was not happy, but
the Belgian press was enthusiastic.

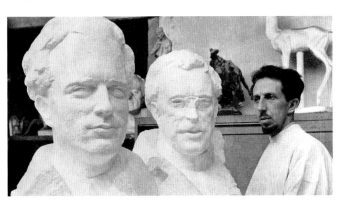

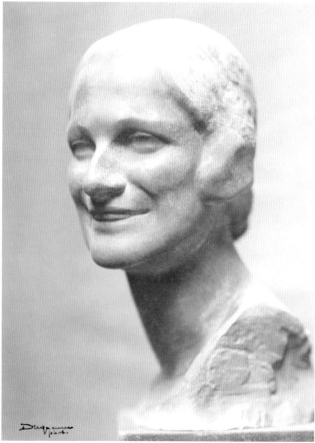

Queen Astrid of Belgium, 1934; her bust is missing.

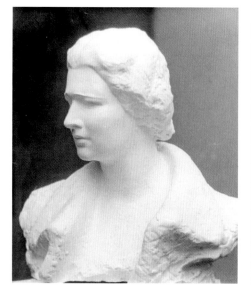

Queen Marie of Yugoslavia, Brussels, 1933

It is not clear whether Nemon's bust of Queen Astrid was done from life or if he modelled her only after her death. Either way it proved popular. King Albert's bust is now in the Royal Palace in Brussels, while that of his son, King Leopold III, who reigned throughout the war period and later resigned in favour of his son Baudouin, was sculpted much later on.

One of Nemon's many lost works is that of the bust of King George VI, whom Nemon sculpted in 1937. There is a bill for the casting of the bust but no sign of the bust itself, and the British Royal Family know nothing about it.

While sculpting Freud in Vienna Nemon made friends with Princess Marie Bonaparte, a pioneer of psychoanalysis in France and one of Freud's most devoted disciples. Like Freud, the Princess was a dog lover, and she had two chows, Topsy and Tatoun. In July 1937 Nemon was commissioned to create a sculpture of her.

I worked on a sculpture of her and her two dogs in the garden at Saint-Cloud. The weather at that time was glorious, and Princess Marie preferred to pose in the garden rather than to stay indoors. I mentioned a story that I had heard of a

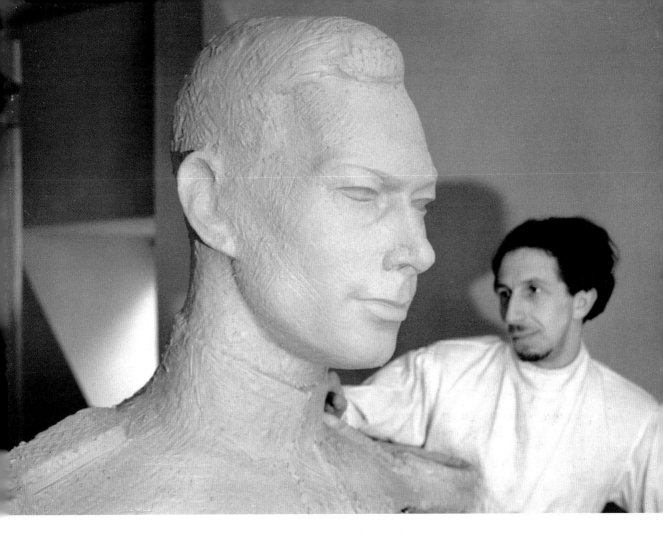

model princess who, when asked why she posed in the nude, gave the reason that the studio was too hot. Princess Marie burst out laughing. 'That was my aunt, Bonaparte's sister, Pauline.'

As he worked he became increasingly aware of the constant background noise of an accordion being played – most incongruous in the gracious setting of the château.

The player came into sight from the edge of the woodlands surrounding the château – Princess Eugenie, Princess Marie's daughter. She came across to us, still playing with considerable expertise. When she got to us she said to me, 'I hope I'm not driving you dotty with this, but it's all my mother's fault, you know. She keeps telling me there will be a war soon, so, as I have never learnt anything in the least practical, I sat down and thought about what I could do if a war really came. There's not much a princess can do, but I thought of the Russian ones playing the accordion in Montmartre, and I think I could do that, too.'

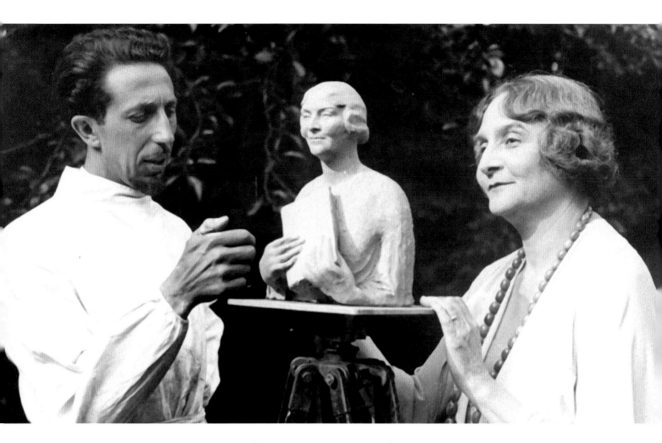

Nemon with Princess Marie Bonaparte in her garden in Paris, 1936

Two years later Princess Marie and Nemon met up in London – by then he had made a firm decision to stay in England – when she wanted to take him to Hampstead to try and cheer up Freud who was disorientated and in pain from his cancer of the jaw. Nemon – as usual – quizzed the Princess about possible contacts for commissions. At first she said most of her friends were dead or in Scotland, but then she thought of Queen Mary, King George VI's mother. Nemon immediately got cold feet but had to make a rapid decision because the car they were in had drawn up in an impressive courtyard. Princess Marie said, 'Young man, I'm lunching with Queen Mary, and we are at this moment in the forecourt of Marlborough House.' Still Nemon prevaricated – he felt unready and underdressed. 'All right,' she said, 'but don't forget I gave you the chance.' My father took up the story in his memoir:

> As I was about to get back into the car, Princess Marie stopped me. 'By the way,' she said, 'I want you to send me straight away all the sculptures you have done for me, so that I can put them and some other treasures in a safe place before everything blows up.' I said that I had just had an exhibition in Brussels and that my sculptures were over there. I would, though, be going over in three weeks' time, and could take them across myself to Paris. She said, 'In three weeks' time,

Topsy, Princess Marie Bonaparte's chow dog, sculpted by Nemon in Paris in 1938

you say? Very well, then, goodbye for four years!' – and she turned and walked through the entrance of Marlborough House.

Her prediction was more than justified; it was over six years before I had news of her. One day after the war I heard suddenly that Princess Eugenie was in London having lunch with the King. I managed to track her down by telephone. She told me that she and her family had been safe in Africa during the war and that, when they got back eventually to Saint-Cloud, they found that it had remained completely untouched and unplundered – except for the accordion, which was missing when they returned.

Meanwhile Nemon's girlfriend Jessie Stonor was becoming a sculptor of royals in her own right. An interview with her appeared in a newspaper just before her first exhibition at the Beaux Arts Gallery in London and illustrated her own predilection for royal sitters. She described her first sitting with the Duke of Kent on 31 March 1938.

Today my first sitting with the D of K. Nemon came with me to the corner of the square, and I walked rather quakingly to Number 5 where I was admitted and ushered upstairs to the drawing-room, where I was left severely alone for fifteen minutes during which time I made several tours of the room (a great many lovely things, especially a great lacquer screen) and was feeling comparatively at ease by the time the Duke suddenly popped in and surprised me examining some jade livestock. He had a spruce waxy look and was very civil. I sat him in a stiff chair against the light and started drawing, and then Princess Marina came gaily in, in her blue pleated skirt – I thought she was just as lovely as her photographs, and she was very charming indeed. She stayed and talked for several minutes, and I showed her some photographs I had brought, and then she said she thought we'd get on better without her and went gaily away. I finished my drawing (presently my

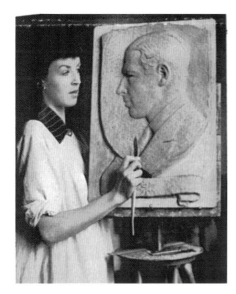

Above
Jessie Stonor with her
relief of the Duke of
Kent in 1938

Right
Sculpture of General
Draža Mihailović
given to the Serbian
Orthodox Church
of St Sava, London,
by Queen Marie of
Yugoslavia
PHOTOGRAPH
BY DANIEL ZEC

hand ceased to tremble), and we talked the while about his new chow puppy and
Princess Marie of Greece and her chows, about Julie d'Hautpoul, Uncle Harry and
about old Madame Grouitch. The next sitting is fixed for next Thursday.

It is hard to establish the precise date when Nemon sculpted the heads of King
Peter of Yugoslavia and of his mother Queen Marie – whether it was before or
even during the war. No doubt Mme Grouitch – the formidable American-born
wife of the Yugoslav Minister in London – had something to do with the
arrangements. She knew Nemon well and liked him. It is equally uncertain when
he did a portrait of the Serbian nationalist General Draža Mihailović (and later
Chetnik commander, executed in 1946 by the victorious Tito), who was also
close to the Yugoslav Royal Family. This bust turned up in the Serbian Orthodox
Church of St Sava in London's Notting Hill, a gift that dated back to the early
1950s. It may have been given to St Sava's Church by Queen Marie of Yugoslavia
who was grateful to Mihailović for supporting the Yugoslav Royal Family during
the Second World War.

As for Nemon's first contact with the British Royal Family, that is easy to verify. The link was the Prime Minister Winston Churchill. Sir Owen Morshead, the Royal Librarian in Windsor Castle, wrote to Nemon on the Queen's behalf, requesting him to do a bust of the Prime Minister to place in Windsor Castle. Sir Owen was an important man behind the scenes. He had been sent to Germany immediately after the war by King George VI on missions that appear to be connected with the recovery of documents and artworks. His most controversial act, however, had been to recruit the notorious spy Anthony Blunt into the royal household to help catalogue the old-master drawings in the Windsor library. In the 2011 film *My Week With Marilyn*, Derek Jacobi played Sir Owen as a smooth charmer who delighted Marilyn Monroe by showing her some of the treasures in the library.

Sir Owen also succeeded in charming the Queen into agreeing to commission a head of Sir Winston to be sculpted by Nemon. He wrote to Bella on 11 November 1952, 'I have definitely received an order from the Queen, but I won't be getting very much for it but possibly other orders.' Once again he was trying to use a (poorly paid) high-profile commission to attract new clients. He added wistfully in the same letter to his sister, 'I'm sorry that we haven't received the major gain that we have been waiting for since we were born.'

Nemon's friend David Dear wrote to Simonne, David's former wife, in the middle of December as soon as he heard the news about the royal commission.

> I hear of you indirectly, from Nemon and from Jimmy Huizinga [Jessie Stonor's widower]. Has Nemon told you of his big triumph? The Queen has commissioned him to do Churchill . . . and he goes to Downing Street almost every day. Churchill is very touched and feels he is more honoured than if he had the Garter – and he has decided that Nemon is a genius.

But in fact there was an almost immediate setback, demonstrating that royal favour and the personal patronage of Britain's most famous Prime Minister were no shortcut to fame and fortune. On 18 March 1953 Gerald Kelly, the President of the Royal Academy of Arts, sent a confidential letter to Sir Owen, saying, 'I have taken action, and we should like to have Mr Nemon's bust in this year's academy. Will he take the necessary steps to send it in, and I will look after it this end? It is the most rigid rule of the Royal Academy that nothing is ever "invited" but it is quite obvious that a portrait of Winston in the Coronation Year should be in the Royal Academy.' This invitation was clear enough. Yet the President's support fell on deaf ears when it came to judgement day, before the serried ranks of the Academy's committee of sculptors. Royal and prime ministerial backing failed to sweeten their sour rejection of a man they considered an interloper in

their hallowed halls – perhaps another example of anti-Semitic prejudice. Kelly was reduced to writing an abject letter of commiseration to Nemon.

> I am sorry to say that the Sculptors are unanimous in feeling that your bust should not be included. Therefore it has been refused.
>
> The Royal Academy has had to learn over many years how to treat the large number of works that are sent in for approbation, and with our ordinary treatment you might not receive notice that your sculpture had been refused for another fortnight or even three weeks. But I think it wise and kind to let you know at once that your bust of Mr Churchill will not be included in our Exhibition, now, today, when I understand that you will be at No. 10 Downing Street for another sitting. I do not want you to learn this news from Mr Churchill whom I informed the day before yesterday.

A couple of days later Nemon wrote to the Prime Minister in defiant tones.

> I was indeed deeply moved by the kindness and grace you showed me, although you were aware of the refusal of my work by the sculptors of the Royal Academy. They no doubt have been inspired by highly moral motives, as to have acted otherwise would have made the path to fame too easy for an artist to whom Fortune in this instance has granted the privilege of so unique a model.
>
> There seems to be a natural law that anything lasting has to weather the storm, for instance, my sculpture of King Albert, now in the Belgian royal palace, was twenty years ago the subject of a bitter controversy; but now even the sculptors condescend to admit its merits.
>
> I hope this incident of the Royal Academy will amuse rather than annoy you! As for me, I hold the hammer and chisel more firmly than ever.

Sir Jock Colville wrote to Nemon from Downing Street to comfort him after his rejection by the Academy by reminding him that the same fate had befallen Augustus John and Walter Sickert. Colville went on, 'If I were you I should not be greatly upset, and the bust will earn greater fame on a permanent pedestal in Windsor Castle than on a temporary one at the RA Summer Exhibition!'

But, of course, Nemon was deeply upset and far more annoyed than amused.

The next involvement with royalty happened at the beginning of 1956, when Roy Harrod, a don as well as Curator of Pictures at Christ Church, the eminent Oxford College founded by Cardinal Wolsey, approached Nemon with a project.

> It was the tradition of Christ Church during two centuries to have a marble bust of the reigning monarch, who is *ex officio* our Visitor, placed behind the High Table

Nemon with his bust of
the Queen Mother in
the garden at Clarence
House, 1970s

in the centre of the back wall of Hall . . . We had a very poor one of Queen Victoria,
now relegated to the Library, and after that the tradition petered out.

I had the idea that the tradition should be revived, and it was with this in view
that I visited you the other day. And the Governing Body has now instructed me to
find out if you would be willing to undertake the task . . . In assisting it to reach the
decision I mentioned the figure of £1,000 . . . In due course the Dean will have to
approach the Queen through the usual channels. But this will not be done until we
know if you are willing, as it would be expedient to use your name as an integral
part of the proposal.

By the end of February the Queen had given her approval. Her Private Secretary,
Martin Charteris, warned, however, that he was afraid it may be 'some time
before Her Majesty will be able to find time to give Mr Nemon sittings, as there
are a number of artists waiting to whom sittings have already been promised'. He
was also interested in finding out if Nemon would be working with clay rather

than marble and also about a limitation to the number of reproductions – both issues Harrod was happy to leave up to the artist himself.

In fact, the delay in getting started was not as long as envisaged. In the middle of August Harrod was reporting to Nemon that there could be some sittings that autumn. Perhaps knowing Nemon's reputation for failing to meet deadlines, he added plaintively, 'I don't suppose you can at present make any prediction as to when it is likely to be finished.'

I wrote in my diary on 24 October 1956 that my father was taking me to Buckingham Palace. I was thirteen years old and very nervous. We were taken to the Yellow Drawing-Room where the sittings took place. Sadly, I never saw the Queen, but I was taken off to the Balcony Room and left there. I opened the net curtain and peered out. Then I realized someone had seen me and pointed up at the window. I remember feeling terrified that someone would come and scold me. But, of course, nothing happened.

Indeed, for some time after this nothing much happened with the bust itself. Progress was slow, and it was not until the beginning of March 1958 that Harrod was able to write to Nemon to say that he found the bust 'perfectly lovely' and 'infused with a great beauty' but – a big but – it was in profile and 'we must have it looking down the Hall', a stipulation that he repeated in another letter six days later, adding, rather hopefully, that 'I hope you will not think very much needs altering and improving.'

Two whole years later . . . and Harrod wrote:

> Now that the baby is born, what? It is my duty now to persuade you to take action. You showed me a most beautiful head, but with the neck too much twisted for the purpose of the Hall two or three years ago. I doubt if you can treat that one.

Another two years went by and Harrod put pen to paper again. It was now June 1960.

> The Queen told me to tell Charteris that she would consent to more sittings. I think that the idea was two. I told him that I would impress on you that you really *must* perfect [sic] this time! I have written to Charteris.

Slow-forward to March 1961. The news is good. Nemon had shown Harrod and the Christ Church team his new bust of the Queen. Harrod was ecstatic.

> It has delicacy, grace, originality, beauty, likeness and a touch of regality. Above all it is sympathetic. You have fully come up to my expectations. It was because I was very keen that the bust should have some of those qualities that I thought of *you*

Left

George and Aurelia cutting the cake in front of Nemon's bust of Queen Elizabeth II in Christ Church's Great Hall, Oxford, 1964

PHOTOGRAPH BY FALCON STUART

Above

Nemon with Aurelia and George Young after their wedding in Christ Church Cathedral, Oxford, 1964, with their bridesmaids Eva Stevens and Helen Scott

PHOTOGRAPH BY FALCON STUART

and resisted the alternative proposal, which was made at the time, to commission Epstein.

I should be perfectly happy if you would now think of your work as over and done with, except for the technical task of converting it into bronze.

I do not know if the Queen would be willing to come for an unveiling later . . . The Queen has visited or, at least, looked in on Christ Church rather a short time ago. Of course, if she was willing to come again so quickly that would be splendid.

One of Nemon's busts of Queen Elizabeth II sculpted during his sittings at Buckingham Palace in 1957

Nemon's connection with Martin Charteris was to have further fruitful consequences. The two became good friends, and Nemon gave Charteris lessons in sculpture. (Nemon's memoir contains no references at all, however, to this period in his life and, perhaps out of discretion, no mention of his dealings with any member of the Royal Family.) It was Charteris who was instrumental in finding Nemon a magnificent studio in St James's Palace, next to the garden of Clarence House where the Queen Mother lived.

In the summer of 1968 Nemon was already at work on another portrait bust of the Queen, this time commissioned by Cunard Line, presumably for HMY

Britannia. He was offered a fee of £2,500, which would include a pedestal. The original plan was that it should be finished in aluminium. Cunard had originally wanted a full-length statue but eventually decided that would be on 'too grand a scale'. Lord Mancroft, the Deputy Chairman, was obviously aware of Nemon's propensity not to deliver on time. He wrote to the artist on 7 June that 'I think I ought to remind you that "time is of the essence".' He gave the latest date for delivery as mid-October and added for good measure, 'As you've been good enough in the past to let me visit your studio while you have been at work, perhaps you would do me the kindness of letting me view the work in progress in the not too distant future.'

His deadline was indeed optimistic. It was almost a year later, on 9 April 1969, that Mancroft wrote again to Nemon.

I am delighted that the portrait bust of the Queen is now finished, and I quite see how the sitter described it as impressive. I think it is a magnificent piece of work and well worth waiting for.

As I told you, we must, without fail, have the bust installed in the Queen's Room at the end of April between the ship's arrival back from her short eight-day cruise and departure for her maiden voyage. This gives us very little time, but it is essential that we are able to show it to the Queen when she lunches with us during that short period.

Nemon's children and grandchildren after the unveiling of the Queen's bust in the House of Lords, 2009. From left: Hugo (Aurelia's son), Marianne and Gerry (Aurelia's daughter-in-law and son), Sophia and Camilla (Aurelia's daughters), George and Aurelia Young, Mike Bradley, husband of Sorrel (Electra's daughter), Electra, Paris (Electra's son), Ze (Falcon's son), Alice (Falcon's widow), Julian Maddison (husband of Alice) and Pendragon (Falcon's son)

© UK PARLIAMENT/ DERYC SANDS

In his book *Of Comets and Queens* Sir Basil Smallpiece, Chairman of Cunard, wrote about that visit:

> After lunch we were passing through the Queen's room, as the principal lounge was named. Stormont Mancroft pointed out to the Queen the Oscar Nemon bust of herself. 'You are putting it here are you?' she said. 'How did he manage to finish it so soon?' 'Oh, it's not finished yet, Ma'am,' Stormont said. 'This is only a plaster cast painted over.' The Queen continued: 'He is a great perfectionist, isn't he? I have sat now seven times for this bust, and each time he finds something wrong with it.' "That's no good," he says, and wrenches my head off' – using her hands as she spoke to demonstrate wringing her neck.

Queen Elizabeth and Prince Philip unveiling Nemon's bust in the House of Lords in 2009

PHOTOGRAPH BY SHAUN CURRY

In the Tate Gallery archives I found a description by Sir John Rothenstein, its Director, of the time Nemon failed to turn up for one sitting with the Queen.

> When the Queen enquired, at the time arranged, where Nemon was, Sir Martin Charteris said, 'I am afraid, Ma'am, that he isn't here.' When told what had occurred, the Queen laughed, saying such a thing had never happened before. Charteris then telephoned to ask why he had not arrived. Nemon explained that he was in bed with a migraine. 'If that is your only excuse, it is impertinent.' Distressed, Nemon apologized. Charteris put

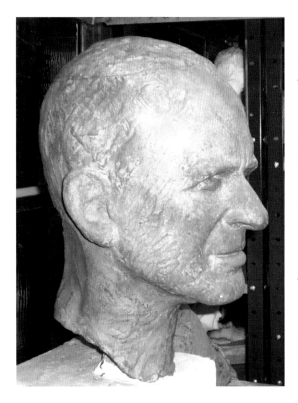

Nemon's bust of Prince Philip, 1978; the intended sittings never seem to have taken place, and the bust remains in Nemon's studio.

down the telephone but rang up shortly afterwards and a sitting was arranged for the afternoon. The Queen was amiability itself and nicknamed Nemon 'the missing Oscar'.

Later, in 2009, one of his busts of the Queen was unveiled by her in the Royal Gallery in the House of Lords. Viscount Falkland, Chairman of the House of Lords Works of Art Committee, described it as regal.

At the unveiling ceremony I asked the Queen if she remembered sitting for Nemon fifty years before. Her Majesty rolled her eyes back and said, 'Yes, many times.'

In May 1978 Prince Philip wrote to Nemon, saying he would be free to sit for him in November. Although my father made a bust of Prince Philip, I am not sure if any sittings took place. In 2017, at the ceremony to celebrate the hundredth anniversary of the Companions of Honour, of which my husband George is a member, I used the occasion to ask the Prince if he had sat for my father. He said he had not. I then sent the Prince's Private Secretary a photograph of the bust, and he replied that Prince Philip had seen it, said it was a striking image and remarkable likeness and regretted the sittings had never taken place.

Nemon had a happier experience with the Queen Mother, who would often come next door to inspect progress. Her bust is now in the Grocers' Hall, next to the Bank of England in the City of London.

In 1984 Nemon was commissioned by Wedgwood to make a relief of Princess Diana. At the time of the commission Diana was pregnant with Prince Harry, who was born in September. Nemon waited until after the birth for his first sitting with the Princess, as he said her face would change during pregnancy.

He was summoned to sculpt her in the Royal Apartments at Kensington Palace. During the first sitting he was able to make a couple of sketches. Unfortunately, not long afterwards my father suffered a mild heart attack and was admitted to the John Radcliffe Hospital in Oxford for observation. My mother told me not to worry and that he would be home soon, so I was reassured.

But only a little later I received a call in the middle of the night. Nemon had died of a second unexpected heart attack. I lay in bed trying to absorb what I had been told and planned to drive from my home in Cookham early next morning.

Then I felt engulfed by a wonderful feeling of closeness to my father, as if his spirit had come to embrace me in his love. The nurse who was with him told me Nemon had been having a very interesting conversation with her when he suddenly died. It was a great relief to me that he died as he had spent much of his life – talking in his soft voice to attractive women.

My mother was of course distraught to hear the news. She had remained devoted to him from the day she met him at Dr Ernest Jones's party in 1936 to the day he died in 1985; quite a remarkable devotion, since so much of their lives was spent with money worries and when, towards the end of his life, the bank wanted to make them bankrupt.

I rang Kensington Palace to inform them that Nemon would be unable to attend his next sitting with the Princess. Diana wrote me a very generous and heartfelt letter.

Nemon's sketch of Diana, Princess of Wales, after his sitting with her in Kensington Palace, March 1985

> Dear Lady Young
>
> I just wanted to say how terribly sad I was to hear about your father. The very least I can do is to send you my deepest sympathy and to say that I am thinking of your family a great deal. I wish there was more I could do because I can imagine when something like this happens how empty you must feel. Words are such inadequate things to express what one really wants to say but I *so* wanted you to know how much I feel for you at this time.
>
> I was greatly looking forward to my next sitting with your father and now I will remember that happy hour I was fortunate enough to spend with him.
>
> Yours sincerely
> Diana

I told her Private Secretary that Nemon had been able to make some preliminary sketches of the Princess and that his assistant had finished the relief. My brother Falcon and I were invited to Kensington Palace to show it to her. We were led into her sitting-room where she was surrounded by photographs of her little boys. On the mantelpiece there was a 'No Smoking' sign. I said, 'My husband would be very happy to see your sign, as he is a Health Minister who is trying to ban smoking in public places.' Diana laughed and said that their friends completely disregarded the sign.

After my father's death, the Queen sent my mother Patricia a telemessage from Windsor Castle saying that Prince Philip and she sent their deepest sympathy and that 'his work will ensure that his name and reputation survive'.

Right and opposite
Diana, Princess of
Wales, photographed
by Falcon at Kensington
Palace in 1985

The Princess of Wales's letter to Aurelia after Nemon's death in 1985

KENSINGTON PALACE

April 15th
1985.

Dear Lady Young,

I just wanted to write & say how terribly sad I was to hear about your father.

The very least I can do is to send you my deepest sympathy & to say that I am thinking of your family a great deal.

I wish there was more I could do because I can imagine when something like this happens, how empty you must feel.

Words are such inadequate things to express what one really wants to say but I so wanted you to know how much

KENSINGTON PALACE

I feel for you at this time.

I was greatly looking forward to my next sitting with your father & now I will remember that happy hour I was fortunate enough to spend with him.

Yours sincerely, Diana

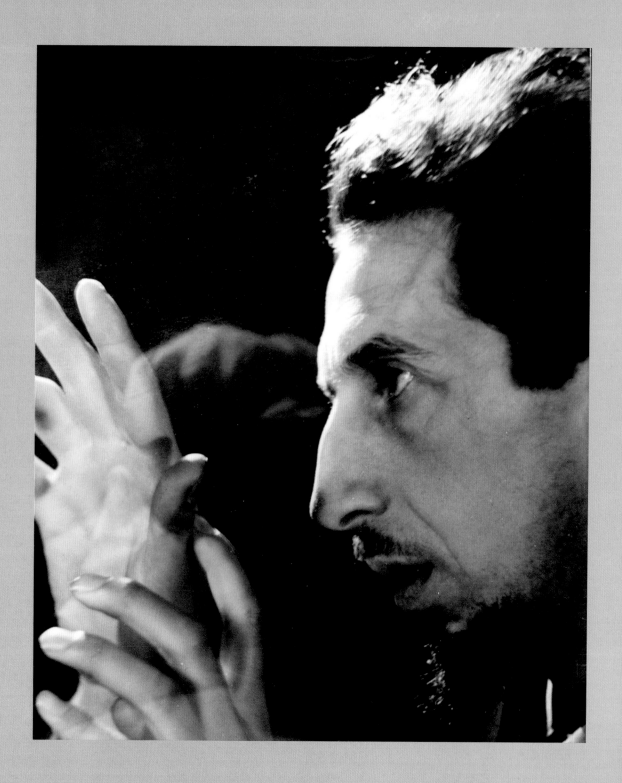

Nemon's sensitive and expressive
hands; the 'magical, hypnotic and
exotic' man Patricia fell in love
with in the 1930s

Epilogue

AM NOT SURE if my quest to find Oscar Nemon will ever end. There are still busts and maquettes unaccounted for, while others are unidentified. Who are – were – these people who sat for Nemon and whose likenesses languished for decades in a cold shed on Boars Hill but which have now been rescued by Alice, Falcon's widow, and put on display?

One cannot ever truly find another person, only try to build up a picture, a maquette, a model. Having no aptitude for sculpting, I have had to use words. Ironically, it was Sigmund Freud, one of my father's most famous subjects, who said that biography 'is not to be had', so likely is the picture to be idealized. And, of course, the picture that I paint is bound to be only partial. But finding whatever I can of my father has been an exciting quest for me.

Nemon's talent was recognized during his lifetime, becoming as he did the sculptor of choice of many of the good and the great. Yet he never received any of the honours normally bestowed on those who achieve this artistic distinction (with one exception – he was made Honorary Doctor of Letters by St Andrew's University in 1977). Patricia, more conscious than Nemon of social status, probably minded more about this than he did. My father would never have dreamt of pushing for such recognition for himself, but he did suspect that he had some disappointed rivals who may have been able to influence these decisions. We know he was never proposed for the Royal Academy, and his now famous bust of Churchill (in Windsor Castle) was deemed to be unworthy of its exhibition. Even after the horrors of the Second World War there were residual traces of anti-Semitism in British society, as exemplified by his own mother-in-law.

Although he was on familiar terms with many in the establishment, he was not of the establishment. His relationships and conversations with his sitters often took place when he was in scruffy white overalls with clay in his hand rather than in his dinner jacket holding a glass of champagne. You would never have found him at Ascot, Henley or Wimbledon – although he was a supporter of Tottenham Hotspur and occasionally visited the club's football ground at White Hart Lane. He was polite but not deferential; enquiring but not inquisitive; discreet but not silent; well informed but always ready to learn more.

 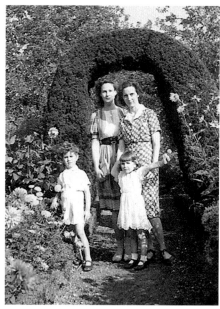

While in some respects Nemon was an insider – enjoying the confidence of those in positions of power and influence – he was essentially an outsider, a first-generation immigrant speaking English with a marked (although delicate) accent. He had a limited range of friends and maintained a modest standard of living.

There were exceptions to his professional relationships with some of his sitters, especially if they were good-looking women susceptible to his undoubted and well-attested charms. Fidelity to one woman was never Nemon's strong suit, while Patricia remained faithful to him despite his waywardness. It is difficult, even for a daughter, to speculate about the exact nature of my parents' relationship. They were fond of each other certainly, and he took his responsibilities for his wife and children as seriously as his often precarious finances allowed. But the day-to-day responsibility for the welfare of his children rested with Patricia, who had to grapple with the challenges of housekeeping.

As a professional sculptor Nemon believed that his job was to mine the seams of his sitter's personality and turn the gold that he discovered into a bust – in other words, turning personality into substance. This challenge was well summarized by the moving tribute paid by his good friend and neighbour Albi Rosenthal at Nemon's funeral.

> The capturing, the revealing of the essential was the mainspring of his art. His was not the facile reproducing of external features. What mattered to him was to find the complex nature of the *anima* of his sitters, the secrets of their inner selves, and intimations of their destinies, and *then* to make the inner image, as it were, shape

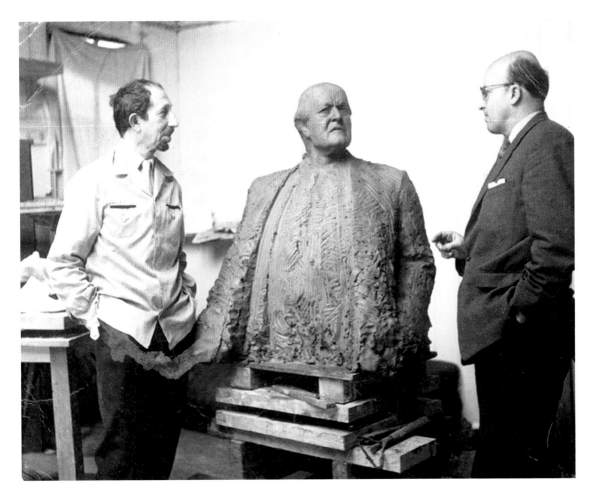

Nemon and Albi
Rosenthal with the bust
of John Christie in 1960
PHOTOGRAPH BY
FALCON STUART

the visible outlines of the portrait. For Nemon, Winston Churchill symbolized greatness of character as a bulwark against inhumanity – this was the mainspring of Nemon's message, as expressed in the numerous busts and statues of Churchill now in many lands. The long span of his life was immensely rich in vicissitudes, experiences, adventures, wanderings, mysteries and revelations. In his sphere he was supreme, and his work has a secure place for all time.

Nemon was scarred by the loss of so many members of his family in the Holocaust – one reason why he was such a strong supporter of Churchill, and perhaps why there is no record of him ever having sculpted a German. Like many refugees of his generation he was grateful to Britain for the security and opportunities which it offered him.

Almost by its nature, and certainly in modern times, a portrait sculptor is a figure in the artistic shadows. After all, how many portrait sculptors of the twentieth century and beyond can anyone actually name? Perhaps a few experts or enthusiasts can come up with a name or two, but for the most part my father's

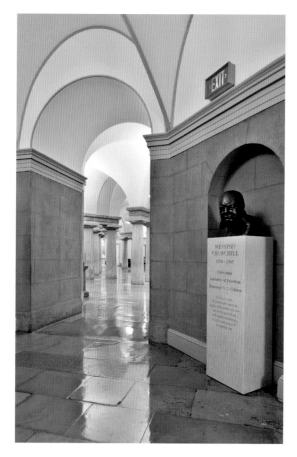

Nemon's bust of Churchill in the Capitol, now located on the first floor of the Small House Rotunda

name is equally as unknown as his sculptures are well known – or, as with some of his figures of Winston Churchill, even famous. But in Nemon's case – not uniquely, of course, because it applies to some extent to all artists – the works *are* the man.

I am sure my father would have liked to have made more money from his great talent and application. In the winter of 1937 when leaving Austria for Belgium, Nemon's psychoanalyst friend Paul Federn saw him off at the station in Vienna to return to Brussels. As the train drew out, Federn called out, '*N'oubliez pas: l'argent, c'est la liberté!*' Much later, recalling the incident in his memoir, Nemon reflected wryly that the idea that money is freedom had 'never, as a philosophy, entirely caught up with me. The whole business of making concessions for the sake of expediency, of degrading one's art, is something alien.' But when he did make some money he seldom held on to it – partly because of his generosity but also partly because financial prudence was alien to him.

I still find it hard to know if my father was justifying his life of financial insecurity after the event as an example of artistic purity or if, had circumstances been slightly different, he would have been happy to accept at least a bit more financial comfort without compromising his integrity as an artist. He was constantly trying to make a better living from his work. The mechanics of the commercial aspect of making sculptures were constantly frustrating. He wanted to support his wife as well as his three children. But he never managed to rid himself of equating financial success with compromise.

I am certain that if one wants to do something of artistic value one has to impose one's will or produce a travesty. There can be no compromise but a constant stubborn loyalty to one's convictions and one's vision. This is a lifetime's quest.

And he remained faithful to his own quest until he died at the age of seventy-nine.

As *The Times* recorded, Nemon was buried on 19 April 1985 in the graveyard of Wootton Church – the parish where Boars Hill is located. Exceptionally, the church authorities allowed his sculpture, *Heredity*, to be placed near his grave.

Aurelia's photograph of her parents, Nemon and Patricia, at Pleasant Land, Boars Hill, 1964

Heredity, Nemon's, Patricia's and Falcon's gravestones in Wootton churchyard
PHOTOGRAPH BY ALICE HILLER

On 14 November a service of thanksgiving for his life and work was held at St Margaret's Church, Westminster, the parish church of the House of Commons, where the address was given by Lord Charteris (as Martin Charteris had become).

My mother's friend Elizabeth Milburn wrote to me, 'I hope when you write a book about Nemon you will not forget the magical, hypnotic, exotic quality your father had; a powerful passion not obvious under normal acquaintance. But perhaps the secret of his exceptional talent.'

I hope I have been able to do that.

Nemon's sketch of
Falcon and Aurelia,
1945

Nemon Museum and
Archive Centre on Boars
Hill, Oxford
PHOTOGRAPH
BY ZE STUART

Below
Sigmund Freud's return
to Vienna; photograph
taken after the unveiling
of the statue of Freud
on the campus of the
Medical University of
Vienna on 4 June 2018.
From left: Heinz
Faßmann, Aurelia
Young, David Freud,
Stephan Doering,
Alice Hiller, Electra May,
Markus Müller
PHOTOGRAPH BY
CLIVE ROBINSON

Aurelia with Nemon
after her wedding in
1964

Select Bibliography

Arnold, Eve, *The Great British*, Alfred A. Knopf, New York, 1991

Black, Jonathan and Sara Ayres, *Abstraction and Reality: The Sculpture of Ivor Roberts-Jones*, Philip Wilson Publishers, London, 2014

Colvin, Ian, *Flight 777: The Mystery of Leslie Howard*, Pen and Sword, Barnsley, revised edition 2013

Dimancescu, D. *Uncharted Journey, Memoirs of Dimitri D Dimancescu*, BTF, 2016

Eforgan, Estel, *Leslie Howard: The Lost Actor*, Vallentine Mitchell, Edgware, 2010

Freud, Sigmund, *The Diary of Sigmund Freud 1929–1939*, ed. Michael Molnar, Scribner, New York, 1992

Gilbert, Martin, *Churchill and the Jews*, Simon and Schuster, London, 2007

Nicholls, C., *The History of St Antony's College, Oxford, 1950–2000*, Palgrave Macmillan, Basingstoke, 2000

Ramsden, John, *Man of the Century: Winston Churchill and His Legend Since 1945*, HarperCollins, London, 2002

Rodman, F. Robert, *Winnicott: His Life and Work*, Da Capo, Cambridge, Massachusetts, 2003

Rothenstein, John, *Time's Thievish Progress*, Vol. III, Cassell, London, 1979

Soames, Mary, *Clementine Churchill by Her Daughter*, Doubleday, London, 2002

Zec, Daniel, *Oscar Nemon: memoari, eseji, osvrtii zapisi*, MLU, Osijek, 2016

All citations from Oscar Nemon's letters and memoirs are the copyright of the Nemon Estate.

All photograph by Falcon Stuart are the copyright of the Estate of Falcon Stuart.

The Nemon Studio Museum and Archive are based at the sculptor's former studio on Boars Hill near Oxford and may be consulted for research purposes.

Nemon's grandson
Ze in the studio at
Pleasant Land just after
Nemon's death in 1985
PHOTOGRAPH BY
FALCON STUART

Index